Perspective as Symbolic Form

Translated by Christopher S. Wood

Perspective as Symbolic Form

Erwin Panofsky

ZONE BOOKS · NEW YORK

1997

© 1991 Urzone, Inc.
ZONE BOOKS
40 White Street, 5th Floor
New York, NY 10013

First Paperback Edition
Third Printing 2002

The Publisher would like to acknowledge Dirk Obbink
for translating the Latin and Greek passages and trans-
literating certain Greek phrases; and also Riccardo Di
Giuseppe for translating the Italian passages in note 68.

Originally published as "Die Perspektive als 'symbo-
lische Form,' " in the *Vorträge der Bibliothek Warburg*
1924–1925 (Leipzig & Berlin, 1927), pp. 258–330.

Printed in the United States of America.

Distributed by The MIT Press,
Cambridge, Massachusetts, and London, England

Library of Congress Cataloging in Publication Data

Panofsky, Erwin, 1892–1968.
 [Perspektive als symbolische Form. English]
 Perspective as symbolic form / Erwin Panofsky.
 p. cm.
 Translation of: Die Perspektive als symbolische
 Form. Includes bibliographical references.
 ISBN 0-942299-53-1 (pbk.)
 1. Perspective. I. Title.
NC750.P2313 1991
701'.82–dc20 91-10716
 CIP

Contents

Introduction

by Christopher S. Wood

Panofsky's early theoretical voice has proved both resonant and elusive. This capacious essay on perspective, in particular, enjoys a reputation well outside the professional territory of art history. Yet that reputation has often overwhelmed the finer modulations of Panofsky's argument and obscured its theoretical provenance. To listen to the voice of the perspective essay again, to attend to its undertones, is a project of more than merely biographical interest. Panofsky, who was born in 1892, belonged already to a second generation of German critics of positivistic historical scholarship. These critics generally shared a vision of a more comprehensive science of culture, a scholarly practice that would seek to understand and not simply to accumulate data. Panofsky also belonged to a subset of critics sensitive to the inevitable deficiency of cultural history, namely the underestimation or neglect of a dimension of meaning proper to certain kinds of objects (texts, images), a dimension intractable to historical explanation. Artistic products, Panofsky wrote in 1920, "are not statements by subjects, but formulations of material, not events but results."[1] Any historical treatment would have to acknowledge the autonomy of such an object, the impossibility of deriving the object from its phenomenal circumstances. This was the necessary first stage of any nonmaterialist cultural history.

This preliminary isolation of the work of art resembles the maneuvers of Russian Formalism and New Criticism. For both these parallel refinements of reading practice served, in different ways, the long-term

7

purpose of sharpening our sensitivity to the social character of the lin-
guistic sign, and ultimately to the inextricability of the text from the
world. The strategy was to isolate the work temporarily in order to
grasp more clearly its deep structural principles, and then ultimately to
reinsert the work into its primordial environment on more legitimate
grounds. Indeed, Panofsky in "Perspective as Symbolic Form" was work-
ing within a methodological framework built by the early art historical
Formalists: Heinrich Wölfflin and, above all, Alois Riegl. This is not an
altogether obvious point. For it was not least Panofsky's own (later)
scholarly achievements that finally discredited art historical Formalism,
indeed helped turn virtually the entire profession against it.

In his essay on Riegl's term *Kunstwollen*, Panofsky condemned both
the wild and irresponsible concession to the irrational power of the art
object (the "Expressionist" art history of Wilhelm Worringer or Fritz
Burger), and any resigned retreat into skeptical historicism. Panofsky
endorsed instead Riegl's "more-than-phenomenal" treatment of artistic
phenomena. In Riegl's visionary synchronic *Weltanschauungsphilosophie*,
tempered by a certain deliberate philological myopia, Panofsky saw the
germ of a new art history, a reconciliation of materialist and idealist his-
tories; he called it a "serious *Kunstphilosophie*."[2]

Riegl had commenced his cultural history by introducing a new rep-
ertoire of formal categories. Haptic and optic, internal and external
unity, coordination and subordination – like Wölfflin's famous "princi-
ples" – were deep structural attributes of the work. Analysis of struc-
ture at this level transcended not only history, but also questions of
function or value, beauty or meaning. Structural analysis revealed a pat-
tern behind the temporal sequence of works of art, an internal *telos* or
motivation, which Riegl personified as *Kunstwollen* or "artistic will."
Cultural history, then, would proceed by coordinating that will with
something called the general *Wollen* of the epoch. Riegl said in the clos-
ing pages of *Spätrömische Kunstindustrie* that the *Kunstwollen* of an epoch,
the prevailing structural principles of its artistic phenomena, "is plainly
identical to the other main forms of expression of the human *Wollen* in
the same epoch." There is no doubt what to call that general *Wollen*:
man is an active and sensory being disposed to interpreting the world "in

the way most open and accommodating to his needs (which vary among peoples, places, and times). The character of this *Wollen* is embraced by that which we call the respective *Weltanschauung*."[3]

In the end, however, Riegl declined to answer the last synchronic questions about artistic phenomena. This reluctance to interpret has usually been condemned as an aestheticizing insulation of the art object from life. Riegl's immediate purpose, clearly stated in the introduction to *Spätrömische Kunstindustrie*, was indeed to undermine the materialist art history exemplified by the work of Gottfried Semper. Riegl dismissed function, materials and technology as merely negative restrictions on form, mere "frictional coefficients," and instead asserted the autonomy of formal development. Riegl scrupulously avoided confusing form not only with the functions that the physical work might have once served, or still serves, in the world, but also with the possible references to the world made by form, and the possible meanings that those references might have generated or still generate. This is why the *Kunstwollen* has been called a Husserlian "bracketing device."[4]

The art historian's disengagement of objects from the world may very well stand as a correlative to various, more general convictions about the superiority of spirit to matter, or imagination to reason; about the detachment of the artist from society; about the inescapably self-reflexive and circular nature of interpretation; about artistic tradition carrying more weight than individual gestures of innovation. Early art historical Formalism was associated with versions of all of these. "The effect of picture on picture as a factor in style," Wölfflin said, "is much more important than what comes directly from the imitation of nature."[5] Wölfflin's aphorisms are the most often remembered, although others said similar things. But this does not mean (except in some extremely general and meaningless sense) that these methods were allied with aestheticism. On the contrary, the Formalists generally thought of themselves as emancipated from aesthetics: these were antimaterialist yet positivistic histories, sciences of the spirit. This is a paradox, for clearly the attribution of dependence or independence is related to the initial criterion of selection of the objects. It is generally easier or more natural to attribute independence to a sequence of objects selected by

an aesthetic criterion, for the work of art since Kant is normally defined as discontinuous with the very conditions that made it possible (the "world"), and underivable from those conditions. An authentically "aesthetic" history of art would altogether detach certain formal qualities from the work and hypostatize them as "style"; the history then becomes a pure morphology, a study of changes in form that are only incidentally played out in material works. Riegl, on the contrary, was hostile to any absolute or supra-historical aesthetic category; at any rate he would not incorporate such a category into his historical project. "Works of art" for him were simply man-made objects with some high level of artificial formal organization. He wrote about applied art or even entirely ordinary objects because, like works of art, they are subject to independent formal logic. For Riegl the primary level of facts was not style itself (the morphology), nor even the sequence of objects, but the *Kunstwollen* of an epoch, just as for Wölfflin it was the form of seeing.[6]

It would be a mistake to dismiss Riegl, and for that matter Wölfflin, as doctrinaire formalists who underrated the fullness of the relationship between the work of art and the world. Riegl was not blind to those grand images of cultural totality sketched by Burckhardt or Dilthey, and which would later animate Aby Warburg. Rather, the operation of filling in that image was simply too delicate and hazardous for his temperament. He was too scrupulous a philologist, too much a nominalist at heart, to complete his own project. Riegl truncated his *Weltanschauungsphilosophie* almost as a matter of conscience. Perhaps he was postponing the fulfillment of those ambitions to an old age which he never had; or perhaps he was willing to leave the risks to his students.[7]

The most successful and at the same time most disastrous extensions of Riegl's *Weltanschauungsphilosophie* were indeed carried out by his own immediate successors and students, including Max Dvorak, and above all Hans Sedlmayr, Guido von Kaschnitz-Weinberg, and Otto Pächt, the core of the so-called Second Vienna School. They sought to drive Riegl's structural analysis farther along its synchronic axis by refining and elaborating the categories of the initial pictorial analysis. Their ambitions were superbly ascetic. The latent structural principles of the work would alone yield the insight into the world that produced that work.[8]

The flaws of Viennese *Strukturanalyse* were the flaws of any struc-
turalism: it was driven by a certain sentimental faith in the organic integ-
rity of culture, in the mysterious interconnectedness of events; and
consequently it tended to leave the crucial link between work and world
strangely unexamined. The bracketing device that cut all the ordinary
ties between work and world was originally a way of heading off crude
propositions about the relationship between work and world; it set pre-
liminary limits on what could be said about synchrony, about context.
But this was a calculated risk. The initial bracketing often made it more
difficult, or even somehow unnecessary, to find a path back to the world
of ordinary events. Here is where Sedlmayr went astray. He discovered
in works of art an appealing parallel universe, a "Welt im Kleinen,"
almost a parody of Heidegger's radically autonomous *Kunstwerk* whose
adequacy to the world was no longer at issue. *Strukturanalyse* degener-
ated into a kind of nostalgic aestheticism with theological and even
theocratic (not to speak of Fascist) leanings.

Any successes or failures of this method, then, followed from the ina-
bility of its practitioners to resist a temptation presented by Riegl. It is
not far-fetched to cast this in ethical terms, for it is in just such terms
that the Second Vienna School was repudiated, in America already in
the thirties,[9] in the German-speaking countries after the war. Panofsky
in the teens and twenties was obviously exposed to the same tempta-
tion; what has been difficult to see is the extent to which he was vul-
nerable to that temptation. The distinction between aesthetic insulation
and ascetic bracketing was one that Panofsky appreciated. Moreover, he
thought he could resolve those antagonisms between philosophy and
philology that had paralyzed Riegl.

Panofsky preserved Riegl's *Kunstwollen* only by fragmenting it. The
concept survives in Panofsky only in shards, strewn about his argument
in the form of a "*Stilwille*," in the verb "*willen*," in words like "striving"
and "ambition." He resisted the *Kunstwollen* because there was some-
thing amateurish about it. Indeed, Riegl used it precisely because it was
not clearly derivable from academic philosophy, which he mistrusted;
it was a homemade concept, and so Riegl used it with a certain confi-
dence, and little anxiety about its ultimate legitimacy. Panofsky actu-

ally accepted Riegl's framing of the problem, but needed, on the one hand, to camouflage or disperse his simplistic philosophical machinery and, on the other hand, to replace it with a more professional model, the philosophy of the "symbolic form." In effect Panofsky was trying to buttress Riegl with neo-Kantianism. He reinterpreted the *Kunstwollen* as the immanent *Sinn* or meaning of a sequence of artistic phenomena, and then insisted that this *Sinn* was accessible only through analysis of those phenomena according to a priori formal categories. This would be Riegl with philosophical substance.

This adaptation often resembles the Vienna School adaptations of Riegl. Panofsky's rhetoric was less bombastic and aggressive, and need-less to say free of nationalist or racist undertones. Panofsky was more attentive to philological matters and had more historical scruples; he also relied more heavily, almost instinctively, on texts. Panofsky's struc-turalism is hard to recognize because it is obscured and dissipated by his philological habits (a resistance to systems, a tendency to wander away from argument, a natural sobriety of tone). But his aims and even his actual practice overlapped with those of the *Strukturforscher*. The affinity between them now looks more important than the breach – along the Kantian–Hegelian fault – described by Sedlmayr in 1929.[10] The image of the American Panofsky choosing history over philosophy is thus rather misleading. In fact, he had made the essential move toward a reconciliation of philology and philosophy well before emigration. Panofsky's adaptation and extension of Riegl was more or less rounded out by the mid-twenties, in the book on German medieval sculpture[11] and above all in the essay on perspective. And it is not obvious that that move was reversible, that the philosophy could be disentangled from the philology.

The precondition for the move from the level of "form" to the level of "structure" was the disengagement of the work from the category of the aesthetic. Riegl managed this quietly, in part by simple abandonment of conventional terminology, in part by refusing to draw distinctions between works of art and other artifacts. Panofsky, again, wanted more substantial philosophical justification. He decided to consider artistic perception as a special case of cognition. On the last page of *Idea* (1924),

Panofsky makes the fundamental neo-Kantian point about the incommensurability of cognitive models:

> In epistemology the presupposition of this "thing in itself" was profoundly shaken by Kant; in art theory a similar view was proposed by Alois Riegl. We believe to have realized that artistic perception is no more faced with a "thing in itself" than is the process of cognition; that on the contrary the one as well as the other can be sure of the validity of its judgments precisely because it alone determines the rules of the world (i.e., it has no other objects other than those that are constituted within itself).

In a footnote, however, Panofsky admits a distinction between artistic perception and cognition in general:

> The laws which the intellect "prescribes" to the perceptible world and by obeying which the perceptible world becomes "nature," are universal; the laws which the artistic consciousness "prescribes" to the perceptible world and by obeying which the perceptible world becomes "figuration" must be considered to be individual – or... "idiomatic."[12]

To some extent the perspective essay collapses this distinction. It does this by taking perspective as its subject in the first place. Perspective made a promising case study not because it described the world correctly, but because it described the world according to a rational and repeatable procedure. Perspective overrode the distinctions of the idiomatic. This is what Panofsky means when he calls perspective the "objectification of the subjective" (p. 65, below), or the "carrying over of artistic objectivity into the domain of the phenomenal" (p. 72). Perspective encourages a strange kind of identification of the art-object and the world-object. It is perspective, after all, that makes possible the metaphor of a *Weltanschauung*, a worldview, in the first place.

Naturally Panofsky was self-conscious about his project to write the history of Western art as a history of perspective. In the second section, after the hypothesis about Vitruvius and curved perspective, he offers an initial justification of his topic:

Granted, this looks more like a mathematical than an artistic matter, for one might with justice point out that the relative imperfection, indeed even the total absence, of a perspectival construction has nothing to do with artistic value (just as, conversely, the strict observance of perspectival laws need in no wise encroach upon artistic "freedom"). But if perspective is not a factor of value, it is surely a factor of style. Indeed, it may even be characterized as (to extend Ernst Cassirer's felicitous term to the history of art) one of those "symbolic forms" in which "spiritual meaning is attached to a concrete, material sign and intrinsically given to this sign." (pp. 40–41)

This is not simply a plurality of possible meanings but a hierarchy. The first is the *künstlerisch* or artistic, which is made equivalent here to the aesthetic. Panofsky implicitly disparages "value" as a merely local and self-serving category; in the same stroke he grants artists their "freedom" and then dismisses their decisions as arbitrary or idiomatic. The second level of meaning is style as it was isolated and concretized by early Formalism, by Wickhoff, Riegl, Wölfflin; perspective is at least this kind of meaning, and therefore a legitimate object of a scientific art history. But the most profound level is the "symbolic form." This is the structural level so deep that the ordinary functions of form are suspended and excluded from the historical analysis. The essence of Cassirer's theory of symbolic forms (as Panofsky read it) was the notion of a core symbolizing activity. The different spheres of human creativity were the "forms" produced by this activity. We recall that for Riegl, art had been merely one among various expressions of a central human *Wollen*, or a drive toward a "satisfying shaping of a relationship to the world."[13] Thus the symbolic form provided a philosophical vindication and completion of Riegl's incipient *Weltanschauungsphilosophie*.

But how sharp was the resolution of Panofsky's image of Cassirer? The proposed "application" of the symbolic form is never theoretically justified beyond the initial statement in the second part of the essay. This is somewhat discouraging. The practice or tactic of the essay is to juxtapose an art-historical narrative and a characterization of a *Weltanschauung* (which is often achieved by a narrative about intellectual history), and then marry them in a brief and dramatic ceremony. This

junction does not necessarily bear up under close scrutiny. In the first section, for instance, after showing how difficult it has been since the Renaissance to overcome the habit of seeing in linear perspective, Panofsky makes the point that this habit was no mere arbitrary imposition upon the public eye: for the linear perspective employed by the painters is "comprehensible only for a quite specific, indeed specifically modern, sense of space, or if you will, sense of the world" (p. 34). What does it mean to slide from *Raumgefühl* to *Weltgefühl* only by way of an informal "*wenn man so will*"? *Welt* carries a heavy burden here; it is more than the physical universe, it is shorthand for experience in general. Does this mean that the experience of space is somehow central to or generative of other experience?

This association of experience in general with the experience of space is the first of two successive links that together connect world-views to paintings (and to other concrete formulations of thought). The second link in the chain is the relationship between the experience of space and the construction of paintings. In the sentence immediately following the remark just quoted about *Weltgefühl* and *Raumgefühl*, modernity is characterized as "an epoch whose perception was governed by a conception of space [*Raumvorstellung*] expressed by strict linear perspective." This "expression" is evidently a simple and derivable relationship; it is a species of equivalency or mimesis. The expression of the *Raumvorstellung* in the picture entails no loss or transformation.

The same double linkage is proposed after the discussion of Greco-Roman painting in the second section: "Antique perspective is thus the expression [*Ausdruck*] of a specific and fundamentally unmodern view of space [*Raumanschauung*]...[and] furthermore the expression of an equally specific and equally unmodern conception of the world [*Weltvorstellung*]" (p. 43). Again there is an initial link between "space" and "world," this time accomplished by a chiasmus that crosses the familiar term *Weltanschauung* with the new term *Raumvorstellung*. But what is the precise mechanism of the other link, the "expression" of the view of space in the painting? Panofsky divulges this by reformulating the famous question posed by Rodenwaldt about why Polygnotus did not paint naturalistic landscapes, and then reformulating his own answer

to that question offered in the *Kunstwollen* essay.[14] To ask whether the antique painter "could not" or "would not" paint a certain way, Panofsky argued then and now, is to pose a false question. The matter was in fact out of the painter's hands altogether, for the artistic "will" is properly an impersonal force. Panofsky speaks in Riegl's voice: antique painters did not overlook Euclid's Eighth Axiom and arrive at linear perspective "because that feeling for space which was seeking expression in the plastic arts simply did not demand a systematic space." It is the *Raumgefühl* that "seeks" and "demands"; the artist is an instrument of *Kunstwollen*, and the exponent of the "immanent meaning" of the period.

This is a complicated piece of conceptual machinery. It functions slightly differently every time it is set in motion. In the context of seventeenth-century perspective, Panofsky argues that

> the arbitrariness of direction and distance within modern pictorial space [*Bildraum*] bespeaks and confirms the indifference to direction and distance of modern intellectual space [*Denkraum*]; and it perfectly corresponds [*entspricht*], both chronologically and technically, to that stage in the development of theoretical perspective when, in the hands of Desargues, it became a general projective geometry. (p. 70)

Here the relationship between the *Bildraum* and its mathematical formulation is one of "correspondence"; elsewhere it is "expression": "Once again this perspectival achievement is nothing other than a concrete expression [*Ausdruck*] of a contemporary advance in epistemology or natural philosophy" (p. 65). The most precise and complex statement of the various relationships is the final sentence of section II, after the discussion of antique philosophies of space:

> And precisely here it becomes quite clear that "aesthetic space" and "theoretical space" recast perceptual space in the guise of one and the same sensation: in one case that sensation is visually symbolized, in the other it appears in logical form. (pp. 44–45)

Thus art and philosophy are parallel transformations of empirical real-

ity, and both are in some sense controlled by an *Empfindung* which can only be the *Weltanschauung*. Only art, however, is a symbolic form: the relationship of philosophy to the *Weltanschauung* is logical and thus not problematic. This is why the diagnosis of art can refer interchangeably to the *Weltanschauung* and to the formulations of philosophy.

In a sense, it is unfair to extract Panofsky's propositions from their contexts, as if to suggest that his arguments consisted of nothing but a series of imprecise manipulations and recombinations of philosophical terminology. But then he does argue in a peculiar rhythmic fashion, in cycles of quite sober philological and pictorial analysis culminating in brief synthetic pronouncements, like the conclusion to section II just quoted. These are rhetorically ambitious moments: they thrive on parallelism and paradox; they claim a certain aphoristic autonomy; in effect they offer closure and explanation in the form of linguistic, even grammatical, operations. This kind of writing certainly has its purposes; it can serve a cultural criticism, or a philosophical history. But Panofsky's cultural history also claims a certain historical verisimilitude. Panofsky's account of the morphology, the sequence of works of art, is understood as reliable; this is his *métier*, in a sense. But the verisimilitude of the entire cultural history is contingent upon the reliability of that double link between the history of art and the *Weltanschauungen*. If it is a function, it must be regular and intelligible; it must be capable of being both differentiated and integrated. Otherwise the linkage will have no diagnostic value.

This may look like an unreasonable demand. But most cultural histories, and certainly Panofsky's, do claim diagnostic power, that is, the ability to derive initial conditions from cultural products. Such histories are still operating within a framework established by the natural sciences. They survive on a postulated causal relationship between a primary layer of conditions or events and a secondary layer of symptoms or documents. The limits of the explanatory power of this diagnostic model – the limits of its scientific claims – are set by archaeology or some other philological procedure. As a general rule, close historical scrutiny will always disrupt and invalidate causal relationships. (Philologies are of course themselves methods subject to limits, and can

claim no more objectivity than any given method of scientific observation. They are corrected by more exacting philologies, and these in turn by still more exacting disciplines; and so on in an infinite regression, until some threshold of human sensitivity or tolerance is crossed, and the method is found persuasive.) For philology is always hostile to philosophical explanation, to determinations of meaning grounded in scientific principles of inquiry. In order to satisfy the exigencies of philology, Panofsky was in the end constrained to reduce the symbolic form to a species of merely adequate or mimetic representation.

This antagonism between the historicist scruple and the structuralist imagination is revealed most graphically in Panofsky's awkward chronological coordinations of art history and intellectual history. Synchrony is never better than approximate. Modern projective geometry as worked out by Desargues corresponds to the directionless space of Descartes, but it also corresponds to Alberti's *costruzione legittima* and to Kantian epistemology. The conceptions of space of Democritus, Plato and Aristotle all correspond to Greco-Roman landscape painting. The Aristotelian revival of the twelfth and thirteenth centuries corresponds to High Gothic sculpture. These are great blind spots in Panofsky, spectacular moments of irresponsible synthesis, forgiven because they serve as mere rhetorical punctuation of lengthy and substantive arguments. But what do they reveal about those arguments? The two kinds of events, philosophical and artistic, run in parallel because they derive from a common *Weltanschauung*. Because their relationships to that *Weltanschauung* are different – one is logical, the other symbolic – the time scales may diverge. But once they are out of synchrony, we lose our grip on the *Weltanschauung*. We are reduced to coordinating entirely unrelated sequences of events without any sense of why they should be coordinated. The *Weltanschauung* is stripped of its historical reality, exposed as the hypothetical least common denominator between art and philosophy. [15]

Philology is especially lethal to diachronic structures. This is why Riegl was so suspicious of teleologies. The only one he accepted was the one he built himself, upon synchronic foundations. Panofsky installed a new diachronic structure: the problem-solving model. Pictorial devices like perspective solve technical problems that arise when previous

devices are no longer considered effective. The evolution of the representational devices is presented as a series of resolutions of conflict, of "conquests" (p. 55). This agonistic rhythm is mirrored on a grander temporal scale in Panofsky's dialectical model of historical change. Panofsky conceived of historical movement as a series of syntheses. This is still conspicuous in *Early Netherlandish Painting* (1953) and in *Renaissance and Renascences* (1960). In the perspective essay it surfaced at the beginning of section III, in the theory of "reversals":

> When work on certain artistic problems has advanced so far that further work in the same direction, proceeding from the same premises, appears unlikely to bear fruit, the result is often a great recoil, or perhaps better, a reversal of direction. Such reversals, which are often associated with a transfer of artistic "leadership" to a new country or a new genre, create the possibility of erecting a new edifice out of the rubble of the old; they do this precisely by abandoning what has already been achieved, that is, by turning back to apparently more "primitive" modes of representation. (p. 47)

It is hard to say whether the local problems and solutions are mere symptoms of the universal dialectic, or on the contrary the dialectic is composed of countless particular dialectics. At any rate, this is well beyond Riegl. The source is not hard to find; Panofsky elaborated in *Die Deutsche Plastik*:

> The Hegelian notion that the historical process unfolds in a sequence of thesis, antithesis and synthesis appears equally valid for the development of art. For all stylistic "progress," that is, each discovery of new artistic values, must first be purchased with a partial abandonment of whatever has already been achieved. Further development, then, customarily aims at taking up anew (and from new points of view) that which was rejected in the initial onslaught, and making it useful to the altered artistic purposes. (p. 28)

This places a special burden on the historian, needless to say: he or she will want to show that historical individuals conceived of these problems in this way. Philology will virtually always show that they did not.

Moreover, this abstract diachronic will is incompatible with the synchronic will, the will of the culture or the worldview to express itself in art. One of the two perpendicular wills must be dominant; they cannot both claim mimetic power. If the diachronic will is so strong as to be almost predictive – at one point Panofsky says: "we can almost predict where 'modern' perspective will unfold"! (p. 54) – then the synchronic will is reduced to a simple, necessary copying function. One suspects the opposite to be true as well: if one has faith in synchronicity, then the destiny of the diachronic will is no longer a mystery. Antiquity, for example, recognized direction as an objective attribute of space "by intellectual-historical necessity" (p. 70).

It is telling that philology is somehow less disruptive in those passages in the perspective essay on medieval sculpture. Since here the topic is not really perspective at all, the analysis can proceed outside the dominion of the perspectival heuristic model. These are the most difficult passages in the essay, and the closest to Riegl. The analytical model is introduced already in section II, when anthropomorphic and corporeal (haptic) classical art is compared to painterly and spatially unified (optic) Hellenistic art:

> Yet even the Hellenistic artistic imagination remained attached to individual objects, to such an extent that space was still perceived not as something that could embrace and dissolve the opposition between bodies and non-bodies, but only as that which remains, so to speak, between the bodies. Thus space was artistically manifested partly by simple superposition, partly by a still unsystematic overlapping. Even where Greco-Roman art advanced to the representation of real interiors or real landscape, this enriched and expanded world was still by no means a perfectly unified world, a world where bodies and the gaps between them were only differentiations or modifications of a continuum of a higher order. (p. 41)

The manipulation of a priori structural categories is abstract and flexible enough to permit a direct comparison with modern Impressionism, and later with Expressionism. Once the categories are established, Panofsky can stretch the horizons of his argument. Section III begins by pro-

longing this analysis into a general morphology of medieval art, a vast Hegelian schema of advances and reverses. This morphology is conducted in terms of framing devices, surface values, the binding power of the plane, coloristic unity, the homogeneity of space, the emancipation of bodies from mass. The morphology takes place in the historical present tense: it is an explanation rather than a narrative. These pages are indeed what Hubert Damisch calls Panofsky's real *contribution* to the philosophy of symbolic forms, and not merely an application of that philosophy to art history.[16] They are the true outline for a philosophical art history, not pre-positivist (Hegelian) but post-positivist.

The hostility of philology to explanation is more conspicuous in the relatively well-documented periods – antiquity and especially the Italian Renaissance. Panofsky's own philological work contributes to the erosion of synchronic systems simply by interposing networks of biographical and circumstantial detail between theories and pictures. Moreover, since Panofsky has imbedded his analyses of antique and Quattrocento painterly perspective within a much vaster synopsis of Western representations of space, embracing even the relationship of sculpted figures to architecture, rationalized linear perspective comes to look merely like one of many available tactics for representing space, and not necessarily the central and most prestigious achievement of Renaissance painting. In some ways perspective was only a compositional device, or perhaps even a stylistic gesture.[17] The finer the grain of historical detail, the harder it becomes to justify the power conceded to perspective within the *Weltanschauungsphilosophie*.

And yet painterly perspective remains the dominant motif of the essay; indeed, in a footnote Panofsky says that the essential purpose of the essay is to differentiate antique and modern perspectival systems. This is in part because perspective remains an irresistible heuristic model, because it encourages the symbolic unions he proposes. Panofsky exploits perspective constantly in double entendres encapsulating the symbolic relationship between art and worldview. He concludes, for example, that the spatial system of Trecento painting was constructed out of "elements" already present in Byzantine painting (projecting cornices, coffered ceilings, tiled floors and so forth); "it merely required

the Gothic sense of space to join these *disjecta membra* into unity"
(p. 55). The epistemological achievement of perspective is equally an art
historical achievement: perspective brings space and architecture into
coordination, just as Giotto and Duccio synthesized Byzantine and
Gothic art. Nor can Panofsky resist using an unhistorical but systemati-
cally expedient concept of a *Sehbild* or internal visual image (which is
closely related to but evidently not quite identical to the retinal image).
The fundamental distinction between Panofsky's antique and Renais-
sance perspectives is this: the ancients produced superficially false pic-
tures because they would not abandon what they knew about the truth
of perception (p. 43). This assumes that the object of representation was
not the thing itself but our mental image of it, our *Sehbild*. But surely
it is far from obvious why anyone would want to reproduce the *results*
of vision. (Indeed, Wittgenstein wondered how one ever could do so.[18])
As Joel Snyder has pointed out, it is the modern perspectival picture that
furnishes the idea of a *Sehbild* in the first place.[19] Perhaps there was even
something aberrant in Alberti's and Leonardo's desire to depict the way
objects look, rather than to depict them the way they actually are and
then simply to allow subjective vision to operate upon the depiction.[20]

It is in the end this chimerical *Sehbild* that brings down one of the
most sensational ambitions of the essay. Panofsky began with the prom-
ise of undermining the claims to legitimacy or naturalness of linear per-
spective. This project, born of an ascetic relativism worthy of Riegl, has
always been the basis of the perspective essay's celebrity. It is this claim
that has attracted the attention of philosophers and perceptual psychol-
ogists.[21] Whether or not perspective is in fact an arbitrary convention
is not the issue here. For Panofsky in any case fails to fulfill his own
promise; indeed, he rather quickly backs off from extreme relativism.
The *Sehbild*, or retinal image, becomes an objective criterion of real-
ism. Antique perspective is more faithful to the truth of perception than
Renaissance perspective because it attempts to reproduce the curvature
of the retinal image; the truest of all perspectives would be a complete
curvilinear construction.

This is not to say that the *Sehbild* has the last word. Renaissance
perspective, although unfaithful to perception, nevertheless had in

Panofsky's eyes the virtue of instituting a perfect equilibrium between the claims of the subject and the object. Panofsky was always drawn to tripartite schemas, to the reconciliation of opposites. Linear perspective, like Kantian epistemology, involves a necessary abstraction from empiricism. In the end, Panofsky makes the literalism of Greco-Roman perspective look as pedantic and pointless as Hume's skepticism. Linear perspective may be vulnerable to attacks from positions of extreme subjectivism or extreme objectivism. But its occupancy of the moderate center is perfectly secure; Panofsky grants it the same universality that he grants Kant's reconciliation of rationalism and empiricism, which he calls "critical philosophy." He found in the a priori categories an absolute standpoint. He saw no way out of the problem that Kant had framed, and no reason to seek a way out.

That way out, paradoxically, might equally have been generated by perspective. "Perspectivism" since the Renaissance also means relativism: it suggests that a problem is always framed from a particular point of view, and that no point of view is intrinsically superior or more reliable than any other. In granting Renaissance linear perspective special status, Panofsky moved away from Riegl. The extension of Riegl's project in the opposite direction, toward an absolute historical relativism, was never carried out, except insofar as it has been proposed by the philosopher of science Paul Feyerabend. Feyerabend radicalizes Thomas Kuhn's model of the history of science as a sequence of incommensurable paradigms by arguing that paradigms do not change for any rational or even intelligible reasons. Here Feyerabend actually invokes the art history of Riegl. Moreover, his prime object-lesson is fifteenth-century perspective. For even here, where painting is sometimes indistinguishable from science, there is simply no stable criterion by which the accuracy of the representational model can be evaluated. Linear perspective is just another artistic (and scientific) "style."[22]

Panofsky said as much; but then he went on to say, in effect, that perspective was more than a style. He was unprepared to accept, as Feyerabend would, the arbitrariness of the history of culture, of history itself. Feyerabend ridicules the Hegelian assumption "that the change of an idea must be reasonable in the sense that there exists a link between

the *fact* of change and the *content* of the idea changing. This is a plausible assumption as long as one is dealing with reasonable people."[23] Feyerabend's position is the natural extension of a rigorous and anti-contextual philology. At the moment when Panofsky invoked those two volitional mechanisms, the problem-solving model and contextualization (the symbolic form), he moved beyond philology.

And yet it would be a mistake to interpret Panofsky's iconology as a retreat to philology, as is so often done. Although Panofsky in America abandoned entirely the rhetoric of will, the essential diachronic and synchronic structures of the perspective essay remained intact. And once these structures had been installed, any further philological work was destined only to expose and perpetuate their inadequacies. Iconology, in the end, has not proved an especially useful hermeneutic of culture. What it tells us about a culture is usually tautological (something like: this was the kind of culture that could have produced this work). For Damisch, Panofsky departed essentially from Cassirer when he accepted the totalizing metaphor of the *Weltanschauung*.[24] Panofsky was unwilling to perceive a divergence of symbolic systems, to suffer a culture with "faults." Philology would have corroborated exactly such a divergence.

Perspective as Symbolic Form

I

"*Item Perspectiva ist ein lateinisch Wort, bedeutt ein Durchsehung*"
("*Perspectiva* is a Latin word which means 'seeing through.' "). This
is how Dürer sought to explain the concept of perspective.[1] And
although this *lateinisch Wort* was used already by Boethius,[2] and
did not originally bear so precise a meaning,[3] we shall neverthe-
less adopt in essence Dürer's definition. We shall speak of a fully
"perspectival" view of space not when mere isolated objects, such
as houses or furniture, are represented in "foreshortening," but
rather only when the entire picture has been transformed – to
cite another Renaissance theoretician – into a "window," and
when we are meant to believe we are looking through this win-
dow into a space.[4] The material surface upon which the individ-
ual figures or objects are drawn or painted or carved is thus
negated, and instead reinterpreted as a mere "picture plane."
Upon this picture plane is projected the spatial continuum which
is seen through it and which is understood to contain all the var-
ious individual objects.[5]

So far it does not matter whether this projection is determined
by an immediate sensory impression or by a more or less "cor-
rect" geometrical construction. This correct construction was in
fact invented in the Renaissance, and although later subjected to

27

various technical improvements and simplifications, it neverthe-
less remained in its premises and goals unchanged to the time of
Desargues. It is most simply explained as follows: I imagine the
picture – in accord with the "window" definition – as a planar
cross section through the so-called visual pyramid; the apex of
this pyramid is the eye, which is then connected with individual
points within the space to be represented. Because the relative
position of these "visual rays" determines the apparent position
of the corresponding points in the visual image, I need only draw
the entire system in plan and elevation in order to determine the
figure appearing on the intersecting surface. The plan yields the
width, the elevation yields the height; and if I combine these
values on a third drawing, I will obtain the desired perspectival
projection (Figure 1).

In a picture constructed this way – that is, by means of what
Dürer called a "planar, transparent intersection of all those rays
that fall from the eye onto the object it sees"[6] – the following
laws are valid. First, all perpendiculars or "orthogonals" meet at
the so-called central vanishing point, which is determined by the
perpendicular drawn from the eye to the picture plane. Second,
all parallels, in whatever direction they lie, have a common van-
ishing point. If they lie in a horizontal plane, then their vanishing
point lies always on the so-called horizon, that is, on the hori-
zontal line through the central vanishing point. If, moreover, they
happen to form a 45-degree angle with the picture plane, then
the distance between their vanishing point and the central van-
ishing point is equal to the distance between the eye and the pic-
ture plane. Finally, equal dimensions diminish progressively as
they recede in space, so that any portion of the picture – assum-
ing that the location of the eye is known – is calculable from the
preceding or following portion (see Figure 7).

In order to guarantee a fully rational – that is, infinite, un-

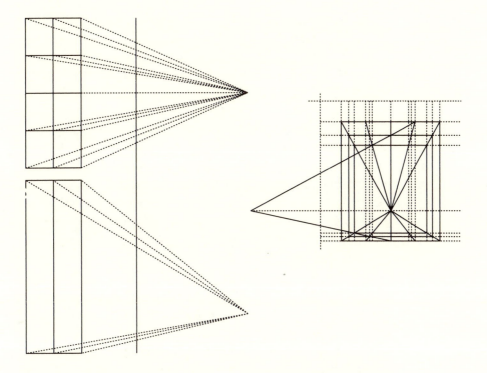

Figure 1. Modern "linear perspectival" construction of a rectangular interior space ("space box"). Left above: plan. Left below: elevation. Right: perspectival image arrived at by combining the segments marked off on the "projection line."

changing and homogeneous – space, this "central perspective" makes two tacit but essential assumptions: first, that we see with a single and immobile eye, and second, that the planar cross section of the visual pyramid can pass for an adequate reproduction of our optical image. In fact these two premises are rather bold abstractions from reality, if by "reality" we mean the actual subjective optical impression. For the structure of an infinite, unchanging and homogeneous space – in short, a purely mathematical

29

ᒥCᴀssɪʀᴇʀ

space – is quite unlike the structure of psychophysiological space: "Perception does not know the concept of infinity; from the very outset it is confined within certain spatial limits imposed by our faculty of perception. And in connection with perceptual space we can no more speak of homogeneity than of infinity. The ultimate basis of the homogeneity of geometric space is that all its elements, the 'points' which are joined in it, are mere determinations of position, possessing no independent content of their own outside of this relation, this position which they occupy in relation to each other. Their reality is exhausted in their reciprocal relation: it is a purely functional and not a substantial reality. Because fundamentally these points are devoid of all content, because they have become mere expressions of ideal relations, they can raise no question of a diversity in content. Their homogeneity signifies nothing other than this similarity of structure, grounded in their common logical function, their common ideal purpose and meaning. Hence homogeneous space is never given space, but space produced by construction; and indeed the geometrical concept of homogeneity can be expressed by the postulate that from every point in space it must be possible to draw similar figures in all directions and magnitudes. Nowhere in the space of immediate perception can this postulate be fulfilled. Here there is no strict homogeneity of position and direction; each place has its own mode and its own value. Visual space and tactical space [*Tastraum*] are both anisotropic and unhomogeneous in contrast to the metric space of Euclidean geometry: 'the main directions of organization – before–behind, above–below, right–left – are dissimilar in both physiological spaces.' "[7]

Exact perspectival construction is a systematic abstraction from the structure of this psychophysiological space. For it is not only the effect of perspectival construction, but indeed its intended purpose, to realize in the representation of space pre-

cisely that homogeneity and boundlessness foreign to the direct experience of that space. In a sense, perspective transforms psychophysiological space into mathematical space. It negates the differences between front and back, between right and left, between bodies and intervening space ("empty" space), so that the sum of all the parts of space and all its contents are absorbed into a single "quantum continuum." It forgets that we see not with a single fixed eye but with two constantly moving eyes, resulting in a spheroidal field of vision. It takes no account of the enormous difference between the psychologically conditioned "visual image" through which the visible world is brought to our consciousness, and the mechanically conditioned "retinal image" which paints itself upon our physical eye. For a peculiar stabilizing tendency within our consciousness – promoted by the cooperation of vision with the tactile sense – ascribes to perceived objects a definite and proper size and form, and thus tends not to take notice, at least not full notice, of the distortions which these sizes and forms suffer on the retina. Finally, perspectival construction ignores the crucial circumstance that this retinal image – entirely apart from its subsequent psychological "interpretation," and even apart from the fact that the eyes move – is a projection not on a flat but on a concave surface. Thus already on this lowest, still prepsychological level of facts there is a fundamental discrepancy between "reality" and its construction. This is also true, of course, for the entirely analogous operation of the camera.

If, to choose a very simple example, a line is divided so that its three sections a, b and c subtend equal angles, these objectively unequal sections will be represented on a concave surface (like the retina) as approximately equal lengths; whereas if projected on a flat surface they will appear, as before, as unequal lengths (Figure 2). This is the source of those marginal distortions

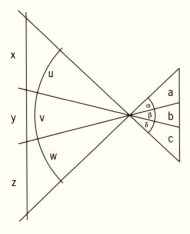

FIGURE 2. Explanation of the "marginal distortions."

which are most familiar to us from photography, but which also distinguish the perspectively constructed image from the retinal image. These distortions can be mathematically expressed as the discrepancy between, on the one hand, the ratio of the visual angles and, on the other hand, the ratio of the linear sections produced by projection upon a flat surface. The wider the total or composite visual angle – that is, the smaller the ratio between the distance from eye to image and the size of the image – the more pronounced the distortion.[8] But alongside this purely quantitative discrepancy between retinal image and perspectival representation, which was recognized already in the early Renaissance, there is as well a formal discrepancy. This latter follows, in the first place, from the movement of the gaze, and in the second place, once again, from the curvature of the retina: for while perspective projects straight lines as straight lines, our eye perceives them (from the center of projection) as convex curves. A normal checkerboard pattern appears at close range to swell out in the

form of a shield; an objectively curved checkerboard, by the same token, will straighten itself out. The orthogonals of a building, which in normal perspectival construction appear straight, would, if they were to correspond to the factual retinal image, have to be drawn as curves. Strictly speaking, even the verticals would have to submit to some bending (*pace* Guido Hauck, whose drawing is reproduced as Figure 3).

This curvature of the optical image has been observed twice in modern times: by the great psychologists and physicists at the end of the last century;[9] but also (and this has apparently not been remarked upon until now) by the great astronomers and mathematicians at the beginning of the seventeenth century. We should recall above all the words of the remarkable Wilhelm Schickhardt, a cousin of the Württemberg architect and Italian traveler, Heinrich Schickhardt: "I say that all lines, even the straightest, which do not stand *directe contra pupillam* [directly in front of the eye]...necessarily appear somewhat bent. Never-

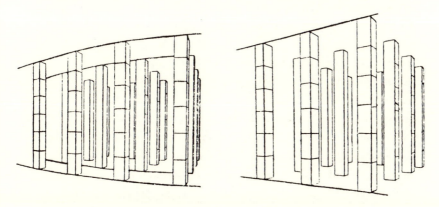

FIGURE 3. Hall of pillars constructed according to "subjective" or curved perspective (left) and according to schematic or linear perspective (right). (After Guido Hauck.)

33

theless, no painter believes this; this is why they paint the straight sides of a building with straight lines, even though according to the true art of perspective this is incorrect.... Crack that nut, you artists!"[10] This was endorsed by none other than Kepler, at least insofar as he admitted the possibility that the objectively straight tail of a comet or the objectively straight trajectory of a meteor is subjectively perceived as a curve. What is most interesting is that Kepler fully recognized that he had originally overlooked or even denied these illusory curves only because he had been schooled in linear perspective. He had been led by the rules of painterly perspective to believe that straight is always seen as straight, without stopping to consider that the eye in fact projects not onto a *plana tabella* but onto the inner surface of a sphere.[11] And indeed, if even today only a very few of us have perceived these curvatures, that too is surely in part due to our habituation – further reinforced by looking at photographs – to linear perspectival construction: a construction that is itself comprehensible only for a quite specific, indeed specifically modern, sense of space, or if you will, sense of the world.

Thus in an epoch whose perception was governed by a conception of space expressed by strict linear perspective, the curvatures of our, so to speak, spheroidal optical world had to be rediscovered. However, in a time that was accustomed to seeing perspectivally – but not in linear perspective – these curvatures were simply taken for granted: that is, in antiquity. In antique optics and art theory (as well as in philosophy, although here only in the form of analogies) we constantly encounter the observations that straight lines are seen as curved and curved lines as straight; that columns must be subjected to *entasis* (usually relatively weak, of course, in classical times) in order not to appear bent; that epistyle and stylobate must be built curved in order to avoid the impression of sagging. And, indeed, the familiar

curvatures of the Doric temple attest to the practical conse-
quences of such findings.[12] Antique optics, which brought all
these insights to fruition, was thus in its first principles quite anti-
thetical to linear perspective. And if it did understand so clearly
the spherical distortions of form, this only follows from (or at least
corresponds to) its still more momentous recognition of the dis-
tortions of magnitude. For here, too, antique optics fit its the-
ory more snugly to the factual structure of the subjective optical
impression than did Renaissance perspective. Because it conceived
of the field of vision as a sphere,[13] antique optics maintained,
always and without exception, that apparent magnitudes (that is,
projections of objects onto that spherical field of vision) are
determined not by the distances of the objects from the eye, but
rather exclusively by the width of the angles of vision. Thus the
relationship between the magnitudes of objects is, strictly speak-
ing, expressible only in degrees of angle or arc, and not in simple
measures of length.[14] Indeed Euclid's Eighth Theorem explicitly
preempts any opposing view. Euclid states that the apparent dif-
ference between two equal magnitudes perceived from unequal
distances is determined not by the ratio of these distances, but
rather by the far less discrepant ratio of the angles of vision (Fig-
ure 4).[15] This is diametrically opposed to the doctrine behind
modern perspectival construction, familiar in the formula of Jean
Pélerin, known as Viator: "*Les quantitez et les distances Ont con-
cordables différences*" ("The quantities and the distances vary pro-
portionally").[16] And perhaps it is more than mere accident that
in Renaissance paraphrases of Euclid, indeed even in translations,
precisely this Eighth Theorem was either entirely suppressed or
"emended" until it lost its original meaning.[17] Evidently, the con-
tradiction was felt between Euclid's *perspectiva naturalis* or *com-
munis*, which sought simply to formulate mathematically the laws
of natural vision (and so linked apparent size to the visual angle),

FIGURE 4. Contrast between the "linear perspectival" and "angle-perspectival" constructions: in linear perspective (left), the apparent sizes (*HS* and *JS*) are inversely proportional to the distances (*AB* and *AD*); in angle perspective (right), the apparent sizes (β and $\alpha + \beta$) are not inversely proportional to the distances (*2b* and *b*).

and the *perspectiva artificialis* developed in the meantime, which on the contrary tried to provide a serviceable method for constructing images on two-dimensional surfaces. Clearly, this contradiction could be resolved only by abandoning the angle axiom; to recognize the axiom is to expose the creation of a perspectival image as, strictly speaking, an impossible task, for a sphere obviously cannot be unrolled on a surface.

I I

At this point we are bound to wonder whether and in what way
antiquity itself might have developed a geometrical perspec-
tive. The ancients, as far as we know, never swerved from the
principle that apparent magnitudes were determined not by dis-
tances but by angles. On the one hand, it is clear that as long
as it respected this principle, antique painting cannot very well
have contemplated a projection upon a surface, but rather would
have had to adhere to a projection upon a spherical surface. On
the other hand, there can be no doubt that antique painting was
even less prepared than was the Renaissance to work in practice
with "stereographic" projection, for example in Hipparchos's
sense. We thus have to consider, at most, whether or not antiq-
uity managed to work out an artistically serviceable approxima-
tion. We might imagine such a construction founded on the
notion of a "sphere of projection" – or, in plan and elevation,
a circle of projection – with, however, the arcs of the circle
replaced by their chords. This would achieve a certain approxi-
mation of the depicted magnitudes to the widths of the angles,
without posing any more technical problems than the modern
procedure. And indeed it seems possible – we dare not claim this
with any certainty – that antique painting, at least by late Hellen-

istic and Roman times, had just such a procedure at its disposal.

Vitruvius, in a much-discussed passage of the *Ten Books on Architecture*, offers the following remarkable definition: "*Scenographia*," that is, the perspectival representation of a three-dimensional structure on a surface, is based on an "*omnium linearum ad circini centrum responsus*."[18] At first, of course, one had hoped to discover in this *circini centrum* the central vanishing point of modern perspective. But not a single surviving antique painting possesses such a unified vanishing point. More importantly, the words themselves appear to rule out this interpretation, for *circini centrum* properly means "compass point," not "center of a circle": the central vanishing point of modern linear perspective, the mere convergence point of orthogonals, cannot possibly be construed as the fixed point of a compass.[19] If, however, Vitruvius is speaking about an exact perspectival construction at all (which the mention of the *circinus* still implies), there is at least a possibility that Vitruvius meant by *centrum* not a vanishing point within the picture, but rather a "center of projection" standing for the eye of the beholder. That center (and this would conform entirely to the antique angle axiom) would then in preparatory drawings be the center of a circle intersecting the visual rays, just as the straight line representing the picture plane intersects the visual rays in modern perspectival construction. In any event, if one now constructs with the help of such a "circle of projection" (whereby, as said before, the arcs of the circle are replaced by the corresponding chords), the result does conform to the surviving monuments in a crucial respect: the extensions of the orthogonals do not merge at a single point, but rather only weakly converge, and thus meet in pairs at several points along a common axis. For when the circle is rolled out, the arcs break apart, so to speak, at the tips. This creates a "fishbone" effect (Figure 5).

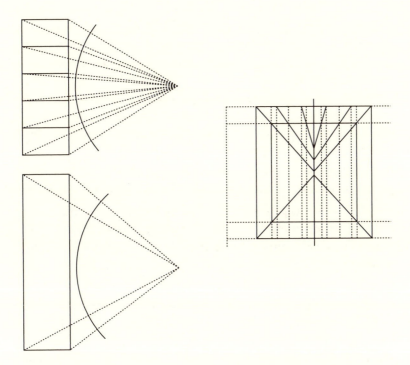

FIGURE 5. Antique "angle-perspectival" construction of a rectangular interior space ("space box"). Left above: plan. Left below: elevation. Right: perspectival image arrived at by combining the segments marked off on the "projection circle."

It is not clear that such an interpretation of the Vitruvius passage can be sustained; it can hardly be proved, since the surviving pictures almost without exception are not rigorously constructed. At any rate, this fishbone or, more formally put, vanishing-axis principle was, at least as far as we can monitor it, crucial in antique spatial representation. Sometimes we find it in the form of a partial convergence, as just described and in accord with our hypothetical circle-construction (Plate 1); sometimes in the

more schematic, but more practicable, form of a more or less pure parallelism of oblique orthogonals. The latter version is attested already on southern Italian vases of the fourth century B.C. (Plates 2 and 3).[20]

But this mode of representing space suffers, in comparison to the modern mode, from a peculiar instability and internal inconsistency. For the modern vanishing-point construction distorts all widths, depths and heights in constant proportion, and thus defines unequivocally the apparent size of any object, the size corresponding to its actual magnitude and its position with respect to the eye. That is precisely the enormous advantage of the modern method, precisely why it was so passionately pursued. A constant distortion is impossible under the vanishing-axis principle because the arrangement of the rays has no validity. This is strikingly illustrated by the inability of the vanishing-axis principle to foreshorten correctly a checkerboard pattern: the squares in the middle are either too large or too small. Already in antiquity, but then above all in the late Middle Ages, when this construction was revived in many parts of Europe, such awkward discrepancies were concealed by an escutcheon, a festoon, a bit of drapery or some other perspectival fig leaf.[21] Moreover, the diagonals of a checkerboard constructed in this way will only run straight if the depth intervals in the rear half of the board appear to grow, instead of diminishing as they should; and conversely if the intervals do diminish, then the diagonals will appear broken.

Granted, this looks more like a mathematical than an artistic matter, for one might with justice point out that the relative imperfection, indeed even the total absence, of a perspectival construction has nothing to do with artistic value (just as, conversely, the strict observance of perspectival laws need in no wise encroach upon artistic "freedom"). But if perspective is not a factor of value, it is surely a factor of style. Indeed, it may even be

characterized as (to extend Ernst Cassirer's felicitous term to the history of art) one of those "symbolic forms" in which "spiritual meaning is attached to a concrete, material sign and intrinsically given to this sign." This is why it is essential to ask of artistic periods and regions not only whether they have perspective, but also which perspective they have.

The art of classical antiquity was a purely corporeal art; it recognized as artistic reality only what was tangible as well as visible. Its objects were material and three-dimensional, with clearly defined functions and proportions, and thus were always to a certain extent anthropomorphized. These objects were not merged in painterly fashion into spatial unity, but rather were affixed to each other in a kind of tectonic or plastic cluster. Hellenistic art, to be sure, began to affirm not only the value of the internally motivated body, but also the charms of its outer surface. It also began to perceive as worthy of depiction (and this is closely related) not only animate but also inanimate nature, not only the plastic and beautiful but also the painterly and ugly, or common, not only solid bodies but also the surrounding and unifying space. Yet even the Hellenistic artistic imagination remained attached to individual objects, to such an extent that space was still perceived not as something that could embrace and dissolve the opposition between bodies and nonbodies, but only as that which remains, so to speak, between the bodies. Thus space was artistically manifested partly by simple superposition, partly by a still-unsystematic overlapping. Even where Greco-Roman art advanced to the representation of real interiors or real landscape, this enriched and expanded world was still by no means a perfectly unified world, a world where bodies and the gaps between them were only differentiations or modifications of a continuum of a higher order. Depth intervals have become palpable, but cannot be expressed in terms of a fixed "module." The

foreshortened orthogonals converge, but they never converge toward a single horizon, not to speak of a single center (even if in representations of architecture, as a rule, the rising of the base lines and the fall of the roof lines are observed).[22] Magnitudes generally diminish as they recede, but this diminution is by no means constant, indeed it is always being interrupted by mal-proportioned figures, figures "not to scale." The transformations effected by distance and the intervening medium upon the form and color of bodies are represented with such bold virtuosity that the style of these paintings has been held up as a precursor of, or even a parallel to, modern Impressionism; and yet they never achieve unified "lighting."[23] Even when the notion of perspective as "seeing through" is taken seriously — for example, when we are meant to believe that we are looking through a row of columns onto a continuous landscape (see Plate 4) — the represented space remains an aggregate space; it never becomes that which modernity demands and realizes, a systematic space.[24] Precisely here it becomes clear that antique "impressionism" was only a quasi impressionism. For the modern movement to which we give that name always presupposes that higher unity, over and above empty space and bodies; as a result its observations automatically acquire direction and unity. This is how Impressionism can so persistently devalue and dissolve solid forms without ever jeopardizing the stability of the space and the solidity of the individual objects; on the contrary, it conceals that stability and solidity. Antiquity, on the other hand, lacking that domineering unity, must, so to speak, purchase every spatial gain with a loss of corporeality, so that space really seems to consume objects. This explains the almost paradoxical phenomenon that so long as antique art makes no attempt to represent the space between bodies, its world seems more solid and harmonious than the world represented by modern art; but as soon as space is

included in the representation, above all in landscape painting, that world becomes curiously unreal and inconsistent, like a dream or a mirage.[25]

Antique perspective is thus the expression of a specific and fundamentally unmodern view of space (although it is certainly a genuinely *spatial* view, Spengler notwithstanding). Antique perspective is furthermore the expression of an equally specific and equally unmodern conception of the world. And only now can we understand how the antique world was able to satisfy itself with what Goethe called "such a precarious, even false" rendition of the impression of space.[26] Why did the ancients fail to take the apparently small step of intersecting the visual pyramid with a plane and thus proceed to a truly exact and systematic construction of space? To be sure, that could not happen as long as the angle axiom of the theoreticians prevailed. But why did they not simply disregard the axiom, as would happen a millennium and a half later? They did not do it because that feeling for space which was seeking expression in the plastic arts simply did not demand a systematic space. Systematic space was as unthinkable for antique philosophers as it was unimaginable for antique artists. Thus it would be methodologically quite unsound to equate the question "Did antiquity have perspective?" with the question "Did antiquity have *our* perspective?" as was done in the days of Perrault and Sallier, Lessing and Klotzen.

As various as antique theories of space were, none of them succeeded in defining space as a system of simple relationships between height, width and depth.[27] In that case, in the guise of a "coordinate system," the difference between "front" and "back," "here" and "there," "body" and "nonbody" would have resolved into the higher and more abstract concept of three-dimensional extension, or even, as Arnold Geulincx puts it, the concept of a "*corpus generaliter sumptum*" ("body taken in a gen-

43

eral sense"). Rather, the totality of the world always remained something radically discontinuous. Democritus, for example, constructed a purely corporeal world out of indivisible elements, and then, only in order to secure for those elements the possibility of movement, postulated further the infinite void as a *mē on* or nonbeing (even if, as a correlate to the *on* or being, this is something of a necessity). Plato let space stand in opposition to the world of elements reducible to geometrically formed bodies, as their formless *huperdochē* or receptacle (indeed it is even hostile to form). Aristotle, finally, with a basically quite unmathematical transfer of qualitative categories to the realm of the quantitative, attributed six dimensions (*diastaseis*, *diastēmata*) to *topos koinos* or general space (up and down, front and back, right and left), even though individual bodies were sufficiently defined by three dimensions (height, width, depth). Moreover, Aristotle conceived this "general space" in turn as merely the furthest frontier of an absolutely large body, namely the outermost celestial sphere — just as the specific location of individual things (*topos idios*) is for him the frontier where the One meets the Other.[28] Perhaps this Aristotelian doctrine of space illustrates with special clarity the inability of antique thought to bring the concrete empirical "attributes" of space, and in particular the distinction between "body" and "nonbody," to a common denominator of a *substance étendue*: bodies are not absorbed into a homogeneous and infinite system of dimensional relationships, but rather are the juxtaposed contents of a finite vessel. For, just as for Aristotle there is no "quantum continuum" in which the quiddity of individual things would be dissolved, so there is for him also no *energeiai apeiron* (actual infinite) which would extend beyond the *Dasein* of individual objects (for, in modern terms, even the sphere of fixed stars would be an "individual object").[29] And precisely here it becomes quite clear

that "aesthetic space" and "theoretical space" recast perceptual space in the guise of one and the same sensation: in one case that sensation is visually symbolized, in the other it appears in logical form.

III

———

When work on certain artistic problems has advanced so far that further work in the same direction, proceeding from the same premises, appears unlikely to bear fruit, the result is often a great recoil, or perhaps better, a reversal of direction. Such reversals, which are often associated with a transfer of artistic "leadership" to a new country or a new genre, create the possibility of erecting a new edifice out of the rubble of the old; they do this precisely by abandoning what has already been achieved, that is, by turning back to apparently more "primitive" modes of representation. These reversals lay the groundwork for a creative reengagement with older problems, precisely by establishing a distance from those problems. Thus we see Donatello grow not out of the pallid classicism of the epigones of Arnolfo, but out of a decidedly Gothic tendency. Likewise, the powerful figures of Konrad Witz had to be supplanted by the more elegant creatures of Wolgemut and Schongauer before Dürer's *Four Apostles* became possible. And between antiquity and modern times stands the Middle Ages, the greatest of those "recoils." The art historical mission of the Middle Ages was to blend what was once a multiplicity of individual objects (no matter how ingeniously linked to one another) into a true unity. This new unity – and this is only apparently a para-

47

dox – was arrived at only by way of smashing the existing unity: that is, by consolidating and isolating objects which were once bound by corporeal and gestural as well as spatial and perspectival ties. At the close of antiquity, and in conjunction with the increase of Eastern influences (whose appearance here, to be sure, is less a cause than a symptom and instrument of the new development), the freely extended landscape and the closed interior space begin to disintegrate. The apparent succession of forms into depth gives way again to superposition and juxtaposition. The individual pictorial elements, whether figures, buildings or landscape motifs, until now partly the contents, partly the components of a coherent spatial system, are transmuted into forms which, if not yet completely leveled, are at least entirely oriented toward the plane. These forms stand in relief against a gold or neutral ground and are arrayed without respect to any previous compositional logic.

This development can be followed almost step by step between the second and the sixth centuries.[30] A work like the Abraham mosaic from San Vitale in Ravenna (Plate 5) is especially noteworthy, for here we can observe quite plainly the disintegration of the perspectival idea: not merely plants, but indeed the formations of the earth, which in the Odyssey landscapes were cut off by the edge of the picture as if by a window frame, must now accommodate themselves to the curve of that edge. It can hardly be expressed more clearly that the principle of a space merely excised by the picture's edge is now beginning to give way to the principle of the surface bounded by the picture's edge, a surface that expects not to be seen through but rather filled. The "foreshortenings" of Greco-Roman art, finally, lose their original representational meaning – that of creating space – and yet retain their fixed linear forms; they thus undergo the most curious, but often uncommonly expressive, reinterpretations: the former vista or

"looking through" begins to close up. At the same time it can be seen how precisely here the individual pictorial elements, which had almost completely lost their gestural and corporeal dynamic relationship and their perspectival spatial relationship, could be joined in a new and, in a certain sense, more intimate relationship: in an immaterial but unbroken tissue, as it were, within which the rhythmic exchange of color and gold or, in relief sculpture, of light and dark, restores a kind of unity, even if only a coloristic or luminous unity. The particular form of this unity once again finds its theoretical analogue in the view of space of contemporary philosophy: in the metaphysics of light of pagan and Christian neoplatonism. "Space is nothing other than the finest light," according to Proclus;[31] here, just as in art, the world is conceived for the first time as a continuum. It is also robbed of its solidity and rationality: space has been transformed into a homogeneous and, so to speak, homogenizing fluid, immeasurable and indeed dimensionless.

Thus the very next step on the path toward modern "systematic space" had to be the refashioning of the world — now unified but still luminously fluctuating — into a substantial and measurable world; substantial and measurable, of course, not in any antique sense, but indeed rather in a medieval sense. Already in Byzantine art, even if much impeded and even here and there repulsed by a constantly reemerging partiality for antique illusionism, a tendency to follow through with the reduction of space to surface declares itself ("follow through," because the world of early Christian and late antique art is not yet a purely linear and two-dimensional world, but rather still a world of space and bodies, even if everything is oriented to the surface). Byzantine art, moreover, tended to exalt that element which within this new two-dimensionality could alone provide stability and system: line. But even Byzantine art, which in the end

never really severed itself from the antique tradition, failed to carry this development through to a fundamental break with the principles of late antiquity (just as, conversely, it never actually arrived at a "Renaissance"). Byzantine art could not decide, as it were, to form the world in a completely linear rather than a painterly fashion; thus its adherence to mosaic, whose nature it is to hide the inexorably two-dimensional structure of the bare wall by spreading a shimmering coat over it. The paths of light and furrows of shadow of antique and late antique illusionism are indeed hardened into line-like forms; but the original painterly meaning of these forms is never so completely forgotten that they become mere lines. Likewise where perspective is concerned: Byzantine art may have ended up treating landscape motifs and architectural forms as mere stage scenery before a neutral background; but these motifs and forms never ceased somehow to suggest space, even if they no longer encompassed space. Thus Byzantine art – and for our purposes this is especially important – managed, for all the disorganization of the whole, nevertheless to preserve the individual components of antique perspectival space, and so to hold them in readiness for the Western Renaissance.[32]

The art of northwest Europe, whose frontier in the Middle Ages was not so much the Alps as the Apennines, transformed the late antique tradition far more radically than did southeast European Byzantinism. After the comparatively retrospective and for that very reason preliminary epochs of the Carolingian and Ottonian "renaissances,"[33] emerged that style which we usually call "Romanesque." The Romanesque, fully mature by the middle of the twelfth century, completed the renunciation of antiquity which Byzantine art never quite carried out. Now line is merely line, that is, a graphic means of expression sui generis which finds its meaning in the delimitation and ornamentation

of surfaces. Surface, meanwhile, is now merely surface, that is, no longer even the vague suggestion of an immaterial space, but rather the unconditionally two-dimensional surface of a material picture support. This style was then extended along the same lines, that is, made still more systematic and tectonic, by the succeeding epoch. How the Romanesque destroyed the last remnants of the antique perspectival view may be clarified by the well-known example (one among countless) of the metamorphosis of the perspectivally foreshortened River Jordan, in representations of the Baptism, into a "water mountain."[34] In Byzantine and Byzantinizing painting, as a rule, the form of the river bank converging into depth and the shimmering transparency of the water are still clearly recognizable. Pure Romanesque (the transition declares itself already around the year 1000) reshapes with ever-greater resolve the painterly waves into a plastic and solid mountain of water, and the space-defining convergence into an "ornamental" surface form. The horizontally foreshortened river which permits the body of Christ to shimmer forth becomes a perpendicularly rising coulisse behind which he disappears (or on occasion even a mandorla which in a sense frames him). The flat bank which carried the Baptist, meanwhile, becomes a staircase which he must climb.

With this radical transformation, so it would appear, all spatial illusionism was abandoned, once and for all. And yet this transformation was precisely the precondition for the emergence of the truly modern view of space. For if Romanesque painting reduced bodies and space to surface, in the same way and with the same decisiveness, by these very means it also managed for the first time to confirm and establish the homogeneity of bodies and space. It did this by transforming their loose, optical unity into a solid and substantial unity. From now on, bodies and space are bound to each other, for better or for worse. Subsequently, if

a body is to liberate itself from its attachment to the surface, it cannot grow unless space grows with it at the same rate.

This process, however, is carried out most vigorously and with the most enduring effects in high medieval sculpture. For sculpture undergoes the same process of revaluation and consolidation that painting does; sculpture, too, sheds all vestiges of antique illusionism and transforms a painterly and agitated surface, a surface broken up by light and shadow, into a stereometrically condensed surface, a surface articulated by linear contours. Sculpture, too, creates an indissoluble unity between figures and their spatial environment, that is, the background surface, with the difference that this unity does not preclude a three-dimensional swelling forward of form. A relief figure is now no longer a body standing before a wall or in a niche; rather, figure and relief ground are manifestations of one and the same substance. Thus emerges for the first time in Europe an architectural sculpture which is not so much set in or on the building, like the antique metope relief or the caryatid, as it is a direct "efformation" or development out of the building material itself. The Romanesque portal statue is a plastically developed doorpost, the Romanesque relief figure a plastically developed wall. Thus the style of pure surface which painting had worked out found its sculptural counterpart in the style of pure mass. Sculpture again possesses three-dimensionality and substantiality: but not, as in antique sculpture, the three-dimensionality and substantiality of "bodies," whose coherence (if we may repeat our own words) is guaranteed for the purposes of artistic effect by an association of distinguishable parts with individually defined extension, form and function (that is, "organs"). This is rather the three-dimensionality and substantiality of a homogeneous substance, whose coherence is guaranteed for the purposes of artistic effect by an association of indistinguishable parts, with

uniform (or infinitely small) extension, form and function (that is, "particles").

Now, the art of the high Gothic again differentiates this "mass" into quasi-corporeal forms; it permits the statue to reemerge out of the wall as an independently developed structure and the relief figure to resolve out of the ground almost like freestanding sculpture. Certainly this renaissance of a feeling for the body can be interpreted as a kind of rapprochement with antiquity; indeed, in many places it was actually accompanied by a newly profound desire for an artistic reception of antiquity. For this was the same high Gothic which through Vitellio, Peckham and Roger Bacon revived antique optics, and through Thomas Aquinas (even if with significant alterations) revived Aristotle's doctrine of space.[35] But the end result was not a return to antiquity but rather the breakthrough to the "modern." For the architectural elements of the Gothic cathedral, conceived once again as bodies, together with its statues and relief figures unfolded back into plasticity, nevertheless remained components of that homogeneous whole whose unity and indivisibility was secured once and for all by the Romanesque. Thus alongside the emancipation of plastic bodies is achieved – one would like to say automatically – the emancipation of a spatial sphere comprehending these bodies. An expressive symbol of this is the high Gothic statue, which cannot live without its baldachin; for the baldachin not only connects the statue to the mass of the building, but also delimits and assigns to it a particular chunk of empty space. Another is the relief which retains its deeply overshadowing arch-covering: here, too, the cover serves the purpose of securing a specific spatial zone for the now plastically emancipated figures, and making their field of activity into a veritable stage (Plate 6). This stage is still limited, just as the high Gothic church is decidedly a spatial construction and yet is still fragmented into a quantity of clearly

divided individual bays, which only in late Gothic architecture will flow into one another. Yet the stage is already a fragment of a world that, even if still built out of limited and individually added cells of space, nevertheless already seems innately capable of an unlimited extension; and within this world bodies and empty space are already considered equivalent forms for expressing a homogeneous and indivisible unity. In the same way, Aristotle's doctrine of space, enthusiastically taken up by Scholastic philosophy, was fundamentally reinterpreted, in that the premise of the finiteness of the empirical cosmos was replaced by the premise of the infinity of divine existence and influence. To be sure, this infinity – in contrast to the modern view, which begins to assert itself from around 1350 – is not yet thought of as something realized in nature. On the other hand, it does probably already represent (in contrast to the genuine Aristotelian version) a true *energeiai apeiron* (actual infinite), which at first, to be sure, remains confined to a supernatural sphere, but which could in principle take effect in the natural sphere.[36]

At this point we can almost predict where "modern" perspective will unfold: namely, where the northern Gothic feeling for space, strengthened in architecture and especially sculpture,[37] seizes upon the architectural and landscape forms preserved in fragments in Byzantine painting, and welds them into a new unity. And in fact the founders of the modern perspectival view of space were the two great painters whose styles, in other ways as well, completed the grand synthesis of Gothic and Byzantine: Giotto and Duccio. Closed interior spaces reappear for the first time in their works. These interiors can in the final analysis only be understood as painterly projections of those "space boxes" which the northern Gothic had produced as plastic forms; and yet they are composed of elements that were present already in Byzantine art.[38] In fact, these elements – though this has been much dis-

puted in the literature – were available in the products of the *maniera greca*. A mosaic from the Baptistry in Florence (Plate 7) displays in a fictional projecting cornice the familiar vanishing-axis principle; indeed, it even has a perspectivally rendered coffered ceiling, although information about the floor and a clear indication of the side walls are missing.[39] A mosaic at Monreale (Plate 8), conversely, shows the side walls foreshortened into depth, but again without a floor and this time without any account of a ceiling, so that the Last Supper – if we are to interpret it realistically – appears to have been staged in an open courtyard. In a second scene from the same series (Plate 9), the floor already has a foreshortened pattern of tiles whose orthogonals converge almost "correctly," even if toward two different vanishing points. But then this tile pattern stands in no relationship at all to the other architectural components; indeed it ends, significantly, almost exactly where the figural composition begins, so that the represented objects appear to stand, for the most part, more above than on the floor.[40] Thus the spatial system of mature Trecento art (for what is true for interiors is, mutatis mutandis, also true for landscapes) was constructed retroactively, as it were, out of its elements; it merely required the Gothic sense of space to join these *disjecta membra* into unity.

The conquest over the medieval representational principle begins with this achievement of Duccio and Giotto. For the representation of a closed interior space, clearly felt as a hollow body, signifies more than a consolidation of objects. It signifies a revolution in the formal assessment of the representational surface. This surface is now no longer the wall or the panel bearing the forms of individual things and figures, but rather is once again that transparent plane through which we are meant to believe that we are looking into a space, even if that space is still bounded on all sides. We may already define this surface as a "picture

plane," in the precise sense of the term. The view that had been blocked since antiquity, the vista or "looking through," has begun to open again; and we sense the possibility that the painted picture will once again become a section cut from an infinite space, only a more solid and more integrally organized space than the antique version.

To be sure, there remained a quantity of work to be done, hardly imaginable to us today, before this goal could be reached. For Duccio's space (Plate 10) is not only a bounded space, in that it is closed in front by the "picture plane," behind by the rear wall of the room and on the sides by the orthogonal walls. It is also an inconsistent space, in that objects — for example, in our panel the table of the Last Supper — appear to stand in front of the "space box" rather than in it; and in that the orthogonals in objects viewed asymmetrically (for example, buildings or pieces of furniture standing off to the sides) still run approximately parallel, whereas in symmetrical view (that is, when the central axis of the picture coincides with the central axis of the represented object) the orthogonals are already approximately oriented toward a vanishing point or, within vertical planes, at least toward a horizon.[41] But even within such a symmetrical view, when the ceiling is divided into several sections, the central section is distinguished from the adjacent parts; for only the orthogonals of the former converge toward that common vanishing region, while those of the latter deviate more or less sharply from it.[42] At first, then, only a "partial plane" was perspectivally unified, and not yet an entire plane, not to speak of the entire space.

Thus within the next generation of artists, at least so far as it took an interest in perspective at all, a curious division set in. Evidently, the need for a certain clarification and systematization of Duccio's "perspective" was keenly felt; but it was arrived at by different routes. One group of painters — in a sense, the conser-

vatives – schematized the vanishing-axis procedure (which Duccio had already dispensed with[43]) and developed it back into a pure parallel construction. These were the likes of Ugolino da Siena, Lorenzo di Bicci or the unknown master of a painting in Strasbourg who sought to circumvent the ominous problem of the central section of the ceiling with a turretlike addition.[44] Another group, meanwhile – in a sense, the progressives – perfected and systematized that method which in Duccio had only been applied to the central section of the ceiling; they now subjected the floor to it as well. It was, above all, the Lorenzetti brothers who took this important step. What makes a picture like Ambrogio Lorenzetti's *Annunciation* of 1344 (Plate 11) so important is, first of all, that the visible orthogonals of the ground plane are here for the first time all oriented toward a single point, undoubtedly with full mathematical consciousness; for the discovery of the vanishing point, as "the image of the infinitely distant points of all the orthogonals," is, in a sense, the concrete symbol for the discovery of the infinite itself. But the picture is equally important for the completely new meaning it bestows upon the ground plane as such. This plane is no longer merely the lower surface of a "space box" closed on the right and left and terminating with the edges of the picture, but rather the ground surface of a strip of space, which, even if still bounded at the rear by the traditional gold ground and in front by the picture plane, can nevertheless be thought of as extending arbitrarily far to either side. And, what is perhaps even more momentous, the ground plane now clearly permits us to read not only the sizes, but also the distances of the individual bodies arrayed on it. The checkerboard tile pattern – already prepared, as we have seen, in Byzantinizing mosaics at Monreale, although it appears there purely as a motif and is not exploited in this sense – now in fact runs under the figures and thus becomes an index for spatial values, and indeed as

much for those of the individual bodies as for those of the intervals. We can actually express both bodies and intervals – and thus the scope of every movement as well – numerically, as a number of floor squares. This is a pictorial motif that will henceforth be repeated and modified with a fanaticism only now entirely comprehensible. It is not too much to claim that a pattern of tiles used in this sense represents the first example of a coordinate system: for it illustrates the modern "systematic space" in an artistically concrete sphere, well before it had been postulated by abstract mathematical thought. And in fact the projective geometry of the seventeenth century would emerge out of perspectival endeavors: this, too, like so many subdisciplines of modern "science," is in the final analysis a product of the artist's workshop.

But even Lorenzetti's painting leaves open the question of whether already the *entire* ground plane was oriented toward a single vanishing point. For when the figures extend all the way to the edges and thus hide the lateral segments of space, as is the case in many other paintings,[45] it cannot be determined whether those orthogonals that would begin outside the picture frame and run past the figures at the right and left would also converge in that single point. One would rather doubt it, for in another painting by the same artist which does leave open the view onto these lateral segments of space (Plate 12), the orthogonals at the edge clearly still evade the common vanishing point of the central orthogonals.[46] Rigorous coherence is still limited to a "partial plane." And yet this very picture with its strong recession seems to prepare even more decisively the coming development. This discrepancy between the central and edge orthogonals can be illustrated with countless examples far into the fifteenth century.[47] It shows, on the one hand, that the concept of infinity is still in the making, and, on the other hand (and this is its art historical significance), that the linear disposition of the space –

however much that space, together with its contents, was felt as a tangible unity, and for all the efforts to make it felt as a unity – was nevertheless still posterior to the linear disposition of the figure composition. Things are not yet at the point where, as Pomponius Gauricus would put it 160 years later, "the place exists prior to the bodies brought to the place and therefore must first be defined linearly."[48]

The conquest of this new and at last "modern" standpoint appears to have been carried out in the north and in the south in two fundamentally different ways. The north knew the vanishing-axis method already before the middle of the fourteenth century, and the vanishing-point method by the last third of the century; in both cases France was out ahead of the other countries. Master Bertram, for example, who was under Bohemian influence, constructs his tile floors entirely according to the vanishing-axis principle; he attempts to conceal the critical central section with a foot treading on it apparently by accident, or with a bit of drapery posed with comically transparent grace (Plate 13).[49] The art of Master Francke, by contrast, can be derived directly from France; like Broederlam and other French and Franco-Flemish masters, he constructs according to the vanishing-point system of the Lorenzetti. Here, however, he is just as uncertain of the orthogonals at the edges (this is especially clear on the right side of the *Martyrdom of St. Thomas*) as were most of his contemporaries and predecessors. It is as if, at first, it actually went against the grain of the artists to turn the lateral orthogonals so far that they would aim at the same point at which the central orthogonals aim.[50]

The fully unified orientation of the entire plane – and now the vertical plane as well – seems to have been consciously realized only at about the stylistic level of the van Eycks (Plates 14, 15, 16, 17; Figure 6).[51] Here, moreover, was attempted the bold

59

FIGURE 6. Perspectival schema of the *Madonna of Canon van der Paele* of Jan van Eyck (Bruges, Musée municipal des Beaux-Arts; 1436). (With the aid of the diagram by G. Joseph Kern.)

novelty of liberating three-dimensional space from its ties with the front plane of the picture; this was an entirely personal exploit of the great Jan van Eyck. Until now, even in the miniature shown in Plate 14 (which may be considered an authentic early work of Jan van Eyck), the represented space reached its forward termination at the picture plane, even if that space could be extended *ad libitum* to the sides and often even back into depth. In Jan van Eyck's *Virgin in the Church* (Plate 15), by contrast, the beginning of the space no longer coincides with the border of the picture: rather, the picture plane cuts through the middle of the space. Space thus seems to extend forward across the picture plane; indeed, because of the short perpendicular distance it appears to include the beholder standing before the panel. The picture has become a mere "slice" of reality, to the extent and in the sense

that *imagined* space now reaches out in all directions beyond *represented* space, that precisely the finiteness of the picture makes perceptible the infiniteness and continuity of the space.[52]

That said, the perspective of Eyckian pictures is, from a purely mathematical point of view, still "incorrect"; for the orthogonals, although they may converge to a single point within an entire plane, do not so converge within the entire space (Figure 6). This latter convergence seems rather to have been arrived at first by Dirk Bouts (Figure 7), or at the very earliest by Petrus Christus.[53] The achievement was at first neither lasting nor generally binding in the North. Even in the Netherlands there were great artists, for example Roger van der Weyden, who took little interest

FIGURE 7. Perspectival schema of the *Last Supper* of Dirk Bouts (Louvain, St. Peter, 1464–1467). (After G. Doehlemann.)

61

in the spatial problems under discussion here, and whose pictures are not unified by any vanishing point.[54] And as for Germany, apart from the works of the half-Italian Michael Pacher, not a single correctly constructed picture appears to have been produced in the entire fifteenth century: that is, not until the adoption of the exact and mathematically grounded theory of the Italians, in particular through the agency of Albrecht Dürer.[55]

The North, then, even if it started from the methods of the Italian Trecento, essentially arrived at "correct" construction by an empirical route. Italian perspectival practice, characteristically, appealed to mathematical theory. Trecento pictures after the Lorenzetti became, so to speak, progressively more false, until around 1420 when *costruzione legittima* was (we may as well say) invented.[56] We do not know, although it is probable, whether Brunelleschi was really the first to have produced a mathematically exact linear perspectival procedure, and whether this procedure in fact consisted of the plan and elevation construction demonstrated in Figure 1. Such a construction was only attésted in writing two generations later, in Piero della Francesca's *De prospectiva pingendi*.[57] At any rate, Masaccio's *Trinity* fresco is already exactly and uniformly constructed;[58] and a few years later we find the then-preferred procedure unequivocally described: a procedure that presents itself as a direct extension of what was already known in the Trecento, even if it does rest on an entirely novel principle. Already the Lorenzetti had respected the rigorous mathematical convergence of orthogonals; but there was still no method for measuring with comparable accuracy the depth intervals of the so-called transversals (in particular, the positions of those transversals contained within a "ground square" beginning with the front edge of the picture). If we can believe Alberti, the erroneous practice of mechanically diminishing each strip of the floor by one third still held sway in his day.[59] Here Alberti

proposes his own definition, which was to remain fundamental for all succeeding generations: "The picture is a planar section of the visual pyramid." And because the perpendiculars of the final picture are already known, he needs to construct that "visual pyramid" only in side elevation, in order to make the desired depth intervals immediately legible along the vertical section, and to be able to insert them effortlessly into the existing system of receding orthogonals (Figure 8).[60]

It is probable that this more convenient and practicable procedure of Alberti's was derived from the complete plan and elevation procedure. For surely the idea of reforming normal Trecento practice by introducing the elevation of the visual pyramid was conceivable only after the systematic construction of the entire visual pyramid was understood. There is no cause for stripping Brunelleschi of the invention of this construction, the achievement of a true architect; and by the same token the fame for bringing an abstract and logical method into harmony with traditional usage, and thus facilitating its practical application, can safely be left to the dilettante painter Alberti. To an extent, of course, the two procedures coincide: since they both rest in the same way on the principle of the *intercisione della piramide visiva*, they permit not only the construction of closed spaces, but also the development of free landscape scenery and finally the "correct" deployment and measurement of the individual objects found therein.[61] In this way the Renaissance succeeded in mathematically fully rationalizing an image of space which had already earlier been aesthetically unified. This, as we have seen, involved extensive abstraction from the psychophysiological structure of space, and repudiation of the antique authorities. But, on the other hand, it was now possible to construct an unambiguous and consistent spatial structure of (within the limits of the "line of sight") infinite extension,[62] where bodies and the intervals of empty space

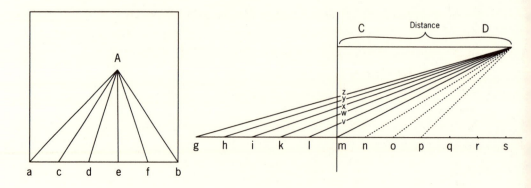

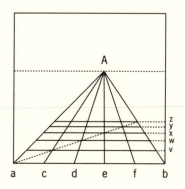

FIGURE 8. Perspectival construction of the checkerboard-type "ground square," according to Leon Battista Alberti. Above left: preparatory drawing executed on the picture panel itself, and identical to the construction of the Lorenzetti (orthogonals of the foreshortened ground square.) Above right: auxiliary drawing executed on a separate sheet (elevation of the "visual pyramid," which yields the intervals of the transversals v, w, x, y, z). Below: final drawing (transfer of the depth intervals obtained from the auxiliary drawing onto the preparatory drawing; the diagonal serves only to control the results).

between them were merged in a regular fashion into a *corpus generaliter sumptum*. There was now a generally valid and mathematically justifiable rule to determine "how far two things ought to stand from another, or how closely they ought to cohere, in order that the intelligibility of the subject matter is neither confused by crowding nor impaired by sparseness."[63]

Thus the great evolution from aggregate space to systematic space found its provisional conclusion. Once again this perspectival achievement is nothing other than a concrete expression of a contemporary advance in epistemology or natural philosophy. The space of Giotto and Duccio corresponded to the transitional, high Scholastic view of space; in the very years when their space was gradually being superseded by true central perspective, with its infinitely extended space centered in an arbitrarily assumed vanishing point, abstract thought was decisively and overtly completing the break — always disguised until now — with the Aristotelian worldview. This entailed abandoning the idea of a cosmos with the middle of the earth as its absolute center and with the outermost celestial sphere as its absolute limit; the result was the concept of an infinity, an infinity not only prefigured in God, but indeed actually embodied in empirical reality (in a sense, the concept of an *energeiai apeiron* within nature). "Between these two propositions: the infinitely powerful is not contradictory, and the infinitely great can be realized in action, the logicians of the fourteenth century — William of Ockham, Walter Burley, Albert of Saxony, Jean Buridan — had erected a barrier which they thought solid and impenetrable. We shall see this barrier collapse; it will not, however, crash suddenly, but rather, secretly ruined and consumed, will crumble little by little, in the time between 1350 and 1500."[64] Actual infinity, which was for Aristotle completely inconceivable and for high Scholasticism only in the shape of divine omnipotence, that is, in a *huperouranios topos* (place beyond

the heavens), has now become *natura naturata*. The vision of the universe is, so to speak, detheologized, and space, whose priority over individual objects was already so vividly expressed by Gauricus, now becomes a "continuous quantity, consisting of three physical dimensions, existing by nature before all bodies and beyond all bodies, indifferently receiving everything." No wonder that a man like Giordano Bruno now outfits this world of the spatial and infinite, and thus of the thoroughly measurable, this world which, so to speak, outgrew divine omnipotence, with an almost religious sublimity of its own; he "invests it, along with the infinite extension of the Democritan *kenon* (void), with the infinite dynamic of the neoplatonic world-soul."[64a] And yet this view of space, even with its still-mystical coloring, is the same view that will later be rationalized by Cartesianism and formalized by Kantianism.

It may strike us today as somewhat strange to see a genius like Leonardo describe perspective as the "rein and rudder of painting," and to hear a powerfully imaginative artist like Paolo Uccello answer his wife's request that he finally come to bed with the now-hackneyed phrase, "But how sweet perspective is!"[65] All we can do is try to imagine what this achievement meant then. For not only did it elevate art to a "science" (and for the Renaissance that was an elevation): the subjective visual impression was indeed so far rationalized that this very impression could itself become the foundation for a solidly grounded and yet, in an entirely modern sense, "infinite" experiential world. (One could even compare the function of Renaissance perspective with that of critical philosophy, and the function of Greco-Roman perspective with that of skepticism.) The result was a translation of psychophysiological space into mathematical space; in other words, an objectification of the subjective.

IV

This formula also suggests that as soon as perspective ceased to be a technical and mathematical problem, it was bound to become all that much more of an artistic problem. For perspective is by nature a two-edged sword: it creates room for bodies to expand plastically and move gesturally, and yet at the same time it enables light to spread out in space and in a painterly way dissolve the bodies. Perspective creates distance between human beings and things ("the first is the eye that sees, the second is the object seen, the third is the distance between them," says Dürer after Piero della Francesca[66]); but then in turn it abolishes this distance by, in a sense, drawing this world of things, an autonomous world confronting the individual, into the eye. Perspective subjects the artistic phenomenon to stable and even mathematically exact rules, but on the other hand, makes that phenomenon contingent upon human beings, indeed upon the individual: for these rules refer to the psychological and physical conditions of the visual impression, and the way they take effect is determined by the freely chosen position of a subjective "point of view." Thus the history of perspective may be understood with equal justice as a triumph of the distancing and objectifying sense of the real, and as a triumph of the distance-denying human struggle for control; it is as much

a consolidation and systematization of the external world, as an extension of the domain of the self. Artistic thinking must have found itself constantly confronted with the problem of how to put this ambivalent method to use. It had to be asked (and indeed it was asked) whether the perspectival configuration of a painting was to be oriented toward the factual standpoint of the beholder (as in the quite special case of "illusionistic" ceiling painting, which goes about laying the picture plane horizontally, and then drawing all the consequences from this 90-degree rotation of the whole world); or whether conversely the beholder ought ideally to adapt himself to the perspectival configuration of the painting.[67] In the latter case, it must further be asked where on the picture field is the central vanishing point best placed,[68] how close or how far the perpendicular distance ought to be measured,[69] and whether and to what extent an oblique view of the entire space seems admissible. In all of these questions, the "claim" of the object (to use a modern term) confronts the ambition of the subject. The object intends to remain distanced from the spectator (precisely as something "objective"); it wants to bring to bear, unimpeded, its own formal lawfulness (its symmetry, for example, or its frontality). It does not want to be referred to an eccentric vanishing point, nor certainly, as in the oblique view, governed by a coordinate system whose axes no longer even appear objectively in the work, but rather exist only in the imagination of the beholder. Clearly, a decision can only be arrived at by involving those great antitheses that we usually call something like free will versus norm, individualism versus collectivism, the irrational versus the rational; and it was just these modern perspectival problems that provoked epochs, nations and individuals to take up especially emphatic and visible positions in such matters.

It thus stands to reason that the Renaissance would interpret the meaning of perspective entirely differently from the Baroque,

and Italy entirely differently from the North: in the former cases, speaking quite generally, its objective significance was felt to be more essential, in the latter cases its subjective significance. Thus even Antonello da Messina, under such strong Netherlandish influence, constructs the study of St. Jerome with a long perpendicular distance, so that, like nearly all Italian interiors, it is basically an architectural exterior with the front surface removed. He also lets the space begin only at (or indeed behind) the picture plane and places the central vanishing point nearly exactly in the center (Plate 18). Dürer by contrast, and he is by no means the first, shows us St. Jerome in a real "cabinet" (Plate 19). We imagine that we ourselves have been admitted into it, because the floor appears to extend under our own feet, and because the perpendicular distance, expressed in real dimensions, would amount to no more than about one and a half meters. The entirely eccentric position of the central vanishing point reinforces the impression of a representation determined not by the objective lawfulness of the architecture, but rather by the subjective standpoint of a beholder who has just now appeared; a representation that owes its especially "intimate" effect in large part to this very perspectival disposition.[70] In Italy, the rise of perspectival construction actually militated against the oblique view, which was still common in the Trecento, even if it did affect only individual architectural elements in the space and not the space as such. Yet someone like Altdorfer used just such a view to create, in the Munich *Birth of the Virgin* (Plate 20), an "absolute oblique space," that is, a space in which there are no more frontals and orthogonals at all; he even reinforces the turning movement, optically and indeed superfluously, with a round dance of inspired angels. He thus anticipates a representational principle first fully exploited only by the great Dutchmen of the seventeenth century: Rembrandt, Jan Steen and, in particular, the Delft

architecture painters, above all De Witte. It is no accident that it was those very Dutchmen who pursued the problem of "near space" to its utmost consequences, whereas it remained for the Italians to create in their ceiling frescoes "high space." In this triad of forms of representation – "high space," "near space" and "oblique space" – is expressed the view that space in an artistic representation is determined by the subject; nevertheless, these very forms, as paradoxical as it may sound, belong to the moment when space as the image of a worldview is finally purified of all subjective admixtures, both by philosophy (Descartes) and by perspectival theory (Desargues). For when art won the right to determine for itself what "up" and "down," "front" and "back," "right" and "left" should be, it was essentially only giving back to the subject something that already belonged to it by rights, that antiquity had only unnaturally (although also by intellectual-historical necessity) claimed as objective attributes of space. The arbitrariness of direction and distance within modern pictorial space bespeaks and confirms the indifference to direction and distance of modern intellectual space; and it perfectly corresponds, both chronologically and technically, to that stage in the development of theoretical perspective when, in the hands of Desargues, it became a general projective geometry. This happened when perspective, replacing for the first time the simple Euclidean "visual cone" with the universal "geometrical beam," abstracted itself completely from the line of sight and thus opened up all spatial directions equally.[70a] Once again, however, it is clear how much the artistic conquest of this not only infinite and "homogeneous," but also "isotropic" systematic space (all the apparent modernity of Greco-Roman painting notwithstanding) presupposes the medieval development. For it was the medieval "massive style" that first created that homogeneity of the representational substratum without which not only the infinite-

ness, but also the directional indifference of space, would have been inconceivable.[71]

It is now finally clear that the perspectival view of space (and not merely perspectival construction) could also be contested from two quite different sides: Plato condemned it already in its modest beginnings because it distorted the "true proportions" of things, and replaced reality and the *nomos* (law) with subjective appearance and arbitrariness;[72] whereas the most modern aesthetic thinking accuses it, on the contrary, of being the tool of a limited and limiting rationalism.[73] The ancient Near East, classical antiquity, the Middle Ages and indeed any archaizing art (for example Botticelli[74]) all more or less completely rejected perspective, for it seemed to introduce an individualistic and accidental factor into an extra- or supersubjective world. Expressionism (for recently there has indeed been yet another shift in direction) avoided it, conversely, because it affirms and secures that remnant of objectivity which even Impressionism was still obliged to withhold from the individual "formative will" — namely, real three-dimensional space. But this polarity is really the double face of one and the same issue, and those objections are in fact aimed at one and the same point:[75] the perspectival view, whether it is evaluated and interpreted more in the sense of rationality and the objective, or more in the sense of contingency and the subjective, rests on the will to construct pictorial space, in principle, out of the elements of, and according to the plan of, empirical visual space (although still abstracted considerably from the psychophysiological "givens"). Perspective mathematizes this visual space, and yet it is very much *visual* space that it mathematizes; it is an ordering, but an ordering of the visual phenomenon. Whether one reproaches perspective for evaporating "true being" into a mere manifestation of seen things, or rather for anchoring the free and, as it were, spiritual idea of form to a manifestation

71

of mere seen things, is in the end little more than a question of emphasis.

Through this peculiar carrying over of artistic objectivity into the domain of the phenomenal, perspective seals off religious art from the realm of the magical, where the work of art itself works the miracle, and from the realm of the dogmatic and symbolic, where the work bears witness to, or foretells, the miraculous. But then it opens it to something entirely new: the realm of the visionary, where the miraculous becomes a direct experience of the beholder, in that the supernatural events in a sense erupt into his own, apparently natural, visual space and so permit him really to "internalize" their supernaturalness. Perspective, finally, opens art to the realm of the psychological, in the highest sense, where the miraculous finds its last refuge in the soul of the human being represented in the work of art; not only the great phantasmagorias of the Baroque – which in the final analysis were prepared by Raphael's *Sistine Madonna*, Dürer's *Apocalypse*, Grünewald's Isenheim altar, indeed perhaps already Giotto's *St. John on Patmos* fresco in S. Croce – but also the late paintings of Rembrandt would not have been possible without the perspectival view of space. Perspective, in transforming the *ousia* (reality) into the *phainomenon* (appearance), seems to reduce the divine to a mere subject matter for human consciousness; but for that very reason, conversely, it expands human consciousness into a vessel for the divine. It is thus no accident if this perspectival view of space has already succeeded twice in the course of the evolution of art: the first time as the sign of an ending, when antique theocracy crumbled; the second time as the sign of a beginning, when modern "anthropocracy" first reared itself.

Notes

INTRODUCTION

1. "Der Begriff des Kunstwollens," reprinted in Panofsky, *Aufsätze zu Grundfragen der Kunstwissenschaft*, ed. Hariolf Oberer and Egon Verheyen (Berlin: Hessling, 1964), p. 29; originally published in *Zeitschrift für Ästhetik und Allgemeine Kunstwissenschaft* 14 (1920), pp. 321–39. Translated by Kenneth J. Northcote and Joel Snyder as "The Concept of Artistic Volition," *Critical Inquiry* 8 (1981), pp. 17–34.

2. "Der Begriff des Kunstwollens," p. 30.

3. Riegl, *Spätrömische Kunstindustrie* (Vienna: Österreichische Staatsdruckerei, 1927; originally published in 1901), pp. 400–401. Translated by Rolf Winkes as *Late Roman Art Industry* (Rome: Bretschneider, 1985).

4. This point was made by Sheldon Nodelman in his essay "Structural Analysis in Art and Anthropology," *Yale French Studies* 36/37 (1966), pp. 89–103. On Riegl's art history generally, see the excellent essay by Henri Zerner, "Alois Riegl: Art, Value, and Historicism," *Daedalus* 105 (1976), pp. 177–88; and the discussion in Michael Podro's *Critical Historians of Art* (New Haven: Yale University Press, 1982), pp. 71–97.

5. Wölfflin, *Principles of Art History* (New York: Dover, 1950), p. 250; originally published as *Kunstgeschichtliche Grundbegriffe* (Munich: Bruckmann, 1915).

6. Wölfflin's most important early methodological propositions are found in his dissertation, *Prolegomena zu einer Psychologie der Architektur* (1886), reprinted

in *Kleine Schriften* (Basel: Schwabe, 1946), pp. 13–47; and of course in the introduction and conclusion to the *Grundbegriffe*.

7. Wölfflin's "structuralism" was less ascetic than Riegl's. Nevertheless he too stopped short of actually practicing the philosophical art history latent within his formalism. Wölfflin detached art from general history, but only to reattach it later. It is not entirely clear why Wölfflin held back; doubtless the wilder experiments of the succeeding generation, which he lived to see, helped him rediscover the virtues of positivistic discretion. See for instance the "Revision" of the *Grundbegriffe* (1933), reprinted in *Gedanken zur Kunstgeschichte* (Basel: Schwabe, 1941), pp. 18–24.

8. The best treatment in English is Nodelman's essay cited in note 4, above. The manifesto of the group was a pair of remarkable volumes edited by Pächt, *Kunstwissenschaftliche Forschungen* 1/2 (1931/1933).

9. See the influential review by Meyer Schapiro, "The New Viennese School," *Art Bulletin* 18 (1936).

10. "Die Quintessenz der Lehren Riegls," Introduction to Riegl, *Gesammelte Aufsätze* (Augsburg & Vienna: Filser, 1929); reprinted in Sedlmayr, *Kunst und Wahrheit* (Mittenwald: Mäander, 1978), pp. 32–48.

11. Panofsky, *Die Deutsche Plastik des elften bis dreizehnten Jahrhunderts* (Munich: Wolff, 1924).

12. *Idea: A Concept in Art Theory*, trans. Joseph J. S. Peake (New York: Harper & Row, 1968), p. 126 and n. 38; originally published as *"Idea": Ein Beitrag zur Begriffsgeschichte der älteren Kunsttheorie*, Studien der Bibliothek Warburg, 5 (Leipzig & Berlin: Teubner, 1924).

13. Riegl, *Spätrömische Kunstindustrie*, p. 401.

14. Panofsky, "Der Begriff des Kunstwollens," p. 32, also n. 11 on the "immanent meaning" of a period.

15. One is not necessarily more confident when the synchrony is exact: see for instance Panofsky's comments on Cubism and Einstein's relativity in *Early Netherlandish Painting* (Cambridge: Harvard University Press, 1953), p. 5, n. 1.

16. Damisch, *L'Origine de la perspective* (Paris: Flammarion, 1987), p. 29.

17. See the excellent essays by Robert Klein, "Pomponius Gauricus on

Perspective" and "Studies on Perspective in the Renaissance," both reprinted in *Form and Meaning* (New York: Viking, 1979); originally published as *La Forme et l'intelligible* (Paris: Gallimard, 1970); and by Marisa Dalai, "La Questione della prospettiva," in the Italian edition of Panofsky, *La Prospettiva come 'forma simbolica'* (Milan: Feltrinelli, 1961), pp. 118–41, and translated as the introduction to the French edition, *La Perspective comme forme symbolique* (Paris: Minuit, 1975).

18. Wittgenstein, *Philosophical Investigations* (New York: Macmillan, 1958), II.xi, p. 193ff.

19. Snyder, "Picturing Vision," *Critical Inquiry* 6 (1980), pp. 499–526.

20. This is one of the implications of Klein's thinking on perspective; see "Pomponius Gauricus on Perspective."

21. See the radical nominalist position of Nelson Goodman in *Languages of Art* (Indianapolis: Hackett, 1976), pp. 10–19, especially p. 16 and n. 17, with references to various like-minded thinkers.

22. Feyerabend, *Against Method* (London: Verso, 1978), p. 223ff., and *Wissenschaft als Kunst* (Frankfurt: Suhrkamp, 1984), pp. 17–84.

23. Feyerabend, "Consolations for the Specialist," in Imre Lakatos and Alan Musgrave (eds.), *Criticism and the Growth of Knowledge* (Cambridge: Cambridge University Press, 1970), p. 213.

24. Damisch, *L'Origine de la perspective*, p. 32ff.

PERSPECTIVE AS SYMBOLIC FORM

1. K. von Lange and F. Fuhse, *Dürers schriftlicher Nachlass* (Halle, 1893), p. 319, l. 11.

2. Boethius, *Analyt. poster. Aristot. Interpretatio* 1.7 and 1.10, in *Opera* (Basel, 1570), pp. 527 and 538; *perspectiva* is characterized in both passages as a sub-discipline of geometry.

3. The word ought to be derived not from *perspicere* meaning "to see through," but from *perspicere* meaning "to see clearly"; thus it amounts to a literal translation of the Greek term *optikē*. Dürer's interpretation is based already on the modern definition and construction of the image as a cross section

through the visual pyramid. Felix Witting, on the other hand, detected in the transformation of the Italian *perspettiva* into *prospettiva* a kind of protest against this understanding of the image ("the former is reminiscent of Brunelleschi's '*punto dove percoteva l'occhio*,' whereas the latter suggests only a seeing forward," *Von Kunst und Christentum* [Strassburg, 1903], p. 106). This is more than doubtful, for it is precisely the most rigorous theoreticians of the cross-section method, such as Piero della Francesca, who use the term *prospettiva*. At most we can grant that *prospettiva* implies more strongly the idea of the artistic achievement (namely the conquest of spatial depth), while *perspettiva* evokes rather the mathematical procedure. A purely phonetic consideration must have then favored the triumph of the term *prospettiva*, to wit, an aversion to the sequence of consonants "rsp."

4. Leon Battista Alberti, *Della pittura*, in *Kleinere kunsttheoretische Schriften*, Quellenschriften für Kunstgeschichte und Kunsttechnik des Mittelalters und der Renaissance, no. 11, ed. Hubert Janitschek (Vienna, 1877), p. 79: "*scrivo uno quadroangulo...el quale reputo essere una fenestra aperta per donde io miri quello que quivi sara dipinto*" (*On Painting*, trans. John R. Spencer [New Haven: Yale University Press, 1966], p. 56: "I inscribe a quadrangle...which is considered to be an open window through which I see what I want to paint"). See also Leonardo (Jean Paul Richter, *The Literary Works of Leonardo da Vinci* [London, 1883], no. 83), where the same analogy to a "*pariete di vetro*," or pane of glass, is drawn.

5. Already Lessing, in the ninth of his *Antiquarische Briefe*, distinguished between a broader and a narrower meaning of perspective. In the broader sense perspective is "the science of representing objects on a surface just as they would appear to our eye at a certain distance.... Not to credit the ancients with perspective in this sense would be rather foolish. For it would mean depriving them not only of perspective but of the entire art of drawing, an art which they had quite mastered. No one could maintain this. Rather, when one contests the antique claim to perspective, it is in this narrower sense, the sense in which artists take the word. For artists, perspective is the science of representing a number of objects together with the space around them, just as these objects, dispersed among various planes of the space, together with their space, would

appear to the eye from a single standpoint" (*Schriften* [Berlin, 1753–1755], vol. 8, pp. 25–26).

Essentially, then, we are adopting Lessing's second definition, only that we formulate it a little more liberally by dropping the condition of the rigorously maintained single point of view. For unlike Lessing we accept late Hellenistic and Greco-Roman paintings as already authentically "perspectival." For us perspective is, quite precisely, the capacity to represent a number of objects together with a part of the space around them in such a way that the conception of the material picture support is completely supplanted by the conception of a transparent plane through which we believe we are looking into an imaginary space. This space comprises the entirety of the objects in apparent recession into depth, and is not bounded by the edges of the picture, but rather only cut off.

There are of course a multitude of transitional cases between mere "foreshortening" (which for its part does represent the necessary first step and precondition for the development of a true perspectival conception of space) and something recognizable as perspective in this sense. An example of such a transitional case are those well-known southern Italian vases which show a figure or even several figures assembled in a foreshortened aedicule. This approximates true perspective insofar as a greater spatial construct already contains within it a number of individual bodies; but this greater spatial construct is itself still offered up as an isolated object, upon a picture support which retains its materiality. Instead, the entire surface of the painting would have to be transformed into a projective plane for a perspectival illusion of the entire space.

6. Lange and Fuhse, *Dürers schriftlicher Nachlass*, p. 195, l. 15: "*Ein ebne durchsichtige Abschneidung aller der Streimlinien, die aus dem Aug fallen auf die Ding, die es sicht.*"

7. Ernst Cassirer, *Philosophie der symbolischen Formen*, vol. 2: *Das mythische Denken* (Berlin: B. Cassirer, 1925), p. 107f. (*Philosophy of Symbolic Forms*, vol. 2: *Mythical Thought*, trans. Ralph Manheim [New Haven: Yale University Press, 1955], pp. 83–84. [In the last sentence of the passage Cassirer quotes Ernst Mach. –TR]). For the psychophysiological view of space, of course, the distinc-

tion between solid bodies and the medium of open space surrounding them is sharper than that between "front" and "back," etc. For immediate and mathematically unrationalized perception, empty space is qualitatively altogether different from "objects." On this subject, see E. R. Jaensch, *Über die Wahrnehmung des Raumes, Zeitschrift für Psychologie*, supplement 6 (Leipzig: Barth, 1911), sec. 1, ch. 6: "Zur Phänomenologie des leeren Raumes."

8. On the phenomenon of marginal distortions, see above all Guido Hauck, *Die subjektive Perspektive und die horizontalen Curvaturen des Dorischen Styls* (Stuttgart, 1879), esp. p. 51ff., and "Die malerische Perspektive," *Wochenblatt für Architekten und Ingenieuren* 4 (1882). On the historical aspects, see Hans Schuritz, *Die Perspektive in der Kunst Dürers* (Frankfurt: H. Keller, 1919), p. 11ff., among others. This problem was rather disconcerting for Renaissance theoreticians because marginal distortions expose an undeniable contradiction between the construction and the actual visual impression; indeed, under some circumstances the "foreshortened" dimensions can exceed the "unforeshortened." The differences in opinion are nevertheless instructive. The rigorous Piero della Francesca, for one, decides the dispute between perspective and reality without hesitation in favor of the former (*De prospectiva pingendi*, ed. C. Winterberg [Strassburg, 1899], p. xxxi). Piero recognizes the fact of marginal distortions and adduces the example (used by Hauck as well as by Leonardo: see Richter, *Leonardo da Vinci*, no. 544) of the exact perspectival construction of a frontal portico, or any comparable structure with a row of objectively equal elements, in which the breadth of the elements increases toward the edges (Figure 9). But so far from proposing a remedy, Piero proves rather that it *must* be so. One may marvel at this, he says; and yet "*io intendo di dimostrare cosi essere e doversi fare*." Then follows the strictly geometrical proof (which is, of course, very easy, for precisely the premise upon which the proof rests, namely the planar section of the visual pyramid, necessarily entails marginal distortions) and, introduced here not unintentionally, a long encomium of perspective. The conciliatory Ignazio Danti (in Jacopo Barozzi da Vignola, *Le Due regole della prospettiva pratica*, edited with commentary by Danti [Rome, 1583]) denies marginal distortions altogether when they are less blatant (see, for example, p. 62); he then recom-

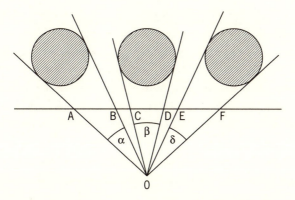

FIGURE 9. Marginal distortions in a linear perspectival construction of a row of equally thick columns: $\alpha = \delta < \beta$, but $AB = EF > CD$. (After Leonardo.)

mends avoiding the most blatant distortions by establishing minimums for the perpendicular distance and for the height of the horizon (see p. 69ff., where it is asserted that if the central vanishing point is too close, the lines of the floor seem to rise and those of the ceiling to fall – "*rovinano*," a term which should be compared to Vasari's statement cited below in note 68 – and that in the most extreme cases the projection could exceed the real dimensions). Leonardo, finally, seeks to illuminate not only the cause but also the consequences of this curious phenomenon, that is, to define the practical boundaries between construction with a short perpendicular distance and construction with a longer distance. In Richter, no. 86 (see also nos. 544–46) he establishes the fact of marginal distortions and then recognizes, entirely in accord with the results of the most modern psychological research, that if the eye is fixed by special mechanical aids exactly at the center of projection, the distortions cancel each other out (on this so-called Verant phenomenon, see Jaensch, *Über die Wahrnehmung des Raumes*, p. 155ff., as well as the excellent study by Rudolf Peter, "Studien über die Struktur des Sehraums," PhD thesis, Hamburg, 1921). In a note in the Paris manuscripts (Charles Ravaisson-Mollien, *Les Manuscrits de Léonard de Vinci* [Paris, 1881–1891], ms. A, fol. 40v [= Richter, no. 543])

Leonardo emphasizes, again anticipating the results of modern psychological research, the especially strong power of illusion of pictures with short perpendicular distances, which rests on the rapidity of the foreshortening and the concomitant expansion of the depth intervals (of course, with the restriction that the illusion is only effective if the eye of the beholder remains fixed exactly at the center of projection, for only then can the *disproporzioni* disappear). Thus the artist ought in general to avoid short perpendicular distances: "If you want to represent an object near to you which is to have the effect of nature, it is impossible that your perspective should not look wrong, with every false relation and disagreement of proportion that can be imagined in a wretched work, unless the spectator, when he looks at it, has his eye at the very distance and height and direction where the eye or the point of sight was placed in doing this perspective." (One must thus fix the eye of the beholder by means of a small peephole.) "If you do this, beyond all doubt your work, if it is correct as to light and shade, will have the effect of nature; nay you will hardly persuade yourself that those objects are painted; otherwise do not trouble yourself about it, unless indeed you make your view at least twenty times as far off as the greatest width or height of the objects represented, and this will satisfy any spectator placed anywhere opposite to the picture." And in Richter, nos. 107–109, occurs the exceedingly perspicacious justification for that apparent canceling out of the marginal distortions when the eye is fixed at the center of projection (see, by contrast, Jaensch's quite unsatisfactory explanation of the phenomenon, in *Über die Wahrnehmung des Raumes*, p. 160): it consists in a collaboration between *perspettiva naturale* – that is, the alteration that the dimensions of the panel or wall undergo when observed by the beholder – and *perspettiva accidentale* – that is, the alteration that the dimensions of the natural object already suffered when the painter observed and reproduced it. These two perspectives work in exactly contrary senses, for *perspettiva accidentale*, as a consequence of planar perspectival construction, broadens the objects off to the sides, whereas *perspettiva naturale*, as a consequence of the diminution of the angle of vision toward the edges, narrows the margins of the panel or wall (see Figure 9). Thus the two perspectives cancel each other out when the eye is situated exactly in the center of projec-

tion, for then the edges of the panel recede with respect to the central parts, by virtue of natural perspective, in exactly the same proportion that they expand by virtue of accidental perspective. Even in this discussion, however, Leonardo again and again recommends avoiding just such a *perspettiva composta* (the term is especially clearly developed in Richter, no. 90) resting on the mutual cancelation of the two perspectives, and instead making do with a *perspettiva semplice*, in which the perpendicular distance is set so large that the marginal distortions have no importance; such a perspective remains palatable regardless of where the beholder stands.

Jaensch seems to have overlooked all these observations of the Italian theoreticians, particularly those of Leonardo, for he claims (p. 159ff.) that Dürer and the masters of the early Renaissance had "not noticed" marginal distortions (which Jaensch, moreover, by neglecting the curvature of the retina, derives exclusively from the discrepancy between the apparent sizes and the size of the retinal image; this is why he treats both the perspectivally constructed image and the photograph as equivalent to the retinal image). According to Jaensch, because they ignored the distortions, they systematically demanded from their representations that powerful illusionistic effect generated precisely by the apparent deformations of the pictures with short perpendicular distances. Leonardo is for Jaensch a prime witness of this desire (in and of itself undeniable) for strong plastic illusion ("*rilievo*"). And yet it was precisely Leonardo who most thoroughly investigated the phenomenon of marginal distortions, and who most decisively warned against constructions with short distances. The Italians, furthermore, for whom this *rilievo* was undoubtedly at least as desirable a goal as for the northerners, in general and on principle preferred greater distances to shorter distances, not only in theory but also in practice. It is no accident that Jaensch draws his concrete examples entirely from northern art (Dürer, Roger van der Weyden, Dirk Bouts). As a matter of fact, construction with a short perpendicular distance was employed not to realize general Renaissance ideals of strong plasticity, but rather to realize the peculiarly Northern ideal of an impression of a quite specifically interior space, that is, an impression of including the beholder within the represented space; see further, p. 69 and note 69, below.

9. See specifically Hermann von Helmholtz, *Handbuch der physiologischen Optik* (Hamburg & Leipzig: Voss, 1910), vol. 3, p. 151 (*Physiological Optics* [New York: Dover, 1960], vol. 3, pp. 178-87); Hauck, *Die subjektive Perspektive*; Peter, "Studien über die Struktur des Sehraums." Especially instructive is the counterproof, the so-called curved-path experiment. If a number of mobile individual points (small lights or the like) are ordered in two rows leading into depth in such a way that a subjective impression of parallel straight lines ensues, then the objectively resulting form will be concave, trumpet-like (see Franz Hillebrand, "Theorie der scheinbaren Grösse bei binocularem Sehen," *Denkschriften der Kaiserlichen Akademie der Wissenschaften*, Mathematisch-Naturwissenschaftliche Klasse, no. 72 [1902], pp. 255-307; the critiques of his arguments – see among others Walther Poppelreuter, "Beiträge zur Raumpsychologie," *Zeitschrift für Psychologie* 58 [1911], pp. 200-62 – do not impinge upon matters essential to us here).

10. Wilhelm Schickhardt, professor of oriental languages and of mathematics at Tübingen, as well as a dilettante woodcut artist and engraver, wrote a small work about a meteor observed on November 7, 1623, in various places in southern Germany. This work, composed very hastily to preserve its topicality, provoked a number of attacks. To refute these attacks, Schickhardt prepared in the following year a most interesting and in part quite spirited and humorous pamphlet; interesting, for example, for its position on the question whether and how far the prophetic meaning of such celestial phenomena could be clarified. The pamphlet was entitled "The Ball of Light, treating, as a primer on the miraculous light which recently appeared, not only that one *in specie* but also similar meteors *in generis*...that is, a kind of German Optics." In this book is found the following remarks as a proof that the trajectory ("*Durchschuss*") of the celestial body in question, even though it may appear subjectively to be curved, is in fact objectively nearly straight (p. 96ff.; Figure 10): "In any case, even if it was somewhat curved, it cannot have been very noticeable, but rather must have happened only *apparenter et optice*; and vision must have been deceived in the following two ways. First, I say that all lines, even the straightest, which do not stand *directe contra pupillam* (directly in front of the eye), or go through

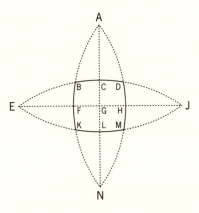

FIGURE 10. Proof of the "optical curves." (After Schickhardt.)

its axis, necessarily appear somewhat bent. Nevertheless, no painter believes this; this is why they paint the straight sides of a building with straight lines, even though according to the true art of perspective this is incorrect. Furthermore – and this will appear absurd even to the scholars of optics themselves, who believe that *omnes perpendiculares apparere rectas* [all perpendiculars appear straight], which, strictly speaking, is not true – it is evident and undeniable that parallel lines appear to the eye to converge and ultimately meet at a single point. It can be observed, for instance, that although long rooms or cloisters may be of objectively equal breadth, they nevertheless appear progressively smaller and narrower. Let us now take as an example a square or a quadrilateral *BDKM* with the eye in the middle, at *G*; the four edges, because they are all in front of the eye, must diminish as they approach the four external points *A*, *E*, *I* and *N*. Or to put it more intelligibly: the nearer an object, the larger it appears, and conversely the further away it is, the smaller it appears; this can be shown with any finger, which close to the eye covers an entire village, further off hardly a single field. For, as in the figure above, the median lines *CL* and *FH* are the nearest to the eye (since they pass through it), they must appear larger; whereas the sides *BD*, *DM*, *MK*, *KB* are further from it, and so must appear smaller. Thus the sides

become narrower and necessarily curved; not like a roof, to be sure, so as to produce a sharp angle at the points *C*, *F*, *H*, *L*, but rather gently and gradually, indeed unnoticeably, something like a belly, as is appropriate for such an arc. Thus it is certainly not true to nature when the painter draws a straight wall on paper with straight lines. Crack that nut, you artists!"

Similar problems were addressed by, besides Kepler (see the following note), Franciscus Aguilonius, *Opticorum libri sex* (Antwerp, 1613), 4.44, p. 265, except that he addresses not so much the bending as the refraction of the lines: "*huic difficultati occurrendum erit plane asserendo omnium linearum, quae horizonti aequilibres sunt, solam illam, quae pari est cum horizonte altitudine, rectam videri, ceteras vero inflexas, ac illas quidem, quae supra horizontem eminent, ab illo puncto, in quod aspectus maxime dirigitur, utrimque procidere, quae autem infra horizontem procumbunt, utrimque secundum aspectum attolli, . . . rursus e perpendicularibus mediam illam, in quam obtutus directe intenditur, videri rectam, ceteras autem superne atque inferne inclinari eaque ratione inflexas videri*" ("This difficulty will be encountered in determining clearly which of all lines are horizontal: that one alone, which is equal in height to the horizontal, appears straight, but the others as *inflexas* [which in the author's usage means "broken," whereas "bent" is rendered as "*incurvus*"], and those lines moreover which rise out above the horizontal, from that point on which one's gaze is especially fixed, from either side fall forward; and again, the line at that middle point of the perpendiculars, on which one's eye is directly fixed, seems straight, whereas the others bend out above and below and in that way appear broken").

11. Johannes Kepler, *Appendix hyperaspistis* 19, in *Opera omnia*, 8 vols., ed. Christian Frisch (Frankfurt & Erlangen, 1858-1871), vol. 7, p. 279; on p. 292 of the same work he reproduces the passage from Schickhardt in the previous note, although not in its entirety: "*Fateor, non omnino verum est, quod negavi, ea quae sunt recta, non posse citra refractionem in coelo repraesentari curva, vel cum parallaxi, vel etiam sine ea. Cum hanc negationem perscriberem, versabantur in animo projectiones visibilium rerum in planum, et notae sunt praeceptiones graphicae seu perspectivae, quae quantacunque diversitate propinquitatis terminorum alicujus rectae semper ejus rectae vestigia repraesentatoria super plano picturae in rectam itidem*

lineam ordinant. At vero visus noster nullum planum pro tabella habet, in qua contempletur picturam hemisphaerii, sed faciem illam coeli, super qua videt cometas, imaginatur sibi sphaericam instinctu naturali visionis, in concavum vero sphaericum si projiciatur pictura rerum rectis lineis extensarum, earum vestigia non erunt lineae rectae, sed mehercule curvae, circuli nimirum maximi sphaerae, si visus in ejus centro sit, ut docemur de projectione circulorum in astrolabium" ("I confess that it is not entirely true, as I have denied, that those lines which are straight cannot apart from refraction be represented in the sky as curved, or similarly with parallel lines or other cases. Since I have retracted this denial, it used to be that projections of visible things were treated in the mind as though projected on a plane surface, and perceptions were noted as graphic and perspectival which, according to the distance from terminal objects, order the represented traces as straight over the surface of the picture in a straight line. But our vision does not in fact have a plane surface like a tablet, on which it contemplates the painting of a half-sphere, but rather that image of the sky, against which it sees comets, it produces in itself as spherical by natural instinct of vision; and if the image of objects is projected into a concave sphere with straight lines of extension, the representations of those lines will be not straight, but in fact curved, just as in the circle, no doubt, of the greatest sphere, if it is seen from its center, as we teach about projection in circular astrolabes"). (See also Kepler's *Paralipomena in Vitellionem* 3.2.7 [*Opera*, vol. 2, p. 167]; the spherical form of the eye corresponds to the spherical form of the visual image, and the estimation of size is carried out by comparing the entire surface of the sphere to the respective portion of it: "*mundus vero hic aspectibilis et ipse concavus et rotundus est, et quidquid de hemisphaerio aut eo amplius intuemur uno obtuto, id pars est huius rotunditatis. Consentaneum igitur est, proportionem singularum rerum ad totum hemisphaerium aestimari a visu proportione speciei ingressae ad hemisphaerium oculi. Atque hic est vulgo dictus angulus visiorus*" ["This world is indeed visible and is itself concave and round, and whatever in the hemisphere we perceive as greater than it in a single glance, this is equal in its rotundity. It therefore follows that the proportion of individual things to the entire hemisphere is estimated by vision in proportion to the image entering in upon the hemisphere of the eye.

And this is commonly called the angle of vision"]. This theory of the estimation of size is entirely in accord with Alhazen, *Optica* 2.37 and Vitellio, *Perspectiva communis* 4.17; on the premise of the spherical field of vision, see note 13, below.) Thus because the bending of the optical image is for Kepler grounded only in, as it were, an erroneous localization of the visual impression, but not in its actual structure, he must necessarily reject Schickhardt's view that even painters ought to represent all straight lines as bent: "*Confundit Schickardus separanda: coeunt versus punctum visionis in plano picturae omnia rectarum realium, quae radio visionis parallelae exeunt, vestigia in plano picturae, vicissim curvantur non super plano picturae, sed in imaginatione visi hemisphaerii omnes rectae reales et inter se parallelae, et curvantur versus utrumque latus rectae ex oculo in sese perpendicularis, curvantur inquam neque realiter neque pictorie, sed apparenter solum, id est videntur curvari. Quid igitur quaeres, numquid ea pictura, quae exaratur in plano, repraesentatio est apparentiae hujus parallelarum? Est, inquam, et non est. Nam quatenus consideramus lineas versus utrumque latus curvari, oculi radium cogitatione perpendiculariter facimus incidere in mediam parallelarum, oculum ipsum seorsum collocamus extra parallelas. Cum autem omnis pictura in plano sit angusta pars hemisphaerii aspectabilis, certe planum objectum perpendiculariter radio visorio jam dicto nullam complectetur partem apparentiae curvatarum utrinque parallelarum: quippe cum apparentia haec sese recipiant ad utrumque latus finemque hemisphaerii visivi. Quando vero radium visivum cogitatione dirigimus in alterutrum punctorum, in quo apparenter coeunt parallelae, sic ut is radius visivus sit quasi medius parallelarum: tunc pictura in plano artificiosa est huius visionis genuina et propria repraesentatio. At neutrobique consentaneum est naturae, ut pingantur curvae, quod fol. 98 desiderabat scriptor*" ("Schickhardt confuses things that ought to be kept separate. All representations of straight lines in the plane of the picture that go out parallel to the angle of vision converge on a point of vision in the plane of the picture. Conversely, all straight lines parallel to themselves are curved not over the plane of the picture, but in the imagination of the visible hemisphere, and they are curved toward either side straight from the eye perpendicular to themselves, and thus they are curved neither in reality nor pictorially, but only seemingly; that is, they only appear to be curved. Why, therefore, do you ask

86

why it is that, in those pictures which are executed in a plane, there is a representation of the appearance of these lines as parallel? There is, and there is not. For to the extent that we consider the lines to be curved toward each other, we cause the angle of the eye to fall in thought perpendicularly in the middle of the parallel lines, and we locate the eye itself apart outside the parallel lines. Moreover, since the entire picture in the plane is in the narrow part of the visible hemisphere, surely the plane projecting perpendicularly from the aforesaid angle of vision will embrace no part of the appearance of curved or parallel lines, especially since this appearance is received on either side and the end of the hemisphere of vision. Indeed when we direct the angle of vision in thought to any other point where the parallel lines apparently converge, in such a way that this angle of vision is in the middle as it were of the parallel lines, then the artificial picture in the plane is a genuine and proper representation of this vision. But it is never consistent with nature to depict them as curved, as the author [Schickhardt] was desiring").

12. That right angles appear round when seen from a distance (and that, by the same token, an arc becomes under certain conditions a straight line) was demonstrated by Euclid, Theorems Nine and Twenty-two; see Euclid, *Optica*, ed. J. L. Heiberg (1895), pp. 166 and 180 (pp. 16 and 32); subsequently Aristotle, *Problemata* 15.6, and Diogenes Laertius 9.89. This is applied more frequently to solid objects, for instance in the proposition that from a distance four-cornered towers appear cylindrical: "*φαίνονται... τῶν πύργων οἱ τετράγωνοι στρόγγυλοι καὶ προσπίπτοντες πόρρωθεν ὁρώμενοι*" ("The square shapes of towers appear cylindrical and falling forward when viewed from a distance"; "Auszüge aus Geminos," in Damian, *Schrift über Optik*, ed. Richard Schöne [Berlin, 1897], p. 22, along with numerous parallel passages from Lucretius, Plutarch, Petron, Sextus Empiricus, Tertullian and others). Later in the "Auszüge aus Geminos" (p. 28) appears the following interesting perspectival explanation of *entasis*: "*οὕτω γοῦν τὸν μὲν κυλινδρικὸν κίονα, ἐπεὶ κατεαγότα* [which should of course be translated not as "broken" but as "weakened"] *ἔμελλε θεωρήσειν κατὰ μέσον πρὸς ὄψιν στενόυμενον εὐρύτερον κατὰ ταῦτα ποιεῖ* (sc. *ὁ ἀρχιτέκτων*) ("Thus, since a cylindrical pillar as though weakened will appear more narrow at the middle,

the architect makes it wider at that point"); see Vitruvius 3.3.13. Vitruvius, too, calls for a curving of the horizontal architectural elements – again by way of compensation – in those eternally discussed passages 3.4.5 and 3.5.8 (see the survey of older views in the commentary, in itself quite unreliable, of Jakob Prestel, *Zehn Bücher über Architektur des M. Vitruvius Pollo* [Strassburg: Heitz, 1912–1914], vol. 1, p. 124). For the stylobate: "*Stylobatam ita oportet exaequari, uti habeat per medium adjectionem per scamillos impares; si enim ad libellam dirigetur, alveolatus oculo videbitur*" ("It is best for the stylobate to be leveled, so that it has in its middle a projection through the use of leveling blocks of unequal heights. For it is constructed according to the book, it will seem hollowed-out to the eye"); and correspondingly for the epistyle and the capitals: "*Capitulis perfectis deinde columnarum non ad libellam, sed ad aequalem modulum conlocatis, ut quae adjectio in stylobatis facta fuerit, in superioribus membris respondeat, epistyliorum ratio sic est habenda, uti . . .*" ("Next, after the capitals of the columns have been constructed not according to the book, but built on an equal level, so that the same projection that will have been made in the stylobate has a corresponding projection in the members above, the proportion in the epistyles is to be similarly made so that . . ."). The apparently correct reading of the first passage, that of Émile Burnouf ("Explication des courbes dans les édifices doriques grecs," *Revue générale de l'architecture* 32 [1875], cols. 145–53; adopted by William H. Goodyear, *Greek Refinements* [New Haven: Yale University Press, 1912], p. 114) seems to have been unfairly disregarded by German scholars: the *scamilli* (literally, "little stools") are not supports for the columns – this would produce not a swelling of the stylobate, but rather only a swelling of the succession of bases – but rather leveling blocks (*nivellettes*) which had been placed on the cut stones to facilitate gauging. If these leveling blocks are "unequal," that is, if they diminish in size toward the middle, this will in fact produce the convexly curved stylobate described by Vitruvius (Figure 11).

All these remarks prove that the ancients were familiar with visual curvatures, and that they were able to explain certain architectural motifs to themselves only as efforts to optically neutralize these curvatures. And if this explanation, considered purely from the viewpoint of art history, seems incon-

88

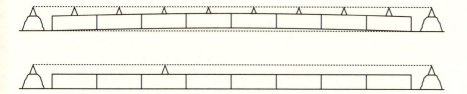

FIGURE 11. Explanation of Vitruvius's *scamilli impares* (after Burnouf): below, the stylobate is leveled by means of equal leveling blocks, such that the stones form a straight line; above, the stylobate is leveled by means of blocks whose size decreases toward the center (*scamilli impares*), creating an upward curve (*per medium adiecto*).

clusive or at any rate one-sided, then it is all the more striking how important those curvatures were to antique artistic theory. There is, however, a curious problem: the architectural curvatures that Vitruvius speaks of behave exactly oppositely to what one would expect in light of their documented purpose, namely to counteract the visual curvature. Moreover, when these curvatures can actually be verified (the most important case is the Parthenon), Vitruvius's claims are usually borne out. Whereas one might suppose that the convexity of the visual curves would be canceled out by a concavity of the architectural curves, the raising of the middle of the stylobate and epistyle produces exactly, on the contrary, a bulging upward of the horizontal (the same effect can also be obtained through a convex arching of the facade in the ground plan, as at Nîmes and Paestum). Guido Hauck's explanation of this phenomenon by the so-called corner-triglyph conflict, or rather by the diminishing of the spaces between the lateral columns which were supposed to alleviate the corner-triglyph conflict (*Die subjektive Perspektive*, p. 93ff.), has been invalidated by the discovery of curvatures even on non-Doric temples, where naturally such a corner-triglyph conflict cannot take place. G. Giovannoni attempted to replace this refuted explanation in "La Curvatura delle linee nel Tempio d'Ercole a Cori," *Mitteilungen des Deutschen Archäologischen Instituts*, Römische Abteilung

23 (1908), pp. 109–30. Our consciousness, he argued, is so alert to the contrast between perspectival appearance and objective reality that, in a sense, it over-compensates for the perspectival modifications; that is, accustomed to regarding the objectively false as correct, we in many cases perceive the objectively correct as false. Exactly cylindrical columns which, in a physiological sense, ought to appear to diminish toward the top, would be psychologically perceived to expand toward the top, for perspectival convergence ordinarily undergoes such a strong overcompensation that only a still-stronger convergence, that is, an objectively somewhat conical structure, will produce the impression of a pure cylindrical form. And likewise the apparent convexity of straight lines would be so strongly overcompensated that we would perceive the real straight lines as concave, and accordingly, in an apparent paradox, would receive an impression of real straightness only when the lines were in fact convex.

As complicated and, as it were, acrobatic this explanation appears, it nevertheless looks like the most plausible, albeit only under the assumption of an almost unimaginably sensitive and elastic sense of form. It is perhaps even corroborated, even if only indirectly, by the passage just quoted from Geminos about towers. If it says there that towers seen from afar seem to "fall forward," then it follows that antique consciousness must in fact have been accustomed to carrying out a kind of overcompensation in Giovannoni's sense. For in and of itself perspectival foreshortening of vertical structures, when it is very strong (for example at close range), produces the impression of falling backward; thus Vitruvius's precept about the inclining of cornices (3.5.13). And when the foreshortening is weak (for example at long range), and when therefore a normal impression of objective verticality might justifiably be expected, then the illusion of falling forward can only be the effect of overcompensation.

It should, however, not be concealed that those very curvatures of the temple of Hercules at Cori upon which Giovannoni built his theory have recently turned out to be merely accidental: see the apparently conclusive presentation by Armin von Gerkan, "Die Krümmungen im Gebälk des dorischen Tempels in Cori," *Mitteilungen des Deutschen Archäologischen Instituts*, Römische Abteilung 40 (1925), pp. 167–80.

It is most interesting that antique theory, when it asserts that an angle appears rounded when seen from afar, finds itself in accord with the most recent psychological research: H. Werner has proven that the less one conceives of an angular structure as "articulated," that is, the more one perceives the "angle" as the mere interruption of a single form and not as the encounter of two forms, then the more the structure undergoes a kind of polishing off or rounding ("Studien über Strukturgesetze," *Zeitschrift für Psychologie* 94 [1924], p. 248ff.). This phenomenon appears, for example, when a broken line is drawn over and over again by an experimental subject instructed to maintain an "integral" perception; but also when unclear vision — for example at a great distance — hinders the "articulated" and favors the "integral" perception. If, on the contrary, the subject is held to the "articulated" perception, then there emerges an increasing tendency toward a concave sharpening of the corner. This would be the case at Segesta, where the tapering off of the facade preserves the clear "articulation" of the building from the rounding off that would otherwise threaten when seen from a distance.

This also sheds light on a curious phenomenon in medieval miniatures (the best-known examples are the Reichenauer manuscripts in Munich, Bayerische Staatsbibliothek, Cim. 57, 58, 59, published by Georg Leidinger in the series *Miniaturen aus Handschriften der Kgl. Hof- und Staatsbibliothek in München*), namely, when the prismatic crib in which the Christ child lies (or towers or other such objects) is represented in the form of Figure 12A. This peculiar rounding off of the rear corner is evidently explained by the failure of the medieval artists to understand the perspectivally foreshortened forms of their (presumably early Christian) models. In this case the psychological obscuring of the *conception* of form favors the suppression of the "articulated" interpretation, just as did the physical obscuring of the *perception* of form when it was seen from a great distance. The acute angles of the original form (Figure 12B) were naturally preserved from the rounding off; but also the obtuse angle at the front (*b*) was, in a sense, spared by the vertical joining it. Thus the rounding off would be limited to the rear angle (*a*), unless the prismatic object is covered by a cloth concealing its lower corner: for in that case this corner too can be

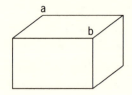

FIGURE 12A. FIGURE 12B.

affected by the rounding off (see, e.g., Cim. 57 [= cod. lat. 4452], pl. 28).

13. See Damian, *Schrift über Optik*, p. 2, art. 11: "*ὅτι ἢ τοῦ τῆς ὄψεως κώνου κορυφὴ ἐντὸς ἐστὶ τῆς κόρης καὶ κέντρον ἐστὶν σφαίρας...*" ("The point of the cone of vision is within the pupil and it is the point of a sphere...") (see also p. 8ff.). From this it becomes immediately evident that it is one and the same form of thought – or better, form of seeing – which, on the one hand, makes the visual magnitudes so strictly dependent on the angles, and on the other hand, emphasizes so strongly the apparent curvature of the straight lines.

14. Euclid, *Definition (horos)* 4–6, *Optica*, p. 154 (p. 2).

15. Euclid, Theorem Eight, *Optica*, p. 164 (p. 14): "*τὰ ἴσα μεγέθη ἄνισον διεστηκότα οὐκ ἀναλόγως τοῖς ἀποστήμασιν ὁρᾶται*" ("Two objects of equal magnitude placed at unequal distances are not seen according to the ratio of their distances"). The proposition is proven by showing that the difference between the distances is greater than that between the angles, and that only the latter (according to the axioms named in the previous note) determine the visual magnitudes.

16. Jean Pélerin (Viator), *De artificiali perspectiva* (Toul, 1505), facsimile ed., by A. de Montaiglon (Paris, 1860), fol. C8r. The corresponding illustration, which is of course dependent on Dürer's *Martyrdom of the Ten Thousand*, first appears in the edition of 1509. (For the explanation, see Figure 4.)

It is very instructive that Leonardo, with respect to the diminishment of distances, arrived "*per isperienza*" at the very result to which linear perspectival construction leads: namely, to the notion that the apparent magnitudes of equal sections are inversely proportional to their distances from the eye (*Das Buch von der Malerei*, Quellenschriften für Kunstgeschichte und Kunsttechnik des

Mittelalters und der Renaissance, nos. 15-17, 3 vols. in 2, ed. Heinrich Ludwig [Vienna, 1881], art. 461; see also Richter, *Leonardo da Vinci*, nos. 99, 100, 223). Here, evidently, linear perspectival thinking showed the way for concrete observation, and in fact Leonardo speaks even here, where he formulates an "empirically" discovered law of *perspectiva naturalis*, of a "picture surface" ("*pariete*"). No matter whether he mentally projected objects onto this picture surface, or whether (and this seems more probable) he in fact made observations with the help of that apparatus with the pane of glass which he knew so well, and which he recommends also for the corresponding observations of color (attenuation of local color in objects at distances of 100, 200, 300 *braccia*, etc.); see *Das Buch von der Malerei*, art. 261 and Richter, no. 294. Thus the establishment of this law in no way constitutes "progress" beyond geometrical perspectival construction (as Heinrich Brockhaus claims in his worthy edition of Pomponius Gauricus, *De sculptura* [Leipzig, 1880], p. 47ff.), but rather only an unconscious application of its results to the direct observation of objects: in a sense, a repercussion of *perspectiva artificialis* upon *perspectiva naturalis*.

In other situations, however, for example with natural objects (that is, where there is no question of a planar projection), antique angular perspective reasserts itself, even in the Renaissance. Dürer, for example, in order that lines of script written on a wall all appear to be of the same height, recommends enlarging them as they rise, such that the respective visual angles are all equal (Figure 13: *a* appears to equal *b* which appears to equal *c*, if $a = \beta = \gamma$; *Unterweisung der Messung* [1525], fol. k10). This is in keeping with Euclid's Theorem Seven and with the often-attested practice of antique sculptors of permitting the proportions of a figure in a high place to increase toward the top in order to counteract

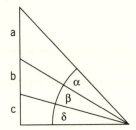

FIGURE 13.

the contraction brought about by the diminishment of the visual angle. See Daniello Barbaro, *La Pratica della prospettiva* (Venice, 1569), p. 9 (with explicit reference to Dürer); Athanasius Kircher, *Ars magna lucis et umbrae* (Rome, 1646), p. 187ff. (with the example of Trajan's column and a citation from Vitruvius, 6.2.1ff., where the same "*detractiones et adiectiones*" are discussed); or Sandrart in his *Teutsche Academie* (Nuremberg, 1675), 1.3.15, p. 98. Even Leonardo, in his doctrine (mentioned in note 8, above) of the "natural" foreshortenings that the margins of any picture undergo, tacitly presupposes the angle axiom. Indeed, *perspectiva naturalis* in general is almost entirely governed by the angle axiom, even when it serves as an introduction to treatises on artificial perspective (as is the case with Barbaro, Serlio, Vignola-Danti, Pietro Cataneo, Aguilonius and others). It was, however, customary either to ignore Euclid's Eighth Theorem, or to disarm it by emending the text; for on account of its reference to the diminishment of magnitudes into depth, it stood too unequivocally in contradiction to the rules of *perspectiva artificialis* (see the following note). Indeed, it can even be stated that the Renaissance, at least as far as *perspectiva naturalis* is concerned, was almost more rigorously Euclidean than the Middle Ages, which knew Euclid only from the Arabic tradition, already somewhat modified. Roger Bacon, for example (*Perspectiva* 2.2.5; p. 116ff. in the Frankfurt edition of 1614), precisely following Alhazen (*Optica* 2.36ff.; p. 50ff. in Risner's Basel edition of 1552), teaches that the visual angle alone does not determine the perception of magnitudes; rather, magnitudes are estimated only by a comparison of the object (that is, the base of the visual pyramid) with the visual angle and the distance of the object from the eye; this distance is itself assessed on the basis of the empirically familiar magnitudes of the intervening objects. And in Vitellio (*Perspectiva communis* 4.20; p. 126 in Risner's edition of 1552) we find even this: "*Omne quod sub maiori angulo videtur, maius videtur, et quod sub minori minus: ex quo patet, idem sub maiori angulum visum apparere maius se ipso sub minori angulo viso. Et universaliter secundum proportionem anguli fit proportio quantitatis rei directe vel sub eadem obliquitate visae..., in oblique tamen visis vel in his, quorum unum videtur directe, alterum oblique, non sic*" ("Anything that is seen at a greater angle appears greater, and anything seen at a lesser angle appears less great. In what appears, the same

thing seen at a greater angle appears greater than the same thing viewed at a lesser angle. And in general the proportion of size of a thing comes about directly according to the proportion of the angle or at the same angle of vision . . . ; nevertheless in the case of things seen from the side or in the case of those in which one thing is seen from the side and another straight on, this is not so"). In Figure 14A, therefore, the apparent sizes are proportional to the visual angles; in Figures 14B and 14C, by contrast, they are not. The justification that Bacon offers for this interpretation, which departs from Euclid, is, interestingly, a purely psychological one: a square is seen from an angle such that $COB > BOA$ (Figure 15), and yet the sides AB and BC are perceived as equal – an impression that indeed can only be explained by the mind's "stabilizing tendency" (see p. 31). It can be seen, however, that the critique of Euclid carried out by medieval *perspectiva naturalis* was entirely differently motivated than that of the modern *perspectiva artificialis*, according to which – in the case just discussed – the difference of the apparent magnitudes (namely, the projections AB and BC onto a straight line XY) must be even greater than the difference between the angles COB and BOA.

17. The metamorphosis of Euclid's Eighth Theorem (at least when it is not simply dropped, as it is in most writings on artificial perspective) can be followed almost step by step. The first complete published translation, that of Zamberto (Venice, 1503), still renders it literally, even if a little misleadingly by virtue of placing "*intervallis*" before "*proportionaliter*": "*Aequales magnitudines inaequaliter expositae intervallis proportionaliter minime spectantur*" ("Equal dimensions set unequally at distances appear least proportionately"; fol. A.A.6 v.). Dürer, or the Latinist he relied upon, immediately fell victim to the ambiguity of this translation, in that he referred "*proportionaliter*" to "*expositae*" instead of to "*spectantur*," and "*minime*" to "*spectantur*" instead of to "*proportionaliter*," thus rendering the sentence perfectly unintelligible: "*Gleich Gross ungleich gsetzt mit proportionirlichen Unterscheiden künnen nit gesehen werden*" ("Equal dimensions set unequally with proportional differences cannot be seen"), Lange and Fuhse, *Dürers schriftlicher Nachlass*, p. 322, l. 23 (indeed, the whole passage from Lange and Fuhse, p. 319, l. 21 to p. 326, l. 19 is a translation from Euclid: see Panofsky, *Dürers Kunsttheorie* [Berlin: Reimer, 1915], p. 15ff.). The standard translation for

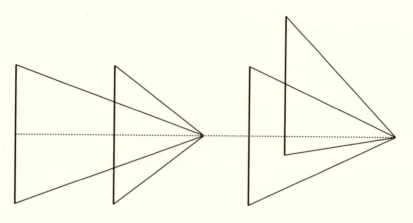

FIGURE 14A. FIGURE 14B.

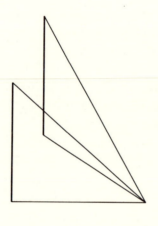

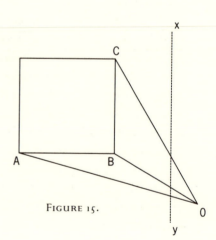

FIGURE 14C. FIGURE 15.

the entire subsequent period, that of Johannes Pena (Paris, 1557, p. 10; 1604, p. 8) emends it thus: "*Aequales magnitudines inaequaliter ab oculo distantes, non servant eandem rationem angulorum quam distantiarum*" ("Equal dimensions standing at unequal distances from the eye do not have the same ratio of angles as their distances"). Both the Italian translation of Ignazio Danti, *La Prospettiva di Euclide* (Florence, 1573), p. 27, and the French translation of Roland Fréart de Chantelou, *La Perspective d'Euclide* (Le Mans, 1663), p. 19, follow Pena exactly. Thus the premise that the angles are not proportional to the distances is made into the conclusion, whereas the actual conclusion, namely the proposition that the ratio of the apparent sizes is determined only by the ratio of the angles and not the distances, is simply omitted. Since Euclid's proof is adopted unaltered, this is in fact a *demonstratio per demonstrandum*.

18. Vitruvius, in the passage in question (1.2.2; on its much-disputed significance for antique perspectival construction, see the following note), takes the term *scenographia* in its narrower sense as the method of representing buildings perspectively on a surface, whether for architectonic or theoretical purposes: *ichnographia* means the representation of the building in plan, *orthographia* means the elevation, and *scenographia* means a perspectival display that shows the sides as well as the facade ("*frontis et laterum abscedentium adumbratio*"; see also the parallel passage, 7, Prooemium, cited in the following note). But the term *scenographia* also has a broader sense, for it can denote quite generally the application of optical laws to the visual arts and architecture in their entirety; that is, not only the rules for making flat pictures on flat surfaces, but also the rules of architectonic and plastic construction, insofar as the latter are interested in counteracting the distortions entailed in the process of seeing (see notes 12 and 16, above). This definition is most clear and complete in Geminos ("Auszüge aus Geminos," in Damian, *Schrift über Optik*, p. 28):

Τί τό σκηνογραφικόν.

Τὸ σκηνογραφικὸν τῆς ὀπτικῆς μέρος ζητεῖ πῶς προσήκει γράφειν τὰς εἰκόνας τῶν οἰκοδομημάτων. ἐπειδὴ γὰρ οὐχ οἶα[τε] ἔστι τὰ ὄντα, τοιαῦτα καὶ φαίνεται,

σκοποῦσιν πῶς μὴ τοὺς ὑποκειμένους ῥυθμοὺς ἐπιδείξονται, ἀλλ᾽ ὁποῖοι
φαινήσονται ἐξεργάσονται. τέλος δὲ τῷ ἀρχιτέκτονι τὸ πρὸς φαντασίαν εὔρυθ-
μον ποιῆσαι τὸ ἔργον καὶ ὁπόσον ἐγχωρεῖ πρὸς τὰς τῆς ὄψεως ἀπάτας ἀλεξήματα
ἀνευρίσκειν, οὐ τῆς κατ᾽ ἀλήθειαν ἰσότητος ἢ εὐρυθμίας, ἀλλὰ τῆς πρὸς ὄψιν
στοχαυομένῳ. οὕτω γοῦν τὸν μὲν κυλινδ(ρι)κὸν κίονα ἐπεὶ κατεαγότα ἔμελλε
θεεωρήσειν κατὰ μέσον πρὸς ὄψιν στενούμενον, εὐρύτερον κατὰ ταῦτα ποιεῖ.
καὶ τὸν μὲν κύκλον ἔστιν ὅτε οὐ κύκλον γράφει, ἀλλ᾽ ὀξυγωνίου κώνου τομήν,
τὸ δὲ τετράγωνον προμηκέστερον καὶ τοὺς πολλοὺς καὶ μεγέθει διαφέροντας
κίονας ἐν ἄλλαις ἀναλογίαις κατὰ πλῆθος καὶ μέγεθος. τοιοῦτος δ᾽ ἐστὶ λόγος
καὶ τῷ κολοσσοποιῷ διδοὺς τὴν φανησομένην τοῦ ἀποτελέσματος συμμετρίαν,
ἵνα πρὸς τὴν ὄψιν εὔρυθμος εἴη. ἀλλὰ μὴ μάτην ἐργασθείη κατὰ τὴν οὐσίαν
σύμμετρος. οὐ γὰρ οἷα ἔστι τὰ ἔργα, τοιαῦτα φαίνεται ἐν πολλῷ ἀναστήματι
τιθέμενα.

What Is Scenography?

As a branch of optics, scenography seeks how to properly draw images
of buildings. Since it is not possible to represent them as they really
are and such as they appear, they [i.e., the scenographers] seek to rep-
resent not the actual proportions, but how they will appear when
constructed. The goal of the architect is to make his construction
well-proportioned in its impression and to discover remedies for the
deceptions of vision, by striving after not actual proportion, but rather
proportion according to visual impression. Thus, since a cylindrical col-
umn as though weakened will appear more narrow at the middle, the
architect makes it wider at that point. And when he draws a circle he
draws it not as a circle but as an ellipse, and a square as a rectangle, and
a group of columns differing in size he draws in different relationships
of extent and size. Such also is the method of the monumental sculp-
tor, who gives the proportion as it will appear in the finished work, in
order that it may be well-proportioned to vision and so that it may not
in vain be fashioned to measure in its actual substance. For the prod-
ucts are not such as appear placed in many a construction.

According to this text, then, "scenography" is: (1) the method of the painter who wishes to represent buildings and must reproduce not their true but their apparent dimensions; (2) the method of the architect who may not apply proportions considered beautiful from the point of view of abstract mathematics, but rather, striving for "*pros opsin euruthmia*" ("proportion according to visual impression"), that is, fine form as a subjective impression, must work against the deceptions of the eyes – thus he thickens columns in the middle, shows circles as ellipses and squares as rectangles and arranges a group of columns of varying sizes in different relationships (that is, different from the abstractly required relationships; we should like to question the accuracy of Schöne's translation on this point); (3) the method of the monumental sculptor ("*toioutos d' esti logos kai tōi kolossopoiōi...*"; Schöne leaves *kai* [and] untranslated and renders *kolossopios* too pallidly as "maker of a colossal work," for he seems not to realize that now, after architects, come the sculptors), who learns from scenography about the future optical impression of his own work of art; the work is meant to appear eurhythmic, rather than pointlessly symmetrical, satisfying only the abstract and mathematical imagination (see the famous passage in the *Sophist*, 235E–236A, where Plato protests precisely against this replacement of the "*ousai summetriai*" ["actual symmetries"] by the "*doxousai einai kalai*" ["those appearing to be beautiful"]).

Whereas an author like Vitruvius or Polybius singles out of this complete survey of scenography only the first point (that is, pictorial perspectival representation), the Platonist Proclus, conversely – and this is both understandable and characteristic – shifts the third point into the foreground. For him *scenographia* is exclusively the study of how to compensate for the apparent distortions of works of art displayed in high places or meant to be seen at a distance: "σκηνογραφικὴν... δεικνύουσαν πως ἂν τὰ φαινόμενα μὴ ἄρυθμα ἢ ἄμορφα φαντάζοιτο ἐν ταῖς εἰκόσι παρὰ τὰς ἀποστάσεις καὶ τὰ ὕψη τῶν γεγραμμένων" ("Scenography is what shows how the things would appear not disproportioned or deformed through the distances and heights of the objects depicted"; Proclus, *In primum Euclidus elementorum librum commentarii*, ed. Gottfried Friedlein [Leipzig, 1873], p. 40, l.12). It is probably not possible to relate the passage, as Richard Delbrück

does ("Beiträge zur Kenntnis der Linienperspektive in der griechischen Kunst," PhD thesis, Bonn, 1899, p. 42) to the rules of perspectival representation rather than to these, as it were, antiperspectival compensatory measures.

We have not been able to determine whether Erich Frank, *Plato und die sogennanten Pythagoräer* (Tübingen: N. Niemeyer, 1923), is justified in claiming that the ancients defined scenography as "optics in a narrower sense." For Proclus, "optics in general" fell rather into three parts: first, on the same level, *scenographia* and the *idiōs kaloumenē optikē* ("science commonly called optics"; which as the doctrine of the causes of optical illusions is not especially related to the arts), followed by the third part, the *katoptrik*.

19. The pertinent passage in Vitruvius and its parallel passage from the Prooemium are the only testimonies that permit us at all to suppose the existence of a mathematically constructed pictorial perspective in antiquity; for other testimonies, although they reveal that artists took the laws of vision into account, nevertheless do not reveal knowledge of a geometrical procedure which would have permitted the exact construction of perspectival representations. They read as follows: (1) "*Scenographia est frontis et laterum abscedentium adumbratio ad circinique centrum omnium linearum responsus*" (Vitruvius 1.2.2); (2) "*Namque primum Agatharchus Athenis Aeschylo docente tragoediam scaenam fecit et de ea commentarium reliquit. Ex eo moniti Democritus et Anaxagoras de eadem re scripserunt, quemadmodum oporteat ad aciem oculorum radiorumque extentionem certo loco centro constituo lineas ratione naturali respondere, uti de incerta re certae imagines aedificiorum in scenarum picturis redderent speciem, et quae in directis planisque frontibus sint figurata, alia abscedentia alia prominentia esse videantur*" (Vitruvius 7, Prooemium). That is: (1) "Scenography is the illusionistic reproduction [this is probably the best translation of *adumbratio*, which is equivalent to *skiagraphia*; on the latter term, see Ernst Pfuhl, *Malerei und Zeichnung der Griechen* (Munich: Bruckmann, 1923), vol. 2, pp. 620 and 678, where he qualifies considerably his own earlier and somewhat extreme interpretation ("Apollodoros *Ο ΣΚΙΑΓΡΑΦΟΣ*," *Jahrbuch des Deutschen Archäologischen Instituts* 25 [1910], pp. 12–28)] of the facade and the sides, and the correspondence of all lines with respect to the center of the circle [actually the "compass point"]"; (2)

"Agatharchos was the first, at the time when Aeschylus staged his tragedies in Athens, to make [usually understood as "to paint," although even that is, strictly speaking, not in the text] a *skena*, and he left a treatise on the subject. Inspired by him, Democritus and Anaxagoras wrote on the same subject, namely on how lines, when the middle point is assumed at a particular place [or at any rate: "when the compass point is placed at a particular point," although Vitruvius in this case normally uses the verbs *ponere* or *conlocare*], must according to natural laws correspond to the location of the visual faculty and the rectilinear extension of the visual rays, in order that clear images of unclear objects ["unclear" because seen from a distance; on the term *incertus*, see the passage 3.5.9] can reproduce in stage-paintings the appearance of buildings, and that something represented on flat, frontal surfaces appears either to retreat or to project forward." There is no more mention here of a *circini centrum* or even a *centrum certo loco constitutum* lying on the picture surface, than there is of lines that converge or are drawn from a vanishing point on that surface (the translation offered by Frank, *Plato und die sogenannten Pythagoräer*, p. 234, is almost as arbitrary as the downright wild version of Jakob Prestel, *Zehn Bücher über Architektur*, p. 339, which renders *centrum* as "fixed picture surface," *ratione naturali* as "natural succession," and *extentio radiorum* as "points of disappearance"). Already Meister, in his still-valuable treatise in the *Novi commentarii soc. reg. Gotting.* no. 5 (1775), objected for very sound reasons to the reading of the passages in question from the standpoint of central perspective, a reading so natural to modern commentators since the days of Cesariano, Rivius and Barbaro (as did the ingenious Johann Heinrich Lambert, *Freye Perspektive* [Zurich, 1774], vol. 2, p. 8ff., and more recently, although with less felicitous arguments, Felix Witting, *Von Kunst und Christentum*, p. 90ff.). We must leave to experts the ultimate clarification of these difficult texts (the wording of the second passage is evidently dictated by the effort to squeeze as many axioms and artistic terms from Greek optics as possible into a single sentence). Yet this much can be said: even if they prove nothing conclusive about our tentative hypothesis of a circular construction, they nevertheless – contrary to the generally accepted view held by (in addition to the authors already named) Delbrück, "Beiträge zur Kenntnis der Linien-

perspektive," p. 42; Christian Wiener, *Lehrbuch der darstellenden Geometrie* (Leipzig, 1884), vol. 1, p. 8; and L. F. Jos. Hügel, "Entwicklung und Ausbildung der Perspektive in der classischen Malerei," PhD thesis, Würzburg, 1881, p. 68ff. – prove even less that antiquity was already familiar with modern plane perspective.

The historical data in the second Vitruvius passage, meanwhile, are rightfully treated with much greater skepticism by the archaeologists than for example by Frank (see Pfuhl, *Malerei und Zeichnung der Griechen*, p. 666ff., and August Frickenhaus, *Die altgriechische Bühne* [Strassburg: Trübner, 1917], p. 76ff.). The perspectival doctrines of Democritus and Anaxagoras were almost certainly not manuals of construction for painters, but treatises on optics along the lines of Euclid; this also better matches the surviving title of a lost work by Democritus, *Aktinographie* (*The Drawing of Rays*).

20. On the antique technique of foreshortening or perspective, to the extent it can be verified in representations of buildings, see (as well as the cited works by Delbrück and Hügel) especially Guido Hauck, *Die subjektive Perspektive*, p. 54ff., whose division of the development into four "stages," it must be granted, has more systematic than historical value. See also Heinrich Schäfer, *Von ägyptischer Kunst* (Leipzig: Hinrichs, 1919), vol. 1, p. 59ff., and especially Wladimir de Grüneisen, "La Perspective dans l'art archaïque oriental et dans l'art du haut moyen âge," in *Mélanges d'archéologie et d'histoire de l'École française de Rome* 31 (1911), pp. 394–434. The essay by J. Six, "La Perspective d'un jeu de balle," *Bulletin de correspondance hellénique* 47 (1923), pp. 107–14, has, on the other hand, nothing to do with the problems discussed here. On the entire development from antiquity to the beginnings of the modern era, see the instructive surveys by Richard Müller, "Über die Anfänge und über das Wesen der malerischen Perspektive," Rektoratsrede (Darmstadt, 1913), and Ludwig Burmester, *Beilage zur Münchner allgemeinen Zeitung*, no. 6 (1906); but above all G. Joseph Kern, *Die Grundzüge der linear-perspektivischen Darstellung in der Kunst der Gebrüder van Eyck und ihrer Schule* (Leipzig: Seemann, 1907), as well as his important essays: "Die Anfänge der zentralperspektivischen Konstruktion in der italienischen Malerei des 14. Jahrhunderts," *Mitteilungen des Deutschen kunst-*

historischen Instituts in Florenz 2 (1912), p. 39ff., and "Perspektive und Bildarchi-tektur bei Jan van Eyck," *Repertorium für Kunstwissenschaft* 35 (1912), pp. 27–96. We have attempted our own summary of the evolution of antique perspective in note 24, below.

21. See in particular Kern, "Die Anfänge der zentralperspektivischen Kon-struktion," passim.

22. According to Kern (especially in *Die Grundzüge der perspektivischen Darstellung*, p. 33ff. and in "Die Anfänge der zentralperspektivischen Konstruk-tion," p. 62; G. Wolf copies him thoughtlessly in *Mathematik und Malerei* [1916], p. 49), there was a controversy in antiquity and particularly in the Middle Ages over whether "parallels running off into the distance appear to converge in a single point or not"; it seems that Vitellio polemicized against the vanishing-point theory in the twenty-first theorem of the fourth book of his *Perspectiva communis* (p. 127). This opposition, however, appears to be a position derived from the modern evolution of perspective, inadmissibly introduced into the deliberations of antique and high medieval optics. For that "vanishing point" against which Vitellio allegedly "mustered all his eloquence" (in truth this elo-quence was restricted to this single sentence: "*lineae... videbuntur quasi con-currere, non tamen videbuntur unquam concurrentes, quia semper sub angolo quodam videbuntur*" ["Although lines shall seem as if to converge, nevertheless they will never be seen to converge, because they will always be seen at some angle"]) is the point that represents the infinitely distant points of those parallels. It can therefore hardly be the case, from the point of view of empirical psychology, that an actual convergence of two parallels becomes visible ("our faculty of vision does not extend into infinite distances, and moreover in reality there are no infinitely extended lines.... [T]o express ourselves entirely correctly, we must say: parallel lines are represented in a picture thus that if we could extend them sufficiently, their extensions within the picture would intersect at one and the same point"; thus Guido Hauck, quite correctly, in his *Lehrbuch der malerischen Perspektive* [Berlin: Springer, 1910], p. 24). Nor should we be sur-prised if in some familiar verses from Lucretius, cited frequently already in the seventeenth century (for example, by Aguilonius, *Opticorum libri sex*, 4.45,

p. 260, or in the *Opticae libri sex* of Petrus Ramus, edited with commentary by Risner in 1660, 2.70), two parallel colonnades, which are necessarily of very limited extension, do not converge in a single point, but rather only tend toward the "*obscurum coni acumen*" ("indistinct apex of the cone"). Mathematically considered, the theory of the vanishing point is linked to the concept of a limit, that is, to the possibility of imagining that when parallels are infinitely extended, their finite distance from one another, and thus the visual angle subtended by their furthest points, approaches zero. And in fact the principle of the vanishing point as it appears already in Aguilonius, although still in imperfect form, is mathematically justifiable only with the help of this concept of an infinite limit: "*Quaeque tandem longissime provectae ob distantiae immensitatem perfecte coire et inter sese et cum radio optico videantur. Quare punctum quod postulatur, est quodvis huius radii optici signum infinite, hoc est immoderato intervallo ab oculo disjunctum*" ("The parallels at length extended through infinity of distance seem to converge exactly both among themselves and at the central rays. Therefore that point is postulated as drawn infinitely on the central ray, and is disjoined from the eye at an immeasurable distance"; Aguilonius, *Opticorum libri sex*, 4.45, p. 266). A really adequate definition of the vanishing point (for this definition, see any handbook of descriptive geometry, for example, Karl Doehlemann, *Grundzüge der Perspektive*, Aus Natur und Geisteswelt, no. 510 [Leipzig & Berlin: Teubner, 1916], p. 20f., as well as that of Guido Hauck just mentioned) is first found in Desargues, as Burmester, *Beilage*, p. 44, points out.

Thus if Vitellio states that two parallels, notwithstanding their constant striving toward each other, could never actually intersect each other, because two opposing points on the parallels will always subtend an angle, no matter how small ("he clings to the mathematical concept of a point," according to Kern), then he does impose upon the concept of the *concursus* a restriction: but from the standpoint of the mathematics of the day this restriction was simply necessary. He formulates the only possible position for an optics not yet furnished with the concept of a limit. He does not, however, polemicize against "opponents" who could not even exist, for that concept of a limit would have been as foreign to them as to Vitellio himself. That the extension of two objectively

no-longer-parallel lines (and Vitellio is never talking about more than two) drawn on a surface must intersect is self-evident, and Vitellio would never have denied it. But he was concerned not with the laws of representation but with the laws of vision, and if from this standpoint he disputes the possibility of a true *concursus*, this proves nothing more than that the mathematical imagination of his epoch still had no place for the concept of infinity; that concept was in fact arrived at only in the immediately following period (see p. 65).

23. See Pfuhl, *Malerei und Zeichnung der Griechen*, vol. 2, p. 885ff.

24. Unfortunately, we are very poorly informed about the development which preceded the true perspectival representations of the so-called second Pompeian style, and especially about the hardly inconsiderable role (at least on the evidence of Etruscan urns and mirrors; for an example of the latter, see note 40, below) played by the native Italian element in this development. Given the incompleteness and imbalance of the surviving material, it is at best doubtful whether this darkness will ever be entirely illuminated. Insofar as an art historian without professional archaeological credentials can judge, the development seems to have unfolded roughly as follows:

i. An initial "archaic" epoch, which – with certain exceptions – encompasses the style of the ancient Near East and a large portion of black-figure vase painting, seeks to reduce corporeal objects to the purest possible ground plans and elevations. The spatial relationships of these objects to one another can thus be suggested either by a combination of these two formal types (as in the well-known Egyptian representation of a garden which shows the surface of the water in plan but the surrounding trees in elevation, and thus diagonal trees in the four corners: Figure 16); or by a juxtaposition or superposition of elevations. This last method is usually described as lateral or vertical "staggering," and it should be pointed out (contrary to Schäfer, *Von ägyptischer Kunst*, p. 119) that this is not actually to be interpreted as an oblique view, in fact not as a "view" at all, but rather only as a row of outlines.

ii. The subsequent development, which we can follow from about the second quarter of the sixth century, is characterized by the transferral of the principle of "lateral staggering" to the individual body, and in particular, of course,

FIGURE 16. Egyptian representation of a garden, New Kingdom. (After Schäfer.)

to those bodies naturally divisible into a forward and a rear elevation: this means above all the body of the horse, whose rear elevation is now placed alongside the front elevation, just as when entire figures are staggered. This is the source of the sharp foreshortening which characterizes an entire group of black-figure vases of this epoch (Plate 21), and which finds its perfect sculptural counterpart in the famous four-horse metopes of Temple C at Selinus. Soon chairs, triclinia and the like will also be represented such that the back legs are staggered alongside the front legs (see, for example, Ernst Buschor, *Die griechischen Vasenmalerei* [Munich: Piper, 1913], ill. 141/2). Now, when the rear elevation shifts from its position beside the front elevation to a position somewhat above it (a combination, as it were, of vertical with lateral staggering), and when both elevations, for they do after all belong to the same object, are connected by lines, the result is the "parallel perspective" typical of this second period. Nevertheless, the supporting line remains a line. Circles are now, for the first time, represented as ellipses (see, for example, the form of the shield in *ibid.*, ill. 103 with that in ill. 127); and figures display a three-quarter turning of the face and of the thorax as well as a differentiation of the legs into support leg and free leg (although because of the preservation of the supporting line, the latter does

not yet retreat behind the former, but rather remains on the same horizontal).
Thus even now the recession of several objects into depth cannot yet be sug-
gested in any other way than by staggering; however, this is now no longer
restricted to figures alone, but rather extends to the terrain or fragments of rock
accompanying them (as on the "Polygnotan" vases, indeed even on the Ficoroni
cista). Ernst Pfuhl, who earlier (like Hauser) attributed to Polygnotos a highly
evolved faculty for spatial representation, has now retreated to a position almost
resembling Lessing's (*Malerei und Zeichnung der Griechen*, vol. 2, p. 667: "primi-
tive pseudo-perspective of the vertical staggering on the surface"); not even
Apollodoros, in Pfuhl's current view (*ibid.*, p. 620f.), "even with imperfect yet
tolerably convincing perspective," succeeded in "really representing the consid-
erable spatial depth, suggested on the surface, of the great Polygnotan painting."

iii. Only since the turn of the fourth century – inspired probably by stage
painting – does the consolidation of space appear to get under way. We may
infer it, above all, from Plato's (disparaging) comments on landscape painting
and the deceitful *skiagraphia*. Granted, we can gather from his remarks – and
from the reports on the representation of shimmering through water or glass or
on the reproduction of special light effects (the fire-blowing boy of Antiphilos) –
little more than that the experiences of scientific optics in the fourth century
were already to a certain extent at the disposal of painters. For one must always
remember that contemporary or near-contemporary reports can of course only
measure the "naturalism" of an artistic representation against what has already
been achieved, against what is conceivable (Boccaccio, for example, perceived
Giotto's paintings, which for a later beholder are very much in a "style," as
"deceptively true to life"). There is thus no contradiction if behind Plato's
descriptions of contemporary "illusionistic painting" we immediately surmise
something like the Esquiline landscape, even though to the more exacting eye
of Lucian the perspectival design of a painting by Zeuxis was so obscure that
he could not tell whether a figure "was standing merely to the rear or at the
same time higher up" (Lessing, *Antiquarische Briefe*, no. 9).

Two things are certain: first, the supporting line is gradually reinterpreted
as a ground surface, at first by simply having the feet cross it (Metrodoros stele,

reproduced in Pfuhl, *Malerei und Zeichnung der Griechen*, ill. 746; Etruscan mirrors); second, the coffered ceilings of buildings are perspectively "deepened" to such an extent that objects and people appear really to stand "in" the architectural space (southern Italian vases). Of course, this deepening is accomplished primarily with the help of parallel perspective, and we can easily imagine how the representations of buildings in pure elevation from preclassical and classical vase painting (such as Buschor, *Die griechischen Vasenmalerei*, ills. 77 and 108; Pfuhl, *Malerei und Zeichnung der Griechen*, ill. 286; our own Figure 17), by means of foreshortening the beam ends and the coffers in parallel perspective, gradually transformed themselves into the aedicules of the southern Italian vases. When these aedicules happened to appear in symmetrical form, the result was of course that very vanishing-axis perspective which we discussed at length in the text (see Plate 3); for the conflict in the center, in those cases where it had not rather been concealed, gradually brought about a relaxation of pure parallelism in favor of "convergence" (see Plate 1; still in the Trecento, as Guido Hauck has already pointed out, one finds a convergence of orthogonals in symmetrical views even as parallelism is maintained in "lateral" views). A further license is what we

FIGURE 17. Fountain from a red-figure *hydria* by Hypsis. Rome, Torlonia Collection, c. 500 B.C. (After Buschor, *Griechischen Vasenmalerei*.)

should like to call the "turning inward" of the marginal orthogonals, that is, a closer approximation of their slope to the perpendicular; no doubt the intention was to make it possible to broaden the side walls. But even in the southern Italian vases, the evolution of the supporting line into a supporting surface proceeded only hesitantly and inconsistently; even the stele of Helixo, supposedly painted between 280 and 220 B.C. (Rudolf Pagenstecher, *Nekropolis* [Leipzig: Giesecke, 1919], p. 77), shows the ground perspectively raised, but does not actually dare to place the figures on it. The figures do not use the surface of the ground as a supporting *plane*, but rather – almost as on the northern Italian vases – use the rear edge of the ground as a supporting *line*, so that they appear less on than above the ground plane.

iv. The true "interior" and the true "landscape" seem to have emerged only in Hellenistic times, when it was finally understood how to arrange the individual pictorial elements actually "on" the foreshortened ground plane. And even in this epoch we must imagine a rather slow and cautiously experimental evolution: in the sparse testimonies to a pre-Pompeian painting, space either extends only as deep as the layer of figures (for example, in the Battle of Alexander or the Dioscurides mosaic), or the extension into depth is indicated by a simple layering of several coulisses (for example the Niobe fresco, assuming that the architecture was not simply added by the copyist; or the celebrated Hediste stele from Pagasai, second to first century B.C., in Pfuhl, *Malerei und Zeichnung der Griechen*, ill. 748, and elsewhere). In such a layering, the depth intervals are indeed suggested by overlappings and size differences, but they are not legible through any clear relationship to a foreshortened horizontal plane. This is a rather high-handed and, as it were, purely negative method of spatial illusion, in which the individual depth layers appear to stand behind each other and next to each other at the same time: for as in most so-called Greco-Roman reliefs (whether they also use the overlapping layers or only vertical staggering), the depth intervals can be read as zero as easily as infinity, and the empty remainder of the paint surface may be interpreted either as the symbol of an ideal space, or as the material picture support (on this see the instructive study by Arnold Schober, "Der landschaftliche Raum in hellenistischen Reliefbild," *Wiener*

Jahrbuch für Kunstgeschichte 2 [1923], p. 36ff., which came to our attention too late). As far as we can tell from the surviving material, depth intervals were in fact first made really verifiable on Roman soil; in this way, the conception of a material picture support was unequivocally replaced by the conception of an immaterial picture plane. Here, for the first time, the world of things, confronting the spectator as something objective, transformed itself into a "prospect." This is most clearly emphasized by an illusion of an apparently accidental view, especially when glimpsed through something else. Antiquity never developed a truly perspectival relief at all, of the sort we have since Donatello; although the materiality of the picture support was at least sublimated to the extent that the relief ground was no longer presented as the coherent surface of a physical plate, but rather only in small fragments, often covered in shadow and thus functioning more as suggestions of space. It is also significant that reliefs now appear more often in places where the sensibility of an earlier epoch would have demanded actual empty space: the reliefs of the Ara Pacis are on the upper part of the building, where the Pergamon altar had intercolumniations; and the reliefs of the Pergamon altar are found on the lower part, which in the Ara Pacis is decked with ornamental plates.

This evolution of the painterly representation of space, admittedly only hypothetical, nevertheless gains a certain plausibility through an interesting parallelism with the evolution of the *skēnē* (stage set). In the fifth century the *skēnē* is an independent and solid building, and only its large central portal could contain interchangeable representations of cliffs, caves and the like. In the Hellenistic era it becomes a flat relief, structurally still separated from the space of the audience. Only in Roman times will the *skēnē* develop into a true hollow space and merge with the audience's space into a closed architectonic unity. It no longer confronts the spectator as an independent construct, but rather is integrated directly into his sphere of existence. The *skēnē* now presents itself as a genuine "tableau" corresponding to the creations of view-painting. Indeed, an analogous evolution can be traced even in the realm of literature, most plainly in the restricted — but for that reason all the more clearly illuminated by a distinguished study, that of Paul Friedländer — case of *ekphrasis*, or the descrip-

tion of works of art. Moschus was the first to "link thematically" the scenes represented in the described works (which are ordinarily, of course, fictional) "by choosing three moments of the same legend.... And this will to unity extends further. Description, which in all earlier examples of epic was actually a kind of ornamental intrusion, which could be altogether different and yet exercise the same effect, now for the first time enters into an intimate relationship with the surrounding poetry. It is not only a fragment of ancestral history which is unrolled for us here; rather, everything points toward the future. If the cow Io 'walks over the salty paths,' then so the bull Zeus will later 'walk with unmoistened hoofs over the vast waves'; moreover, Io's fate actually rehearses Europa's. Like her forebear, she, too, will have to cross the sea, will have to suffer fear and need, but will also in the end find salvation" (Friedländer, *Johannes von Gaza und Paulus Silentiarius: Kunstbeschreibungen justinianischer Zeit* [Leipzig and Berlin: Teubner, 1912], p. 15). And if the Hellenistic era, in painting just as in *ekphrasis*, achieved a certain consolidation of isolated motifs in the domain of the object, then Virgil lent the resulting tableau both impressionistic looseness and a firm reference to the subjective sphere of the beholder: "The poet cannot and indeed will not give the entirety; he extracts a handful of scenes only. Thus a formless element is introduced into our representation, out of which the individual images arise, and the mystery of the gods is pushed further away from the calculating mind and the suspicious eye.... In the end, when one examines the link between the interlude and the entire epic, something new in Virgil emerges, perhaps again something not at all Greek. For the ancients and still in early Hellenistic times, the *ekphrasis* was mere ornament; the later Hellenistic period brought it into a profounder association with the whole and related it to the content of that whole. In Virgil, the *ekphrasis* refers beyond this content, to something external, just as his poetry in general takes into account a dimension outside itself, namely the present of the poet. The means, both in the case of Aeneas's shield and of the journey to the underworld, is the appropriation of historical material extending all the way to the luminous days of the most recent past. Here Virgil stands to his Greek models as the Ara Pacis stands to the Parthenon frieze, or the Column of Trajan to the Mausoleum" (*ibid.*, p. 20f.).

25. The arguments in this essay overlap considerably, as far as more general questions are concerned, with arguments presented in the author's *Die deutsche Plastik des elften bis dreizehnten Jahrhunderts* (Munich: Wolff, 1924), except that they now seem to have found a certain justification in the more readily verifiable results of an investigation conducted specifically from the standpoint of the history of perspective. The following sentence appears in an ingenious work by Ernst Garger, *Die Reliefs an den Fürstentoren des Stefansdom* (Vienna: Krystall, 1926), which unfortunately could not be used here any more extensively: "Antiquity had true space, almost like that of the Renaissance" (p. 35). In this "almost" lies the problem of the present essay.

26. Goethe, "Die schönsten Ornamente und merkwürdigsten Gemälde aus Pompeii, Herculaneum und Stabiae," *Jahrbuch der Literatur* (1830), sec. 7.

27. See the arguments of Ernst Cassirer adduced above, p. 30.

28. Aristotle, *Physics*, book 4.

29. On the Aristotelian concept of infinity, see especially Pierre Duhem, *Études sur Léonard de Vinci*, vol. 2: *Ceux qu'il a lus et ceux qui l'ont lu* (1909; repr., Paris: F. de Nobele, 1955), p. 5ff.

30. On the formal and structural principles of early Christian art see, as well as Alois Riegl's famous treatise on the late Roman art industry, more recently Hans Berstl, *Das Raumproblem in der altchristlichen Malerei* (Bonn & Leipzig: Schroeder, 1920), and the superb study by Fritz Saxl, "Frühes Christentum und spätes Heidentum in ihren künstlerischen Ausdrucksformen," *Wiener Jahrbuch für Kunstgeschichte* 2 (1923), p. 63ff., where both the preparatory phenomena within the pagan Roman development and the Eastern influences are precisely defined.

This consistently antiperspectival Eastern influence appears especially strongly in, for example, the miniatures of Cosma Indicopleuste, where, as in the ancient Egyptian representation of a garden mentioned in note 24, above, the ground of the Tabernacle is shown in plan and the walls in elevation, so that the four corner posts must maintain a diagonal position (*Le Miniature della topografia cristiana di Cosma Indicopleuste*, ed. Cosimo Stornajuolo [Milan: Hoepli, 1908], pls. 15 and 17). But even in the famous Vienna Genesis, by comparison such a strongly Hellenizing manuscript, one can follow the gradual dis-

integration of perspectival space (how the schematizing reinterpretation of the foreshortened spatial form as an ornamental surface form makes itself felt in the domain of figure representations is shown, for example, by the "floating" position of the apparently backward-turned feet, which originally was the foreshortening of forward-pointing feet; or by the apparently high-shouldered or even hunched form of the "round back," which resulted when the three-quarter profile was adopted as a design but plastically devalued). On plate VI of the edition of Wilhelm von Hartel and Franz Wickhoff (Vienna, 1895) is found the representation, which later disappears almost entirely, of a self-contained and covered interior space (our Plate 22). And yet the ceiling coffers are given in simple flat projection; the upper body of the man leaving through a door already appears outside the room – thus heralding the transformation of the pure interior into a combination of interior and exterior views – and finally, what is most important and what is also closely related to the last point: the interior space itself no longer fills the entire picture field, rather, what is beyond it remains neutral ground. Thus the projection plane has already reverted to being the picture surface, and must await the reverse transformation completed only by Duccio and Giotto. In plate XXXV, Pharaoh sleeps, as the editor remarks, "before" a foreshortened colonnade in asymmetrical side view; in fact he would be lying *in* it, were it not that the two front columns, in order to avoid overlapping the figure, are not extended all the way to the ground.

This fear of overlapping is almost natural to a two-dimensional way of thinking, which prefers to see the contours of the form in back (viewed spatially) led around the contours of the form in front, rather than see them interrupted. In this fear we may also find one of the reasons for the special popularity of so-called reverse perspective. Reverse perspective does occur frequently even earlier (for example, in the well-known Capitoline dove mosaic, indeed even in fragments such as the perspectival meander of Anapa from the third century B.C., illustrated in M. I. Rostovtsev, *Antichnaia dekorativnaia zhivopis' na iugie Rossïi* [St. Petersburg: Imp. Arkhaeologicheskoi kommissii, 1913-1914], pl. XVII/i, and often in the perspectival dentils of southern Italian vases: see our own Plate 2), yet it never achieved the fundamental and universal significance it had in early

Christian, Byzantine and medieval art. The emergence of this reverse perspective was certainly also favored by the degeneration of the Greco-Roman ground surface back toward the ancient Eastern ground line; this, as was emphasized by Grüneisen in "La Perspective dans l'art archaïque oriental et dans l'art du haut moyen âge," was due to Eastern influences. Thus when the entablatures retained their slant, the result was the appearance of a divergence (our own Plate 23; on occasion this authentically Eastern tendency went so far as to make the perpendiculars horizontal – that is, to abandon "foreshortening" – even on the upper or lower roof line, which resulted in very peculiar distortions; see, for instance, the Vienna Genesis [pl. XLIV], our own Plate 24, or the miniature mentioned in note 33 of Amédée Boinet, *La Miniature carolingienne* [Paris: Picard, 1913], pl. CXXIIIa). The opinion of Oskar Wulff in "Die umgekehrte Perspektive und Niedersicht," *Kunstwissenschaftliche Beiträge, August Schmarsow gewidmet* (Leipzig: Hiersemann, 1907), p. 1ff., must be rejected on principle: namely, that "reverse perspective" is a true inversion of normal perspective, in that the image is referred to the point of view of a beholder standing inside the picture instead of outside it; in response see, among others, Karl Doehlemann, "Zur Frage der sogenannten 'umgekehrten Perspektive,'" *Repertorium für Kunstwissenschaft* 33 (1910), p. 85ff.

31. Proclus, *Elements of Physics* 142a, cited by (among others) Eduard Zeller, *Die Philosophie der Griechen* (Leipzig: Reisland, 1920–1923), vol. 3, 2, p. 810.

32. On the representation of space in Byzantine art, which only very seldom extended beyond that nonperspectival mode which lays out buildings and landscape elements almost like moveable scenery against a neutral background, and then only in Italy, see among others Joh. Volkmann, "Die Bildarchitekturen, vornehmlich in der italienischen Kunst," PhD thesis, Berlin, 1900; see especially Wolfgang Kallab, "Die toscanische Landschaftsmalerei im XIV. und XV. Jahrhundert," *Jahrbuch der Kunstsammlungen des allerhöchsten Kaiserhauses* 21 (1900), p. 1ff., and Oskar Wulff, "Zur Stilbildung der Trecentomalerei," *Repertorium für Kunstwissenschaft* 27 (1904), passim, but especially pp. 105ff. and 234ff. But see as well our own remarks on pp. 50 and 55, above, as well as notes 38ff., below.

33. One often detects in Carolingian art in particular an effort to counter-act the flattening tendency through a real revival of antique perspectival motifs, indeed in certain cases even to the point of revoking its own achievements. The Fountain of Life image in the Godescalc Gospel of 781–783 (Boinet, *La Minia-ture carolingienne*, pl. IVb, whence our own Plate 25) derives, according to Strzygowski, from a Syrian model along the lines of the Echmiadzin Gospel (Plate 26), and even though it reintroduces the four rear columns of the foun-tain, it has in common with this latter the true Eastern horizontalism of the ground- and roof-lines (Strzygowski, *Byzantinische Denkmäler*, vol. 1 [1891], p. 58ff.). A generation later, in the gospel of Soissons (Boinet, *La Miniature carolingienne*, pl. XVIIIb, whence our own Plate 27), this fountain has become so "plastic" that it looks rather more like the antique Macellum (Plate 28) which this entire fountain type is modeled after. One sees how Carolingian painting, which initially sought its models among the strongly flattened representations of Syrian art, can now fall back upon the more plastic representations of the West. In our case we can even form a concrete idea of the character of the Western model: Mr. von Reybekiel, a doctoral candidate, has called our atten-tion to the fifth-century cupola mosaics in the church of St. George at Salonika, which agree with the miniature from the Soissons gospel in precisely those motifs which were not present in the Echmiadzin gospel (the niche architecture and especially the frieze of birds; see the illustration in Marguerite van Berchem and Étienne Clouzot, *Mosaïques chrétiennes du IV^{me} au X^{me} siècle* [Geneva, 1924], nos. 72 and 78, our own Figure 18). Further evidence for this "renaissance of perspective" are the buildings of the Utrecht Psalter, often brilliantly drawn (see, for example, Boinet, *La Miniature carolingienne*, pl. LXXVIIIb); and in par-ticular the interior space achieved with the vanishing-axis construction in the Alcuin Bible in London (*ibid.*, pl. CLIV, and our own Plate 29), which Kern already singled out as one of the exceedingly rare medieval examples of a perspectival ceiling ("Die Anfänge der zentralperspektivischen Konstruktion," p. 56f. and fig. 15; but see also our remarks on p. 55, above, and notes 38ff., below). The proper significance and context of these perspectives, however, are by no means always fully understood in the Carolingian renaissance: that is

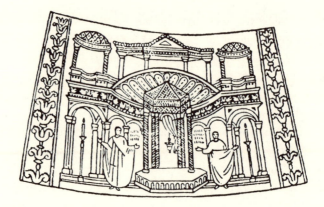

FIGURE 18. Cupola mosaic from the church of St. George, Salonika, beginning of the fifth century A.D.

evident even from the last-mentioned interior, whose side walls by rights ought to lead into depth in orthogonal foreshortening, whereas in fact they appear to be treated as frontal surfaces, filled with unforeshortened circles and curtains. In the same manuscript, moreover, is found an obliquely foreshortened building where the interference of two-dimensional thinking led to a most peculiar misunderstanding: the artist, no longer grasping the perspectival reasons for the apparent rising of the roof lines, figured that this rising ought to open up a view onto a corner of the interior ceiling, and consequently let this corner show forth under the (now really "rising") roof. Thus it is no wonder that this entire "renaissance" of perspective was quite ephemeral, and that already in the Fountain of Life of the Codex Aureus (Boinet, *La Miniature carolingienne*, pl. CXVII) "back" and "front" are again thoroughly confused (see our own Plate 30). In the subsequent period, then, the horizontalization of buildings formerly shown in oblique views is carried out with ever-greater resolve, to the point of banishing all foreshortening – which, however, in no way rules out that at the same time, indeed even in the same manuscript, one may encounter buildings still clearly in oblique view.

34. See Josef Strzygowski, *Iconographie der Taufe Christi* (Munich, 1885): for examples of Byzantine and Byzantinizing miniatures, pls. III/4 and IV/1–4 (especially instructive is Adolph Goldschmidt, *Das Evangeliar im Rathaus zu Goslar* [Berlin: Bard, 1910], pl. 4); for examples of Ottonian transitional cases, pls. IX/2–5. A beautiful example from Eastern art of the tenth century (fresco at Elmali-Klisse) is found in Gabriel Millet, *Recherches sur l'iconographie de l'évangile de Mistra, de la Macédoine et du Mont-Athos* (Paris: Fontemoing et c^ie, 1920), ill. 131. It is not uninteresting that ancient Egyptian art, when it wished to represent a bay or cove, arrived at a similar formation (Schäfer, *Von ägyptischer Kunst*, pls. 26/2 and 32, and p. 126). In that case, however, we are dealing with a combination of plan and elevation (the bay in plan, the main water surface in elevation); our example is a reversion from a true perspectival foreshortening. The combination of two nonperspectival flat images and the flattening of a perspectival spatial image led to results which looked very similar but which in meaning were fundamentally different.

A genuine analogy to the transformation of the foreshortened river into a "water mountain," on the other hand, is a phenomenon which to our knowledge has not yet been remarked upon: namely, that the landscape prospect extended through several picture fields, as seen most beautifully in the Esquiline Odyssey landscapes, survived into the Middle Ages, but only as an evidently purely ornamental band or strip. See for instance the frescoes at Pürgg in Styria (Richard Borrmann, *Aufnahmen mittelalterlicher Wand- und Deckenmalereien in Deutschland* [Berlin, 1897ff.], pls. 17 and 18), whose continuous ground strip surely ought to be considered an ornamental remnant of antique representations of terrain (our own Plate 31). And just as the "water mountain" of the Baptism is in the fifteenth century, with new means, converted back into the perspectivally foreshortened river, so will the motif of the continuous landscape prospect enjoy its own magnificent resurrection in the Ghent altarpiece.

35. On Vitellio, whose *Perspectiva* dates probably from around 1270, see the monograph of Clemens Baeumker, *Witelo*, Beiträge zur Geschichte der Philosophie des Mittelalters, vol. 3, no. 2 (Münster: Aschendorff, 1908). On the

further evolution of the epistemological problem of space, see the following note and p. 65f.

36. See again Duhem, *Études sur Léonard de Vinci*, p. 37ff. This is the point where further speculation can begin: for whereas Aristotle had to reject from the start the possibility of an *energeiai apeiron*, now just such an *energeiai apeiron* is recognized behind the empirical world in the shape of divine omnipotence; what then prevents us from from supposing that it could not also concretize itself in the empirical world, expanding that world, as it were, into an infinite universe?

37. The impression that the vision of space in northern Gothic painting lags behind the vision of space in contemporary sculpture is only an illusion: they stand quite on the same level, except that the means of expression of painting had to remain primarily line and the areas of color bounded by line. For there is a stronger binding power inherent in the conception of a real drawing surface than in the conception of the plane of a block which is destroyed in the process of creation and thus remains only as an ideal. Let it simply be noted that already Villard de Honnecourt, in diagrams of buildings, quite consistently indicates concavity by a downward bending or breaking of lines, and convexity, in contrast, by an upward bending or breaking of lines (see the official edition of the Bibliothèque Nationale, *Album de Villard de Honnecourt* [Paris: Berthaud, 1906]: representations of concavity, pls. XI and LX; convexity, pls. XII, XIX, LXI). Likewise, the apexes of windows, when they are concave, bend away from the central axis of the sheet, and in the opposite case approach it (especially instructive is the comparison of pls. LX and LXI, where the same chapel is represented in concave and convex form). On the other hand, we do find in Villard the apparently primitive mixture of plan and elevation (the sawmill in pl. XLIV is typical) – but always in conjunction with genuine foreshortenings.

38. See Wulff, "Zur Stilbildung der Trecentomalerei"; further, Kern, "Die Anfänge der zentralperspektivischen Konstruktion." It is significant that sculpture, which could *not* pick up the thread of the *maniera greca*, is familiar since Giovanni Pisano with vertical staggering, yet only arrives at "perspectival" relief on the strength of Brunelleschi's and Alberti's achievements.

39. The dating of the individual vault mosaics is not altogether simple; nevertheless, the image in question certainly dates from before 1300 (see Adolfo Venturi, *Storia dell'arte italiana*, vol. 5 [Milan: Hoepli, 1907], p. 218ff., and Raimond van Marle, *The Development of the Italian Schools of Painting*, vol. 1 [The Hague: Nijhoff, 1923], p. 267 ff.). There are other occasional instances of the vanishing-axis construction before Duccio and Giotto, in works of the *maniera greca*, for example in the remarkably confused ceiling on one of the fresco fragments at Fabriano, which likewise dates certainly not later than 1300 (indeed, according to a friendly communication from Dr. Curt H. Weigelt, probably from around 1270; cf. van Marle, *Development of the Italian Schools of Painting*, vol. 1, ill. 235; further, Lionello Venturi, "A Traverso le marche," *Arte* 18 [1915], p. 2). The perspectival string-course in St. Demetrius at Salonika, probably belonging to the seventh-century reconstruction, represents perhaps an intermediary stage; Georg Dehio and G. von Bezold, *Die kirchliche Baukunst des Abendlandes*, vol. 1 (Stuttgart, 1892), pl. 31, no. 9, and Charles Diehl, Marcel Le Tourneau and Henri Saladin, *Les Monuments chrétiens de Salonïque* (Paris: Leroux, 1918). Beyond this, it must be conceded openly that our knowledge of the development before Duccio and Giotto is still very incomplete; especially deserving of closer study, for example, are the lower facade mosaics of S. Maria Maggiore in Rome, which in their architectural representations surpass the level of Cavallini, even if they do not arrive at the representation of a "closed" interior space (that is, a space filling the entire picture surface).

40. In antiquity, significantly, floor patterns are commonly represented only on Etruscan mirrors; but then these floors are composed, as a rule, of diagonally placed squares or even more often of triangles (so far was antiquity from exploiting the floor as an orthogonal coordinate system). Moreover – and to this extent they closely resemble the example from Monreale – these floors did not extend completely under the feet of the figures, but rather terminated quite suddenly with a horizontal line. See, for example, Eduard Gerhard, *Etruskische Spiegel*, 5 vols. (Berlin, 1843–1897), vol. 5, nos. 27, 28, 32, 40, 57, 64, 67, 109, 139/1, etc. The specimen reproduced here as Figure 19 (Gerhard, vol. 5, no. 146) seems especially instructive; it is also distinguished by its unusually advanced

FIGURE 19.

rendering of the interior space (although even here, of course, the peculiarity of a fundamentally still pre-perspectival view of space is revealed in the walls, which end at the right and the left, indeed they are even partially overlapped by the figures who ought to be inside it). The completely misunderstood vestiges of such a tile floor occasionally survived in Western painting of the high Middle Ages; see, for example, the miniature reproduced in Emile Mâle, *L'Art religieux du XIIᵉ siècle en France* (Paris: Armand Colin, 1922), fig. 12 (likewise with triangular floor tiles). The well-known mosaic icon in the Bargello (twelfth century) represents in a sense the counterexample to the mosaic from Monreale: here the floor — this time a checkerboard pattern — does not terminate below the figures, and yet it is devoid of foreshortening; thus it has the effect of a tapestry stretched at half height. If at Monreale the normal three-dimensional relationship between figures and floor is translated into a two-dimensional superposition, here it is translated into a no less two-dimensional overlapping.

41. For more on Duccio's perspective, see Kallab, "Die toscanische Landschaftsmalerei," p. 35ff., as well as Curt H. Weigelt, *Duccio di Buoninsegna* (Leipzig: Hiersemann, 1911), p. 53ff., and Kern, "Perspektive und Bildarchitektur," p. 61.

42. The orthogonals of the lateral sections of the ceiling at first run entirely parallel with the brackets dividing the ceiling (thus in a pure vanishing-axis construction), only to swing inward at the edges, when they encounter the side walls, in a way already familiar to us from antiquity (see note 24, above). In addition, it is hardly accidental if Duccio, in the three analogous interiors of the Maestà (*The Washing of the Feet, The Sending Out of the Apostles, The Last Supper*), called special attention to the vanishing point of the central orthogonals with a small lozenge (hidden in the *Last Supper* by the nimbus of Christ).

43. Kern's view ("Die Anfänge der zentralperspektivischen Konstruktion," p. 56) that the vanishing-axis construction was reintroduced only in the Trecento, *after* Duccio, through a new and, as it were, spontaneous reengagement with antiquity, conflicts first of all with the fact that such a construction – contrary to the claim that it is "unattested in any examples from the middle of the ninth to the thirteenth century" – appears already in the Dugento (the list of examples in note 39, above, would surely increase with broader knowledge of the material), and can with some probability be traced back to a Byzantine tradition. Second, it conflicts with the circumstance that Duccio himself, in the three interiors mentioned in note 42, above, treated the lateral sections of the ceiling (as well as the vertical walls) entirely according to that "antique" principle. Only in a comparatively narrow ceiling (floors are never constructed in Duccio), undivided by any architectonic articulation, as in Kern's example of the *Annunciation* of the *Maestà*, where the partial plane and the entire plane, so to speak, coincide, is the vanishing-axis principle entirely excluded: not because it was still unknown to Duccio, but because in such special cases he could already completely overcome it.

44. *Ibid.*, fig. 6. It is interesting that the shadows in the ceiling coffers are no longer understood as such, but rather are used as a symmetrical pattern.

45. By the Lorenzetti themselves see, for example, the *Madonna with Angels and Saints* in the Pinacoteca in Siena (Plate 32); among Northern works see, for example, the well-known *Presentation in the Temple* of Melchior Broederlam.

46. To be exact, one may not with Kern ("Die Anfänge der zentralperspektivischen Konstruktion," p. 61) speak already of a conquest by the Lorenzetti

of an entire plane; for, considered purely perspectively, even here we are still dealing fundamentally with a mere partial plane which, if the lateral sections of the floor were not covered by the figures, would, in a sense, appear to be enclosed within two marginal planes still constructed according to the principle of the vanishing axis. The difference is that this partial plane is now oriented, with full consciousness and mathematical precision, toward a vanishing point instead of toward a larger vanishing region. The Lorenzetti also surpass Duccio in that their partial plane can occasionally exceed the bounds of the pictorial architecture: see Pietro's Sienese *Birth of the Virgin* of 1342, where the main space extended over two picture fields is perspectively unified by a unified orientation of the floor (while the anteroom represented in the third wing remains in an exceptional position). There is still no question of such a perspectival unification of several picture fields in Duccio; on the contrary, in those cases where two pictures represent two simultaneous events occurring in the same building (*Christ before Pilate* and the *Denial of Peter*), he resorted to the curious expedient of connecting the two parts by a staircase: he thus joined the spaces not perspectively but, as it were, architectonically and functionally.

47. This discrepancy is variously stressed by Kern, "Perspektive und Bildarchitektur," p. 58, reproducing a characteristic Cologne Annunciation, and Alfred Stange, *Deutsche Kunst um 1400* (Munich: Piper, 1923), p. 96. Nevertheless it is always interpreted as an "imprecision" or a "misunderstanding": it is not recognized that the unification of the partial plane, in Italy too, represents a necessary preliminary stage within the evolution toward the unification of the complete plane. This latter unification can only succeed after a homogeneous and unlimited extension becomes conceivable. What holds for the adjacent sections of a complete plane, also holds for the sections of a plane lying behind one another, that is, when the plane is divided crossways: again, each section has its own vanishing point (see, as one among many examples, a northern Italian miniature from between 1350 and 1378, reproduced by Georg Leidinger, *Meisterwerke der Buchmalerei aus Handschriften der Bayrischen Staatsbibliothek in München* [Munich: Schmidt, 1920], pl. 25a; or even Martin Schaffner's votive image in the Hamburger Kunsthalle). Particularly noteworthy, however,

is the following phenomenon: when a carpet runs over the steps of a throne down onto the floor (for instance in Lorenzetti's Sienese Madonna [Plate 32], or the Madonna in Altenburg, reproduced in *Kunstgeschichtliche Gesellschaft für photographische Reproduktion* 3, no. 8), the orthogonals of the carpet, even where the carpet lies on the floor, that is, where it in fact forms a single plane with it, aim not at the vanishing point of the floor but rather at a vanishing point valid only for the orthogonals of the carpet. The integrity of the material concept "carpet" is still stronger than that of the formal concept "complete plane" (see note 51, below).

48. Pomponius Gauricus, *De sculptura*, p. 192: "*Omne corpus quocunque statu constiterit, in aliquo quidem necesse est esse loco. Hoc quum ita sit, quod prius erat, prius quoque et heic nobis considerandum. Atqui locus prior sit necesse est quam corpus locatum. Locus igitur primo designabitur, id quod planum uocant*" ("Every body exists in some state and it is necessary for it to exist in some place. That which thus exists, which exists first, we must also consider to exist prior to this. And it is necessary for the place to exist prior to the object. Therefore the place must be in the first instance designated, and they call this a plane"). This priority of space to individual objects (manifested with exemplary clarity in Leonardo's celebrated study for the background of the Florentine *Adoration of the Magi*) is ever more sharply stressed in the course of the sixteenth century, up until the classical formulations of Telesio and Bruno (cited on p. 66, above; see further L. Olschki, "Giordano Bruno," *Deutsche Vierteljahresschrift für Literaturwissenschaft und Geistesgeschichte* 2 [1924], pp. 1–79, esp. p. 36ff.).

49. It should be pointed out that the spatial achievements of Duccio and his successors were known in the workshop of Jean Pucelle, for we encounter thoroughly Italian "space boxes" already in the Belleville Breviary (before 1343); see also the brief indications in Georg Vitzthum, *Die Pariser Miniaturmalerei* (Leipzig: Quelle und Meyer, 1907), p. 184. Indeed, the *Annunciation* of a Book of Hours preserved in the Rothschild Collection (Léopold Delisle, *Les Heures dites de Jean Pucelle* [Paris: Morgand, 1910], fol. 16) must derive directly from a model in the manner of Duccio's Sienese *Annunciation of the Death of the Virgin*. Since Pucelle's art is purely Parisian, it now becomes evident — especially

in regard to the completely nonspatial frescoes of the Tour de la Garderobe, which incidentally should be dated rather earlier than later — that we cannot overestimate the role played by Avignon in the reception of Italian art in the north. We are faced with a movement that is far too fundamental to be dependent on the sole fact of the papal exile; surely the development would not have been essentially different even if the popes had remained in Rome throughout the fourteenth century.

50. In Master Francke's *Martyrdom of St. Thomas*, the orthogonals at the left edge of the picture already converge somewhat with the central orthogonals, whereas those on the right swerve strongly aside. The principle of the "partial plane" is thus, as it were, halfway overcome. Otherwise the swerving of the outer orthogonals on both sides is so common that is hardly worthwhile to list examples (there are many in Camille Couderc, *Album de portraits d'après les collections du département des manuscrits* [Paris: Berthaud, 1910], pls. XX, LVI, LVIII, etc.). The vanishing-axis principle, too, survives well into the fifteenth century (see, for example, the Goldene Tafel of Lüneburg, reproduced in Carl Georg Heise, *Norddeutsche Malerei* [Leipzig: Wolff, 1913], ill. 47). Indeed, the famous dedication miniature extending over two pages of the Brussels Hours of the Duc de Berry (good reproduction of the entire double sheet in Eugène Bacha, *Les Très belles miniatures de la Bibliothèque royale de Belgique* [Brussels: Oest, 1913], pl. VI, whence our own Plate 33) displays on the page with the patron a vanishing-point perspective (inexact, of course) in the manner of the Lorenzetti or Broederlam, and on the page with the Madonna, by contrast, pure vanishing-axis perspective in the manner of Lorenzo di Bicci or Ugolino da Siena: the two methods worked out by Duccio's followers collide in one and the same work!

An interesting special case arises when an artist feels obliged by a particular model to let the side walls of the "space box" (and with them the lateral boundaries of the ground square) converge quite sharply, yet dares not turn the adjacent orthogonals as sharply: the result is often that the lateral boundaries run through the floor tiles as diagonals (see, for example, Couderc, *Album de portraits*, pls. LX and LXXV). These diagonals may initially have corresponded to an entirely logical and objective state of affairs; this in turn was rooted in a

most important process, a process especially significant for the derivation of the modern view of space out of high Gothic sculpture. For the diagonals may be explained by a more or less conscious adherence to polygonal space as it emerged when the baldachin of the Gothic statue was translated into two dimensions. Monumental sculpture survived until the early thirteenth century for the most part on the transferral of small-scale sculptural and, above all, pictorial models into monumental format (numerous examples for the latter process in Mâle, *L'Art religieux du XII^e siècle*, *passim*; for the former, see the adoption of a particular Christ type from a Carolingian ivory first into the *Noli me tangere* relief of the Hildesheim cathedral doors, then into the *Ascension* tympanum from Petershausen, now in the museum at Karlsruhe, even though the composition as a whole depends already on models from Burgundy and southwest France). But the development of Gothic sculpture brought about a radical reversal of this relationship, in the sense that from now on small-scale sculpture and even painting for the most part live off monumental sculpture. (For a masterly demonstration of this in an individual case – the representation of the crucifix – see Adolph Goldschmidt, "Das Naumburger Lettnerkreuz im Kaiser-Friedrichs-Museum in Berlin," *Jahrbuch der Königlich Preussischen Kunstsammlungen* 36 [1915], p. 137ff.; but see as well the drawings of Villard de Honnecourt, or a figure such as the St. Helen in the baptismal chapel of St. Gereon, reproduced in Paul Clemen, *Die romanische Monumentalmalerei in den Rheinlanden* [Düsseldorf: Schwann, 1916], pl. XXXVI, which derives unmistakably from a statuary type along the lines of the Magdeburg Madonna; see Goldschmidt, *Gotische Madonnenstatuen in Deutschland* [Augsburg: Filser, 1923], ill. 12.) And in the course of this great process (which shifted again in the fifteenth century), the polygonal baldachins and a little later the polygonal platforms of the plastic figures were also translated into flat forms (readily accessible examples in Georg Dehio, *Geschichte der deutschen Kunst* [Berlin & Leipzig: De Gruyter, 1921], vol. 2, ills. 404–405, still as simple flat projection; ill. 407 is already "perspectival"). Thus emerges a polygonal space which appears to push forward halfway out of the picture surface, and whose oblique rear walls must, of course, intersect the floor diagonally. For further developments of this "baldachin space"

on a vaster scale, indeed even on a monumental architectonic scale, see Adolfo Venturi, *Storia dell'arte italiana*, vol. 5, fig. 558 or 602, or even Broederlam's well-known *Presentation in the Temple* in the museum at Dijon.

Alongside these more or less progressive floor perspectives, one still encounters for a long time, and chiefly in the North, the completely primitive representation of the ground plane in simple geometrical outline, without any foreshortening at all.

51. On the perspective of the Eycks, see especially the works of Kern cited in note 20, above, as well as Doehlemann, "Die Entwicklung der Perspektive in der Altniederländischen Kunst," *Repertorium für Kunstwissenschaft* 34 (1911), pp. 392ff. and 500ff., and "Nochmals die Perspektive bei den Brüdern van Eyck," *Repertorium für Kunstwissenschaft* 35 (1912), p. 262ff. Given that the true unification of the entire horizontal plane is first achieved at this stylistic level and not already in the Trecento, it is appropriate that the principle of the unified vanishing point is now – and only now – carried over to the vertical plane, which until now was always managed entirely with parallel perspective or, in symmetrical views, with a more or less freely handled vanishing-axis construction. It is equally appropriate that the orthogonals of a carpet extending over several steps now – and only now – follow the orthogonals of the respective planes which the carpet belongs to, that is, of the steps or the floor as the case may be (see note 47, above). All of these are stages on the route toward the priority of infinite space over finite things, which, however, is only perfectly realized when the orthogonals of *all* planes vanish to a single point.

52. Perhaps it only now becomes probable that the Berlin *Virgin in the Church* (Plate 15) is indeed the work of Jan van Eyck alone, even when – or rather precisely when – one claims the much-disputed miniatures in the Turin-Milan Hours for Hubert van Eyck. Moreover, it can hardly date from before 1433–1434. The reason for the early dating of the *Virgin in the Church* and its attribution to Hubert (supposing he really was the author of the early miniatures) is above all its affinity with the *Office of the Dead* in the Turin-Milan Hours (Plate 14). No matter that in both cases a Gothic church is represented from a similar aspect, that is, with a central vanishing point strongly shifted to the side:

against this mere analogy of objects, the stylistic differences – particularly in regard to the perspectival view of space – only stand out in stronger relief. The Turin miniature does not yet dare to cut the space with the edge of the picture such that its objective beginning appears to lie on our side of the picture plane; rather, in a most significant compromise with the older mode of representation (which presents the architecture as a plastically self-contained exterior body even though the interior space is visible), it introduces the curious fiction that the building is unfinished, and that its already constructed parts are all to be found on the other side of the picture plane. Thus the entire building fits into the picture space (the vaulting of the first bay is interrupted ostensibly by accident). In the *Virgin in the Church*, by contrast, we no longer see an objectively interrupted space, but rather a subjective "slice" of space (and the old copies in the Palazzo Doria and the Antwerp museum show that this effect is not the result of, say, a later reduction of the Berlin picture). We see a space that reaches across the picture plane and is, in a sense, intersected by it; the space seems to include the beholder within it. The space grows in our imagination precisely because the picture shows us only a portion of it. This aligns the *Virgin in the Church*, as far as perspective is concerned, with the Arnolfini portrait of 1434 (Plate 17). For in its conception of space the Arnolfini portrait bears exactly the same relationship to the *Birth of John the Baptist* in the Turin-Milan Hours (Plate 16) that the *Virgin in the Church* bears to the *Office of the Dead*. Here it is the bourgeois domestic space, not the church space, which is represented such that the picture plane appears not to limit it but to intersect it (note in particular the severed orthogonal beams of the ceiling!). Less of this space is shown than is actually there. Now everything else falls into place: not only is the Child of the *Virgin in the Church* fraternally related to the Child of the *Lucca Madonna*, but also the Virgin is a sister to the St. Catherine of the Dresden altarpiece and in particular, even to the drapery folds, of Jeanne de Chenany in the Arnolfini portrait. The problem faced by the mature Jan van Eyck was how to couple the illusion of an open space filled with light and shadow with a sculptural consolidation and plastic rounding of individual bodies (later, a slight stiffness and flattening would appear, as can be observed especially in the Antwerp *Virgin at*

127

the Fountain with its angular drapery style, its Child twisted almostly violently into the surface, and its almost archaic renunciation of the open view onto a landscape). In the *Virgin in the Church* we see this problem posed and solved in exactly the same sense as in the Arnolfini portrait and in the *Lucca Madonna*. In the Turin-Milan miniatures the figures are small and slender, almost incorporeal, and entirely subordinated to space. In the works of the middle thirties, by contrast, a perfect equilibrium between space and figures is established; the forms are large, massive, surrounded by heavy drapery, reminiscent almost of the classic monumental sculpture of the thirteenth century. This very *Virgin in the Church*, for all her painterly refinement perceived as especially plastic, grows upward so violently that the artist, in order to avert inconvenient overlappings, had to make space by raising the triforium of the choir. It is also no accident that the architectural style of the church interior of the Turin *Office of the Dead* differs from that of the Berlin picture in a curious and in what at first seems an almost paradoxical way. In the earlier work we find the fine-spun and capital-less pillars of the late Gothic, in a sense entirely dissolved into narrow strips of light and shade, as befits the overall antiplastic and antistructural character; in the later work we find the plastically developed and powerfully differentiated compound piers of the classic Gothic of Amiens and Reims, which express their static function with their capitals. Thus one may choose whether to see, in the *Virgin in the Church*, the overcoming of Hubert van Eyck's artistic vision by Jan, or rather — and following Friedländer, we should still like to consider this the more probable — the overcoming of the young Jan by the more mature Jan. In both cases, however, one must in our opinion attribute the work to the younger brother and date it roughly to the time of the Arnolfini portrait.

It is significant, incidentally, that the oldest of the many works that imitated the space of the *Virgin in the Church* seem to shrink from its brilliant audacity and indeed modify it back toward the very view of space which had been most decisively overcome. Both the silverpoint sheet in Wolfenbüttel (published by Hildegard Zimmermann as an Eyckian drawing, "Eine Silberstiftzeichnung Jan van Eycks aus dem Besitze Philipp Hainhofers," *Jahrbuch der Königlich Preussischen Kunstsammlungen* 36 [1915], p. 215) and the church interior by the

Hamburg Master of Heiligenthal (reproduced in Heise, *Norddeutsche Malerei*, ill. 90, our own Plate 34) yield to the need to objectively close the pictorial architecture in front — Rogier's Chevrot triptych and Cambrai altar do the same, although with more refined means — and to "complete" the pure interior view of the space with a fragment of exterior architecture. Indeed, the Master of Heiligenthal appended to the Eyckian interior an entire anteroom, with a floor possessed of its own vanishing point.

53. On this question, see the exchange between Kern and Doehlemann in *Repertorium für Kunstwissenschaft* 34 (1911) and 35 (1912). Kern seems to be right that Petrus Christus's Frankfurt *Madonna* of 1457 is already constructed with a single vanishing point for the entire space. Yet it is at the very least risky then to trace this final perfecting of northern perspective back to Jan van Eyck simply because it ought to be entrusted to the great pioneers rather than to the comparatively insignificant epigones. For, to cite Lessing once again, "perspective is not a matter for genius." One can very well believe that the rather sober mind of Petrus Christus tried to secure, by means of a thorough consolidation of linear perspective, that which Jan van Eyck managed to achieve even without a fully rationalized linear framework, by means of a "somnambulistic certainty in striking every nuance of color" (Friedländer). In the field of portraits, too, Petrus Christus took a step beyond his great predecessor: whereas Jan van Eyck was satisfied in all his half-length portraits with a simple dark background — although, again by virtue of that "somnambulistic certainty," it never has the effect of a dead monochrome surface — Petrus Christus creates the "cornerspace" portrait (see the portrait of Sir Edward Grymestone from the collection of the Earl of Verulam, on loan to the National Gallery, London), which strains the Eyckian principle of the "slice" of space by trying to create a spatial sphere for the figure with rational means. Let it be noted parenthetically that for this reason we should like to regard the Frankfurt silverpoint of a man with a falcon as a work by (or after?) Petrus Christus; although now often attributed to Jan, the sheet corresponds in its design almost word for word to the Grymestone portrait (see Max J. Friedländer, *Die altniederländische Malerei* [Berlin: Cassirer, 1924–1937], vol. 1, pl. XLVIII, p. 124).

On perspective in Bouts (who, like all Northerners in the fifteenth century, used in practice the method described in note 60 below), see Kern, "Zur Frage der Perspektive in den Werken des Dirk und Aelbrecht Bouts," *Monatshefte für Kunstwissenschaft* 3 (1910), p. 289.

54. Only the Sibyl wing of the Bladelin altar appears to possess a unified spatial vanishing point: it would lie in the lap of the Virgin and would thus coincide exactly with the thematic center of gravity of the composition. This would correspond entirely to Rogier's dramatic, centripetal and not at all relaxed artistic character.

55. On perspective in fifteenth-century German painting, and especially in Dürer, see Schuritz, *Die Perspektive in der Kunst Dürers*. On Dürer as a theoretician of perspective, see also Panofsky, *Dürers Kunsttheorie*, p. 14ff. The various mechanical expedients designed to replace the lengthy geometrical construction, and over which Dürer especially troubled himself, are treated comprehensively in a small work by Daniel Hartnaccius, *Perspectiva mechanica* (Lüneburg, 1683).

56. One still reads in Cennino Cennini's handbook (*Das Buch von der Kunst, oder Tractat der Malerei*, Quellenschriften für Kunstgeschichte und Kunsttechnik des Mittelalters und der Renaissance, no. 1, ed. Albert Ilg [Vienna, 1871], chs. 85 and 87) that the distant parts of the landscape are to be represented darker than the nearer parts (a view which Leonardo, *Das Buch von der Malerei*, art. 234, had to combat expressly), and that in buildings the lines of the roof moldings are to fall, those of the base moldings are to rise, and those of the moldings in the middle of the building are to run "evenly," that is, horizontally.

57. See, among others, Schuritz, *Die Perspektive in der Kunst Dürers*, p. 66f.

58. See Kern, "Das Dreifaltigkeitsfresko von S. Maria Novella," *Jahrbuch der Königlich Preussischen Kunstsammlungen* 34 (1913), p. 36ff., as well as Jacques Mesnil, "Masaccio et la théorie de la perspective," *Revue de l'art* 35 (1914), pp. 145–56.

59. Alberti, *Kleinere kunsttheoretische Schriften*, p. 81.

60. There is surely now a consensus on Alberti's perspectival procedure, which frequently used to be identified with the well-known "distance-point

construction." See Panofsky, "Das perspektivische Verfahren Leone Battista Albertis," *Kunstchronik* N.F. 26 (1915), cols. 505–16; Kern, " '*Costruzione legittima*' oder 'Distanzkonstruktion' bei Alberti?" in *ibid.*, cols. 515–16; and the recent synthesis by H. Wieleitner, "Zur Erfindung der verschiedenen Distanzkonstruktionen in der malerischen Perspektive," *Repertorium für Kunstwissenschaft* 42 (1920), p. 249ff.

In the North, before the exact perspectival method emerging directly out of the idea of the intersected visual pyramid became generally known, the accurate measurement of the depth intervals (that is, insofar as accuracy was valued at all) was achieved with diagonals laid down through the "ground square." In Italy these diagonals were used, for example by Alberti, only as a means of verifying the accuracy of a construction arrived at by another route. It was also possible, however, to use them as a direct means of construction, in that their points of intersection with the orthogonals readily provide the desired transversals. The persistence of this workshop practice in the North is revealed in the *Perspectiva* of Hieronymus Rodler, published in 1546 (in Frankfurt) and yet entirely unaffected by modern exact theory. Here the purely mechanical procedure is recorded explicitly: one should first extend the orthogonals to a vanishing point; then, in order to determine the depth intervals, "select a half-diagonal stroke, and carry that diagonal higher or lower, according to whether you will have the floor tiles broad or narrow. For the shorter the distance you travel upward with that half or whole diagonal, the broader the tiles, and the more disproportioned they become when the diagonal stroke or line reduces the tiles; for properly, the deeper they stand in the room, and the more distant they are, the more they should reduce or diminish" (col. A.4vff., and our own Figure 20). Perhaps the availability of such a method explains the curious circumstance that the so-called distance-point method (Figure 21), first taught in Italy only by Vignola-Danti in 1583 (Serlio passes on a superficially similar but in fact false procedure, and a perspectival drawing by Vincenzo Scamozzi in the Uffizi, cart. 94, no. 8963, is still done according to Alberti's method), is in the North attested already by Jean Pélerin–Viator and some of his followers (Jean Cousin and Vredeman de Vries). For the workshop practice handed down by

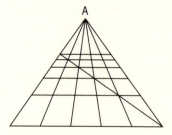

FIGURE 20. Perspectival construction of the checkerboard-type "ground square," according to Hieronymus Rodler (the forerunner of the "distance-point method"): the diagonal serves not as a mere control, but actually provides the depth intervals; yet its position is arbitrarily determined.

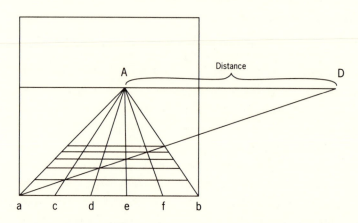

FIGURE 21. Perspectival construction of the checkerboard-type "ground square," according to the "distance-point method": the depth intervals are provided by the diagonal, whose endpoint D is established on the horizon at the given "distance" (i.e., the distance of the eye from the picture plane) from the vanishing point A.

the theoretically quite innocent Hieronymus Rodler (he is not even afraid to recommend, in order to broaden the background, a construction with two central vanishing points!) may actually be described as a distance-point method without a distance point. It agrees with it insofar as the diagonals directly indicate the depth intervals of the transversals, and one can well imagine that it would be easier to arrive at the true distance-point procedure from this position than it was in Italy itself. The eye alone taught, as Rodler expressly put it, that the foreshortening proceeds more rapidly the higher one "travels up" with the diagonal, and from here it was only a step to the recognition that the distance separating the intersection of this diagonal with the horizon from the vanishing point stands in a definite lawful relationship to the distance of the eye from the picture plane (for even Pélerin–Viator does not expressly state that this distance is exactly equal to the perpendicular distance of the eye; on the contrary, he says only [fol. A.5r] that the "*tertia puncta*" or "*tiers points*," that is, the "distance point," is farther from or closer to the vanishing point "*secundum sedem fingentis et praesentem aut distantem visum*" ["according to the location of the person indicating and the presence or distance of the object seen"]). Thus the correct and thoroughly worked out distance-point procedure of Vignola-Danti, like Alberti's *costruzione legittima*, is probably the theoretically purified and systematized form of older workshop customs; only that in Vignola-Danti's case we are dealing with a usage from the Northern drawing practice, and in Alberti's case with a legacy of the Italian Trecento tradition.

It is at best doubtful whether the distance-point procedure was known in Italy *before* Vignola-Danti. Wieleitner, too, concedes that Piero della Francesca did not know it (in a response to Panofsky in *Repertorium für Kunstwissenschaft* 45 [1925], p. 86). As far as Leonardo is concerned, the drawing reproduced by Schuritz, *Die Perspektive in der Kunst Dürers*, fig. 15 (Ravaisson-Mollien, *Les Manuscrits de Léonard de Vinci*, ms. A., fol. 40r) surely proves only awareness of the fact that the diagonals of the upper and lower surfaces of a cube converge to a single point; and the drawing reproduced by the same author as fig. 16 (*ibid.*, ms. M, fol. 3v, our own Figure 22) may have nothing to do with perspective at all: for the most crucial line of all is missing, namely, the rear side of the ground

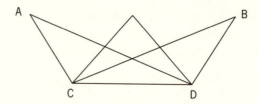

FIGURE 22. Leonardo, perspectival sketch (redrawn).

square, whereas conversely the lines *AC* and *BD* would be perspectivally entirely superfluous. It is possible that the drawing illustrates only the proposition that triangles with equal bases and equal height are equal in area.

In this context we may briefly consider the perspectival procedure of Pomponius Gauricus. His account has been considered unintelligible since the reading proposed by Brockhaus (in his edition of *De sculptura*, p. 51) was with good reason rejected by Paul Kristeller (*Andrea Mantegna* [Berlin: Cosmos, 1902], p. 104ff.) and yet never replaced (see also Schuritz, *Die Perspektive in der Kunst Dürers*, p. 14). But if one renders the text quite literally, and recognizes that, with its incessant interventions of "*hic*" and "*sic*," the text is intended only as accompaniment to a direct graphic demonstration and so appears somewhat erratic and incomplete, it ought to be possible to come up with a satisfactory reading. The text is as follows, with literal translation (*De sculptura*, p. 194f.):

Ad perpendiculum mediam line-am demittito, Heinc inde semi-circulos circunducito, Per eorum intersectiones lineam ipsam ae-quoream trahito, Nequis uero fiat in collocandis deinde personis er-ror, fieri oportere demonstrant hoc modo, Esto iam in hac quadrata, nam eiusmodi potissimum uti-	Drop a vertical in the middle [i.e., of the sheet of paper!]; then from here draw semicircles. Through their points of intersection draw a horizontal. Now in order not to err in the distribution of the figures, one should proceed as follows, as was taught to us: on this quadran-gular panel, for this is indeed the sort we most commonly use, this line [i.e., the horizontal] should already be present. But how far should

mur, tabula hec inquiunt linea,
At quantum ab hac, plani defi-
nitrix distare debebit? Aut ubi
corpora collocabimus? Qui pros-
picit, nisi iam in pedes despexerit,
prospiciet a pedibus, unica sui ad
minimum dimensione, Ducatur
itaque quot volueris pedum linea
hec, Mox deinde heic longius at-
tollatur alia in humanam statu-
ram Sic, Ex huius autem ipsius
uertice ducatur ad extremum ae-
quoreae linea Sic, itidem ad om-
nium harum porcionum angulos
Sic, ubi igitur a media aequorea
perpendicularis hec, cum ea que
ab uertice ad extremum ducta
fuerat, se coniunxerit, plani fini-
tricis Lineae terminus heic esto,
quod si ab equorea ad hanc fini-
tricem, ab laterali ad lateralem,
absque ipsarum angulis ad angu-
los, plurimas hoc modo perduxeris
lineas, descriptum etiam collo-
candis personis locum habebis,
nam et cohaerare et distare uti
oportuerit his ipsis debebunt
intervallis.

the boundary of the ground plane [i.e., the rear side of the foreshortened ground square, the establishment of which is always the first task of a perspectival construction method, and not for example the horizon!] be removed from it? And where will we place the bodies? Whoever looks in front of him, unless he is looking directly at his own feet, will see at least as far forward as the length of his own body. Thus this line must be prolonged forward as many feet as you wish. Then a second line of the height of a man may be erected at some distance [not of some length!], thus. From its apex a line will be drawn to the beginning of the horizontal, thus; likewise to the terminus of all these partial lengths, thus. Now the point where this central vertical intersects that line which was drawn from the apex [i.e., of the line of the height of a man] to the beginning of the horizontal should be the location of the boundary of the ground square. And now if you have drawn several lines from the horizontal to this boundary, from one side to the other, as I do now, and have connected the intersections, then you will have defined the place for the distribution of the figures; for they will be appropriately related to and removed from one another at these very distances.

From this no doubt diffuse and, as said before, somewhat incomplete account, this much at least can be inferred with certainty: the location of the rear side of the ground square is transferred to a vertical line when one draws a visual

135

ray from the apex of a second vertical, of the height of a man, to the beginning
of the horizontal line, with the base of this second vertical shifted sideward to
a distance corresponding to the perpendicular distance of the eye. To this extent
Gauricus's instructions aim at nothing other than a side elevation of the visual
pyramid, just as it is constructed in Alberti's auxiliary drawing (Figure 8, upper
right). They also agree with Alberti's method in that the horizontal is to be
divided into equal sections whose endpoints are likewise to be linked to the
apex of the vertical with the height of a man. Thus it may be assumed, without
further ado, that just as the rear side of the ground square is to be determined
by the intersection of the uppermost visual ray with the "central vertical," so
are the remaining transversals to be determined by the points of intersection
of the other visual rays with this same vertical. The lines that are drawn "from
the horizontal to the (rear) boundary of the ground square" are manifestly the
orthogonals (except it is not expressly stated that they must converge in a cen-
tral vanishing point at the same height as the apex of the vertical; but then that
is one of those matters, of course, which the text, supplemented by direct dem-
onstration, can omit). Finally, the lines drawn "*absque ipsarum angulis ad
angulos*" ("connecting the intersections") are without any doubt those diago-
nals of the ground square that conclude and validate the entire construction.
In sum, then, the procedure of Pomponius Gauricus is from beginning to end
identical with that of Alberti, or, more obviously, with that method – taught
by Dürer, Piero della Francesca and Leonardo – which Dürer described as the
"shorter way," and which differs from Alberti's procedure only in that the entire
construction is carried out on a single sheet, without a separate auxiliary draw-
ing (this sheet must of course be larger than the picture field itself). Thus the
instructions of Gauricus begin quite consistently with a halving of this large
drawing sheet by a central vertical, so that the construction of the side eleva-
tion can unfold off to the side. Alberti, who assumes rather the viewpoint of
the practicing painter, must banish this side elevation to a separate drawing,
since there is no room for it on the painter's panel (on this, see Panofsky, "Das
perspektivische Verfahren Albertis," col. 513). In modern terminology, then,
Gauricus's method would be described as follows (Figure 23): I divide the entire

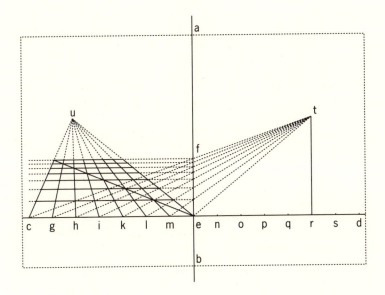

FIGURE 23. Perspectival construction of the checkerboard-type "ground square," according to Pomponius Gauricus. The procedure is essentially identical with that of Alberti (see Figure 8, above).

drawing surface by a central vertical line *AB* and establish on it, at point *E*, the horizontal *CD*. I divide this into equal sections with the points *G, H, I, K, L, M, N, O, P, Q, R* and *S*, and raise at point *R* the perpendicular *RT*. I connect *T* with *C, G, H, I, K, L, M* and *E*. The intersection of *TC* with *AB* gives me the location *F* of the rear boundary of the ground square; the intersections of *TG, TH* and so on with *AB* give me the locations of the transversals. Now I create the point *U*, whose distance from *CD* should equal *RT*, but whose lateral position may be chosen freely, and connect it with *C, G, H, I, K, L, M* and *E*. This connecting line gives me the orthogonals of the ground square, within which I can now draw the diagonal lines by connecting those points where the orthogonals meet the already-established transversals (whereby, as in Alberti, the correctness of the construction is confirmed, for in an incorrectly foreshortened square the corner points of the various subsquares cannot be joined by a straight line).

This interpretation of the passage from Gauricus may be considered fairly secure precisely because, without in the least forcing the text, it amounts to the very method long since familiar to all Italian perspectival theory, the method which Gauricus not only could have known, but which he in fact must have known. This, of course, renders Brockhaus's hypothesis of a separate "Paduan school" of perspective untenable.

Supplement to note 60: Just as Hieronymus Rodler, in order to encompass more "material," suggests putting two central vanishing points in the picture, so Lucas van Leyden, in order to permit a greater development into depth in his *Chess Players* in Berlin, did not hesitate to give the chessboard twelve transverse rows of squares to match its eight orthogonal ranks, and thus to transform it into an oblong turned back into the picture. Naturally, he could have achieved the same effect as well by a rapid foreshortening of a normal chessboard, but – and this is the essential point for us – he was apparently less shy of a material inaccuracy (until now unmentioned, in fact) than of a formal inflexibility.

61. Alberti's method, far less complicated than the plan and elevation procedure, has the sole disadvantage that it breaks down (like the distance-point construction, of course) with structures that cannot be derived (by division, multiplication, inscription or circumscription, or elevation) from the square. Yet this disadvantage is of practically no consequence, since in any case (all the efforts of Piero and Dürer notwithstanding) the exact perspectival construction of completely irregular structures, above all the human or animal body, hardly ever entered into day-to-day practice.

62. See Alberti, *Kleinere kunsttheoretische Schriften*, p. 81: "*quali segnate linee* [i. e., the orthogonals] *a me dimostrino in che modo, quasi persino in infinito, ciascuna traversa quantita segua alterandosi*" (*On Painting*, trans. Spencer, p. 56: "These drawn lines, [extended] as if to infinity, demonstrate to me how each transverse quantity is altered visually").

63. Pomponius Gauricus, *De sculptura*, p. 200: "*Constat enim tota hec in uniuersum perspectiua, dispositione, ut intelligamus quacunque ratione spectetur, quantum ab alio aliud distare aut cohaerere debeat, quot necessariae sint ad illam rem significandam personae, ne aut numero confundatur, aut raritate deficiat*

intellectio" ("It is agreed that we understand that by some principle all things are seen in general in perspective and in placement, namely how far things ought to stand from one another, or how closely they ought to cohere, or how many items are necessary for the subject matter, in order that its intelligibility is neither confused by overcrowding or impaired by sparseness").

64. See Duhem, *Études sur Léonard de Vinci*, p. 45. The transition from the basic cosmological vision of the Middle Ages to that of modernity (and this was generously pointed out to us by Professor Cassirer) is especially clearly seen in Nicolaus Cusanus, for whom the world was not yet truly "infinite" (*infinitus*), but nevertheless "unlimited" (*indefinitus*), and who relativized its spatial center (its spiritual center lay, as before, in God) when he explained that any random point in space "may be considered" the center of the universe – just as perspectival construction can determine entirely freely the "vanishing point" in which the respective represented world appears to be "centered."

64a. [Panofsky's original numbering of the notes, both here and at n. 70a, has been preserved in order to keep the English and German texts uniform. –TR] Olschki, "Giordano Bruno"; also Jonas Cohn, *Geschichte des Unendlichkeitsproblem in abendländischen Denken bis Kant* (Leipzig, 1896). It is especially interesting how Bruno, in order to establish his own concept of an infinite space against the Aristotelian and high Scholastic view, seizes consciously upon the pre-Socratic fragments, especially the teachings of Democritus. In a certain sense – and this is actually typical for the Renaissance – one antiquity is played off against another, and the result is in all cases a new, third antiquity: the specifically "modern." A most striking contrast to Bruno's beautifully formulated definition of space as a "*quantitas continua, physica triplici dimensione constans*" ("a continuous mass existing in a three-fold physical dimension") is the medieval representation (in the Baptistry of Parma) of the personifications of *four* dimensions, parallel to the four Evangelists, the four rivers of Paradise, the four elements and so forth.

65. Vasari, *Le Vite de' più eccellenti pittori, scultori ed architettori*, 7 vols., ed. Gaetano Milanesi (Florence: Sansoni, 1878–1885), vol. 2, p. 207: "*Oh, che dolce cosa è questa prospettiva!*"

66. Lange and Fuhse, *Dürers schriftlicher Nachlass*, p. 319, l.14, and Piero della Francesca, *De prospectiva pingendi*, p. 1. On the concurrence between the two, see Panofsky, *Dürers Kunsttheorie*, p. 43, and (apparently independently) Schuritz, *Die Perspektive in der Kunst Dürers*, p. 30.

67. Already in the fifteenth century, as we know, this alternative led to two completely different systems of ceiling painting: on the one hand, to the "illusionism" of Mantegna and Melozzo, developed further especially by Correggio, which to a certain degree denies the existing ceiling architecture by a perspectival illusion of elevating or even breaking through the ceiling; and on the other hand, to the objectivism of all other artists, who, in a Renaissance continuation of the medieval principle of a simple division of surface, affirm the existing ceiling architecture by making its functionality visible. (The ceilings of Raphael, especially that of the Capella Chigi, represent a synthesis of these two possibilities, whereas Michelangelo followed an entirely individual path, not illusionistically broadening the space but illusionistically narrowing it by placing relief layers in front of it.) In the seventeenth century we still see Bernini, who in the question of theory assumed an almost academic standpoint, with solemn passion take up a position against the subjective, illusionistic system (see Panofsky, "Die Scala Regia im Vatikan und die Kunstanschauungen Berninis," *Jahrbuch der Preussischen Kunstsammlungen* 40 [1919], p. 264ff.).

Even in the realm of true wall painting, the question of whether the picture ought to take into account the actual standpoint of the beholder, and so in a sense extend the room whose walls it adorns, has a certain importance (on this, see Karl Birch-Hirschfeld, *Die Lehre von der Malerei im Cinquecento* [Leipzig, 1912], p. 68ff., where the arguments of Lomazzo in particular are discussed; further, see the following note). The celebrated example is Leonardo's *Last Supper*; but already the *Last Supper* of Castagno in the refectory of St. Apollonia is constructed such that for a beholder standing exactly in the middle of the room (the perpendicular distance comes to about fifteen meters, with an overall room length of about thirty meters) the architecture of the room appears to continue perspectivally.

The question whether and to what extent the point actually perpendicular

to the eye of the beholder ought to coincide with the perspectival center of the painting is investigated from the standpoint of modern psychology by von Öttingen, "Das Beurteilen perspektivischer Abbildungen in Hinsicht auf den Standpunkt des Beschauers," *Annalen für Naturphilosophie* 5 (1906), pp. 394–478.

68. Leonardo, *Das Buch von der Malerei*, art. 416, for example, recommends assuming a central vanishing point at the height of the eye of a man of medium height, but leaves the lateral position unspecified. Vignola-Danti, *Le Dve regole di prospettiva*, p. 86, requires for ceiling painting, as a rule, a centrally placed vanishing point, unless special circumstances justify an exception, for example when the flow of traffic in passageways runs sideways. More recently on the problem of "eccentric" or "centric" positioning of the vanishing point, see Ernst Sauerbeck, "Ästhetische Perspektive," *Zeitschrift für Ästhetik und allgemeine Kunstwissenschaft* 6 (1911), pp. 420–55, 546–89, and the thematically less limited but methodologically more objectionable – indeed often grossly mistaken – book by Theodor Wedepohl, *Ästhetik der Perspektive* (Berlin: Wasmuth, 1919).

The most remarkable and interesting example of the seriousness with which the position of the vanishing point in the picture field and its relationship to the standpoint of the beholder were discussed in the Renaissance, is the pamphlet of Martino Bassi, *Dispareri in materia d'architettura et perspettiva con pareri di eccellenti et famosi architetti, che li risoluono* (Brescia, 1572) – excerpts are reprinted in Giovanni Bottari and Stefano Ticozzi, *Raccolta di lettere sulla pittura, scultura ed architettura*, vol. 1 (Milan, 1822), p. 483ff; cf. Julius von Schlosser, *Die Kunstliteratur* (Vienna: Anton Schroll, 1924), pp. 368 and 376. The case which occasioned this pamphlet was as follows: there was in the cathedral of Milan a relief of the Annunciation, set at the height of seventeen *braccia* [one *braccio* equals approximately fifty-nine centimeters –TR] above the ground in a perspectivally represented square room with sides of eight *braccia*. The creator of this work had assumed a distance of nineteen *braccia* and ("*per dare più veduta a certi suoi partimenti fatti in uno di essi lati*") had given the vanishing point an asymmetrical position (Plate 35). Now, Pellegrino Tibaldi – reasoning that the vanishing point ought to lie at the eye level of the annunciating angel – introduced a second vanishing point into this relief, in the center of the picture field

and fifteen *pollici* [that is, approximately thirty-three centimeters −TR] higher than the first vanishing point; and on top of this he calculated the lines that converged toward that new vanishing point at a perpendicular distance of only four *braccia* (Plate 36). This provoked a violent uproar among the Milanese experts, with this very Martino Bassi proclaiming himself their spokesman, followed by fruitless negotiations with the unrepentant offender, and finally a questionnaire put to Palladio, Vignola, Vasari and Giovanni Bertani, the Mantuan architect and Vitruvius commentator. Bassi presented the matter to these authorities and at the same time proposed two emendations to which they were to respond: the vanishing point must at any rate be reunified, he argued; indeed, the original situation might even be improved, either if the vanishing point is assumed at the old height but on the new axis (Plate 37), or if the entire pictorial architecture is reconstructed from the real standpoint of the beholder, that is, as a *prospettiva di sotto in sù* with a vanishing point lying seventeen *braccia* below the lower edge of the picture (Plate 38). That the present situation with two vanishing points was intolerable, was of course freely and immediately admitted by all parties. But as for the corrective measures to be adopted, it turned out that precisely in these perspectival questions the positions of contemporary artists could differ considerably, according to their particular conceptions of art.

Palladio, thinking purely architectonically, objects already to the original condition with its unified but eccentric vanishing point: he asserts in purely dogmatic fashion that "according to all perspectival rules the central vanishing point must lie in the middle," so that the representation possesses "*maestà e grandezza.*" Thus he would surely have approved Bassi's first proposal (which in and of itself was certainly the most sympathetic to him), but that another consideration, less a matter of aesthetic than logical doctrine (namely, that it would conflict with reason and the nature of things to look upward at the floor of the represented room from such a deep standpoint), leads him to prefer the second proposal (that is, pure *prospettiva di sotto in sù*). "*E per rispondervi con quell' ordine che voi mi scrivete, dico che non è dubbio alcuno, che la prima opinione, circa il pezzo di marmo del quale si tratta, non sia difettiva, ponendo l'orizzonte in uno dei lati del marmo, il quale orizzonte per ogni regola di perspettiva dev' essere posto*

*nel mezzo. Conciossiachè per dare maggior grandezza e maggior maestà a quelle cose
che agli occhi nostri si rappresentano, devono rappresentarsi in modo che dagli estremi
al punto dell' orizzonte siano le linee eguali. Non può anche esser dubbio appresso di
me che la seconda opinione, la quale vuole che si facciano due orizzonti, non sia da
essere lasciata, si per le ragioni dottissimamente dette da voi, si anche perchè, come
ho detto, il proprio di tali opere è il porre l'orizzonte nel mezzo; e così si vede essere
osservato da tutti i più eccellenti uomini, dall' autorità de' quali non mi partirei mai
nelle mie opere, se una viva ragione non mi mostrasse che il partirsene fosse meglio.
Per le cose fin qui dette potete già comprendere che la terza opinione, la qual pone
un solo orizzonte, mi sodisferebbe più delle due passate, se in essa non vi fosse il piano
digradato, sopra il quale si pongono le figure. Perciò che ripugna alla ragione ed
alla natura delle cose, che stando in terra, in un' altezza di 17 braccia, si possa vedere
tal piano; onde nè anche nelle pitture in tanta ed in minor altezza si vede essere
stato fatto: tutto che in esse si possa concedere alquanto più diligenza che nelle opere
di marmo, massimamente dove vi vanno figure di tanto rilievo. Per la qual cosa…
l'ultima vostra opinione mi piace infinitamente, conciossia che in lei si servino i precetti
della perspettiva, e non vi partiate da quello che la natura c'insegna, la quale dev'
essere da noi seguita se desideriamo di far le opere nostre che stiano bene e siano
lodevoli"* ("And in order to answer you in the same order as you write to me, I
say that the first opinion about the piece of marble that we are dealing with is
undoubtedly not incorrect, for it places the vanishing point [*orizzonte*, which
in the older terminology always means "vanishing point"] into one of the sides
of the marble. In fact, according to all perspectival rules, this vanishing point
should lie in the middle; for, in order to provide the objects represented to our
eyes with higher greatness and majesty, they should be represented so that the
lines from the extremes to the vanishing point are equal. It is also beyond any
doubt, as far as I am concerned, that the second opinion, according to which
there should be two vanishing points, should be discarded. This is so both
due to the reasons most learnedly pointed out by you and because, as I said, a
vanishing point lying in the middle is the characteristic feature of such works.
We see that this characteristic was observed by all the most excellent men, and
I would never depart from their authority in my works, unless a strong reason

143

showed me that it is better to do so. Given what has been said hitherto, you can already understand that I would find the third opinion, according to which there is to be one vanishing point only, more satisfactory than the preceding two, were it not for the presence in it of the inclined plane upon which the figures are to be placed. In fact, it would conflict with reason and the nature of things that such a plane could be seen from the ground at a height of seventeen *braccia*. Therefore, this was avoided even in paintings at an equal or lesser height, although less accuracy may be conceded there than in marble works, especially in the case of figures of considerable relief. Due to this...I like your last opinion infinitely, since both the perspectival precepts are there observed and you do not depart from the teachings of nature, to which we must conform if we wish that our works will be correct and praiseworthy").

Vignola cannot assent to the initial condition either, but is not nearly so intransigent as Palladio (he concedes that special conditions could justify an eccentric position of the central vanishing point). He, too, chooses the *prospettiva di sotto in sù*, although he recommends moderation: the correctly requested lowering of the vanishing point to seventeen *braccia* below the picture would create a violent slanting of the lines; one should thus proceed with "*discrezione*" and "*buon giudizio*," that is, not show the floor of the room from above, but nevertheless not permit the *prospettiva di sotto in sù* to take full effect. "*E prima, sopra il sasso dell' Annunciazione fatto in perspettiva, dico che il primo architetto avrebbe fatto meglio avendo messo il punto della veduta in mezzo, se già non era necessitato per qualche suo effetto fare in contrario. Del parere del secondo architetto, che vuol fare due orizzonti, a me par tempo perduto a parlarne, perchè egli mostra non aver termine alcuno di perspettiva. E per dire quello che mi pare di detta opera, mi piace più il parere di V. S. del quarto disegno, volendo osservare la vera regola di perspettiva, cioè mettere l'orizzonte al luogo suo, o almeno tanto basso, che non si vegga il piano, e non pigli tali licenze di far vedere il piano in tanta altezza; cosa falsissima, come che molti l'abbiano usata; ma in pittura si può meglio tollerare che in scultura. E la ragione è che altri si può cuoprire con dire fingere tal pittura essere un quadro dipinto attaccato al muro, come fece l'intendente Baldassare Petruzzi senese nel tempio della Pace in Roma, il quale finse un telaio di legname essere attaccato a'*

gangheri di ferro alla muraglia; talchè chi non sa che sia dipinto nel muro lo giudica fatto in tela. Pertanto non si può in scultura fare tale effetto; ma, a mio parere, vorrei mettere l'orizzonte non tanto basso, come per ragione vorrebbe stare, ma alquanto più alto, a fine che l'opera non declinasse tanto, riportandomi alla sua discrezione e buon giudizio" ("And first, concerning the relief of the Annunciation realized in perspective, I say that it would have been better for the first architect to place the point of view in the middle, unless he was compelled not to do so for the sake of some particular effect. As for the opinion of the second architect, who wants two vanishing points, it seems to me to be but a waste of time to talk about it, since he gives proof not to have the least notion of perspective. As for my feeling about the above-mentioned work, I prefer the opinion of Your Lordship in the fourth drawing, where the authentic perspectival rule is observed. That is to say, the vanishing point is there in its place, or at least so low that the plane could not be seen; and there is no place for licenses like making the plane visible at such a height. This is indeed quite false, although many have made use of it; at any rate, it can be tolerated more in painting than in sculpture, where one can pretend that the painting is a picture hung on the wall. The expert Baldassarre Peruzzi from Siena actually did so in the S. Maria della Pace in Rome. He feigned that a wooden frame was hung to the hinges in the wall, so that one that does not know that it is a wall painting believes that it is a picture on canvas. Therefore, a similar effect is not to be admitted in sculpture. As far as I am concerned, I would place the vanishing point not as low as it should lie according to reason, but – relying on your moderation and sound judgment – rather higher, in order for the work not to slant too much").

Still more liberal than Vignola is Vasari, who speaks with the open-mindedness of the practicing artist and at the same time the marked need for freedom of the true Mannerist (see Panofsky, *Idea: Ein Beitrag zur Begriffsgeschichte der älteren Kunsttheorie*, Studien der Bibliothek Warburg, no. 5 [Leipzig & Berlin: Teubner, 1924], pp. 41ff. and 101ff.; *Idea: A Concept in Art Theory*, trans. Joseph J. S. Peake [New York: Harper & Row, 1968]): "*Ed in somma vi dico, che tutte le cose dell' arte nostra, che di loro natura hanno disgrazia all' occhio per il quale si fanno tutte le cose per compiacerlo, ancora che s'abbia la misura in mano e sia*

approvata da' più periti, e fatta con regola e ragione, tutte le volte che sarà offesa la vista sua, e che non porti contenta, non si approverà mai che sia fatta per suo servizio, e che sia nè di bontà, nè di perfezione dotata. Tanto l'approverà meno quando sarà fuor di regola e di misura. Onde diceva il gran Michelangelo, che bisognava avere le seste negli occhi e non in mano, cioè il giudicio; e per questa cagione egli usava talvolta le figure sue di dodici e di tredici teste... e così usava alle colonne ed altri membri, ed a componimenti, di andar più sempre dietro alla grazia che alla misura. Però a me, secondo la misura e la grazia, non mi dispiaceva dell' Annunziata il primo disegno fatto con un orizzonte solo, ove non si esce di regola. Il secondo, fatto con due orizzonti, non s'è approvato giammai, e la veduta non lo comporta. Il terzo sta meglio, perchè racconcia il secondo per l'orizzonte solo; ma non l'arricchisce di maniera che passi di molto il primo. Il quarto non mi dispiace per la sua varietà; ma avendosi a far di nuovo quella veduta si bassa, rovina tanto, che a coloro che non sono dell' arte darà fastidio alla vista; che sebbene può stare, gli toglie assai di grazia" ("And, in short, since everything is done in order to please the eye, I tell you that every product of our art whose nature is disliked by this eye, every time that its vision be offended, and that there be no satisfaction as a result of this vision, it shall never be admitted that that art was for the sake of the eye, nor that it was endowed with excellence or perfection, although it be performed according to measure and it be approved by the most expert men. Least of all will the eye approve the object when it is without rule or measure. Therefore, the great Michelangelo used to say that it is necessary to have the compasses – namely, sound judgment – in one's eyes and not in one's hands. Thus, his figures were sometimes twelve or thirteen heads tall... and thus, as for columns and other elements and groups, he always used to look more after grace than measure. [On this, see the pertinent passage in Vasari's life of Michelangelo, in the edition of Karl Frey, *Sammlungen ausgewählter Biographien Vasaris* (Berlin, 1887), vol. 2, p. 244.] Therefore, according to measure and grace, I did not dislike the first drawing of the Annunciation with one vanishing point only, where the rule is not broken. The second one with two vanishing points was never admitted, and the view does not require it. The third is better, because it improves the second as for the vanishing point only, but it does not enrich it so much as to essentially overcome the first. I do

not dislike the fourth, given its variety; but, since it requires again that very low view, it falls so sharply that laymen would take offense; and although it may be all right, much grace is taken away"). Thus Vasari, alone among those polled, has no fundamental objection to the original solution with the central vanishing point off to the side. But the present condition is of course unjustifiable; the first proposed emendation, although in its own right admirable, represents no essential improvement, for it does not "enrich" the picture; and the second proposed emendation, although praiseworthy "*per la sua varietà*," with a really strictly carried out view from below the lines would fall so sharply ("*rovinare*"; see the comment by Vignola-Danti cited in note 8, above) that laymen would take offense.

Bertani, finally, does not in his highly personal contribution wish to deny that Bassi's perspectival deliberations are correct, but rather is opposed to the perspectival relief as such. Here he appeals to the arch of Septimius Severus and other antique monuments which, despite their high placement, all reproduce the ground as seen from above. He conceives the problem of the perspectival relief very acutely as a mixture of fiction and reality, and picks up trains of thought voiced by Leonardo in *Das Buch von der Malerei*, art. 37: "*Vi è poi nel giardino del signor Corsatalio, posto nell' alta sommità del Monte Cavallo la statua di Meleagro col Porco di Calidonia, e molte altre figure con dardi, archi e lance, le quali tutte istorie e favole hanno le loro figure che posano sopra i suoi piani naturali, e non sopra piani in perspettiva. Laonde tengo per fermo che detti antichi fuggissero di far i piani in perspettiva, conoscendo essi che le figure di rilievo non vi poteano posar sopra se non falsamente. Per lo che a me parimente non piace la bugia accompagnata colla verità, se non in caso di qualche tugurio o casupola, o d'altre cose simili fatte sopra i fondi delle istorie. Tengo io la verità essere il rilievo naturale, e la perspettiva essere la bugia e finzione, come so che V. S. sa meglio di me. Ben è vero che Donatello e Ceccotto, nipote del vecchio Bronzino, ambidue usarono di fare i piani in perspettiva, facendovi sopra le figure di non più rilievo di un mezzo dito in grossezza, e di altezza le dette figure di un braccio, come si vede in un quadro di sua mano in casa de' Frangipani, pur a Monte Cavallo, scolpite con tant' arte, magisterio e scienza di perspettiva, che fanno stupire tutti i valent' uomini ed intendenti di tal arte che li*

veggiono. Ho anche in mente molte altre anticaglie, che tutte sarebbero a nostro proposito parlando de' piani, delle quali mi perdonerete se altro non ne dico, perciò che il male mi preme, nè più posso scrivere" ("Moreover, there is the statue of Meleager with the Calydonian boar and many other figures with arrows, bows and spears in the garden of Lord Corsatalio, on top of Monte Cavallo. The figures of all these scenes and fables lie on their natural planes and not on perspectival planes. Therefore, I maintain that the ancients refrained from the realization of perspectival planes, because they knew that the relief figures could not lie on them but falsely. For the same reason I myself do not like lies mixed up with truth, unless it be in the case of dwellings or small houses or the like lying in the background of the scenes. I argue that truth is to be found in natural relief and lie and fiction in the perspective, as I am aware that Your Lordship knows better than I. Both Donatello and Ceccotto, the grandson of old Bronzino – it is true – used to make their planes in perspective, placing upon them figures in relief not thicker than about an inch and one *braccio* tall. This can be seen in a painting by him [sc.: Ceccotto?] at Frangipani's residence, also on Monte Cavallo. These figures are sculpted with such art, skill and science of perspective, that all skillful men and experts learned in this art are astonished when they see them. I also recollect many other antiquities, all of them fitting our present subject of planes, but you will forgive me if I shall not speak about them any longer, since my illness lies heavy on me and prevents me from continuing to write"). (For more on Bertani's opinion, see the arguments in Lomazzo, *Trattato della pittura* 6.13 [Milan, 1584], which also in other ways betrays familiarity with Bassi's pamphlet.)

69. Leonardo, for example, advises making the distance either twenty or thirty times larger than the dimensions of the largest object (cited in note 8, above), or three times larger than the largest dimension of the picture (Richter, *Leonardo da Vinci*, no. 86). Lomazzo (*Trattato* 5.8) also warns against the distorting effect of a short distance, and advises making it at least three times the size of the figures. Vignola-Danti (*Le Due regole di prospettiva*, p. 69ff.) establishes as a minimum one and a half times (or better still, two times) the largest dimension of the picture, which is determined with special meticulousness as the

diameter of the circumscribed circle, that is, the diagonal of the quadrilateral picture field. With an asymmetrically placed central vanishing point, the radius of this circle should be determined by the longest of the possible connecting lines between the central vanishing point and the corner of the picture. If in a ceiling painting the height of the room is not sufficient, then the ceiling should be divided into several compartments or, by means of a painted molding, both actually diminished and apparently raised.

For more on the problem of construction with short perpendicular distances, see the brief but substantial essay by Hans Jantzen, "Die Raumdarstellung bei kleiner Augendistanz," *Zeitschrift für Ästhetik und allgemeine Kunstwissenschaft* 6 (1911), pp. 119–23, and *Das niederländische Architekturbild* (Leipzig: Klinkhardt und Biermann, 1910), p. 144, as well as Mesnil, "Masaccio et la théorie de la perspective." It need only be added that Northern art already in the fifteenth and sixteenth centuries generally preferred a short perpendicular distance in representations of interiors. As with the Netherlandish painters of the seventeenth century, here, too, the will to subjectivism dominated, only that it did not yet to such an extent take advantage of the physiological conditions of vision (lack of clarity of the foreground, and so forth); and in both cases the distant space of landscape painting is the necessary correlative to the near space of interiors (see also Panofsky, "Dürers Stellung zur Antike," *Wiener Jahrbuch für Kunstgeschichte* 1 [1922], p. 86ff.). The views of Wedepohl, *Ästhetik der Perspektive*, p. 46ff., are nearly as doctrinaire as those of Hans Cornelius, who in his *Elementargesetze der bildenden Kunst* (Leipzig & Berlin: Teubner, 1908), p. 23ff., actually forbids construction with a short perpendicular distance and instead advises redrawing with a longer distance.

70. Karl Voll's subtle comparison of the two works, in *Vergleichende Gemäldestudien* (1907), vol. 1, p. 127ff., makes remarkably little allowance for the antagonism between the two perspectival configurations. See further, besides the censorious comments of Wedepohl, *Ästhetik der Perspektive*, p. 50, or of Fritz Burger, *Die Deutsche Malerei*, Handbuch der Kunstwissenschaft, 3 vols. (Berlin-Neubabelsberg: Athenaion, 1913–1919), vol. 1, p. 112ff., the perspectival analysis and reconstruction of Dürer's engraving in Schuritz, *Die Perspektive in der*

Kunst Dürers, p. 34; it is, however, to be objected that the large window should have not five but only four lights, whereby the arguments against the "fidelity to nature" of the representation are further diminished.

70a. See Burmester, *Beilage*, p. 45.

71. There has been considerable confusion regarding the evolution of the oblique view (see as well Kern in *Sitzungsberichte der Berliner Kunstgeschichtlichen Gesellschaft* [Oct. 1905]; Sauerbeck, *Ästhetische Perspektive*, p. 58ff.; and Wedepohl, *Ästhetik der Perspektive*, p. 9ff.), in that oblique placement of the pictorial architecture in the space is not always clearly distinguished from a rotation of the space itself. The oblique view in the first sense is already common in the Trecento, especially in Giotto, who with his propensity for the plastic must have welcomed such motifs, creating depth with almost gestural means (see, besides the Arena Chapel frescoes, the *Raising of Drusiana* in S. Croce, with oblique placement of the entire stretch of wall closing the stage); and in his school (Taddeo Gaddi, *Presentation of the Virgin* in S. Croce). In the North, see alongside the *Presentation of the Virgin* in the *Très riches heures* at Chantilly (which is, of course, copied from Gaddi), the *Annunciation* of Broederlam, the interesting Passion series of a Lake Constance master in the Bayerische Nationalmuseum in Munich, or the Karlsruhe "Hieronymianum." In all these cases, as already in the *Temptation of Christ* from Duccio's Maestà, even the floors of the obliquely rotated buildings are made visible. In the fifteenth century, however, as Kern in particular has correctly stressed (in *Sitzungsberichte*, p. 39), even this form of the oblique view becomes rare in Italy, so that a work like Masaccio's *Betrayal of Judas* (*Catalogue des collections de Somzée*, vol. 2 [Brussels, 1904], pl. XXVIII, no. 306; now in the Johnson Collection, Philadelphia) looked strange to Vasari's connoisseurial eye (*Le Vite*, ed. Milanesi, vol. 2, p. 290). The North, on the other hand, kept the problem in mind all along, even – and this is typical – in the broader and genuinely subjective sense of the true rotated space. Already in the Boccaccio of Jean sans Peur (ed. Henry Martin [Brussels: Oest, 1911], pl. 16, no. LXI, whence our own Plate 39) we encounter the attempt to represent an independent interior (the inside of the Temple of Lokri) in an oblique view, even though a bit of the normally viewed foreground remains visible and the

transition of the oblique pictorial architecture into the frontal frame architecture creates a bizarre contradiction. And in the Book of Hours of Étienne Chevalier by Jean Fouquet we find both on the Madonna side of the dedication page and in the *Annunciation of the Death of the Virgin* similar attempts with similar (although not quite so flagrant) contradictions. The next step is taken in Gerard David's *Judgment of Cambyses*, where the entire foreground together with its architecture is rotated, whereas in the background, as a kind of reassurance, the marketplace appears normally, with a different vanishing point and even a different horizon. Pélerin–Viator, finally, who on the strength of his familiarity with the distance-point method was able to master the problem of the oblique view perspectivally and exactly, gives in his *De artificiali perspectiva*, on fol. bIVr and bVr, two examples of the completely rotated total space, dispensing with all frontals and orthogonals (Figure 24). Already Altdorfer put this achievement to practical use in a number of cases (see, for example, the Munich *Birth of the Virgin* and its interesting preliminary drawing, our own Plate 20, published by Elfried Bock, "Eine Architekturzeichnung Altdorfers," *Berichte der Berliner Museen* 45 [1924], p. 12ff., with a good analysis – in need of emendation only in details – of the perspective; further, see, for instance, the *Judgment of Pilate* of the St. Florian altarpiece, or the eighteenth and thirty-sixth images in Holbein's *Dance of Death*). One may therefore stress, against Jantzen's often-repeated assertion (*Das niederländische Architekturbild*, p. 150, cf. also p. 95ff.), that the completely diagonal positioning of the interior space (or, as the case may be, of the architectonically enclosed exterior space) had already been achieved in German and French art of the early sixteenth century, and that here, too, Netherlandish painting of around 1650 (especially Jan Steen and Cornelis de Man, as well as the Delft architectural painters; see also Rembrandt's etchings B.112 and B.285, although in his old age, and in keeping with the overall development of his style, Rembrandt retreats entirely from this way of forming space) finally resolved a problem which northern art had posed itself from the start, and which already a century and a half earlier had led to similar solutions.

It is no accident that the evolution of the oblique view played itself out preeminently in the North. Innate to "mass," that specifically Northern formal

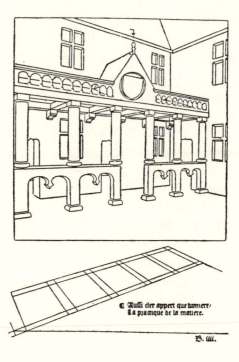

FIGURE 24. Oblique space from Jean Pélerin (Viator), *De artificiali perspectiva* (1505).

substance, is a peculiar indifference to direction (on this, see Hermann Beenken's review of Panofsky, *Die deutsche Plastik*, in *Zeitschrift für bildende Kunst*, Beilage "Die Kunstliteratur" [1925], vol. 1, pp. 1–6); and as soon as the perspectival mode of representation had been adopted, that indifference would have been transferred at once to the "pictorial space." For one may say that the North, compared to Italy, felt even pictorial space as "mass," that is, as a homogeneous substance within which open space, the space of light, was felt to be almost as dense and "material" as the individual bodies distributed in it. Conversely, it now becomes clear that the working out of geometrical perspective methods was reserved for the Italians: for them, the conquest of space proceeded first

of all from the desire to provide freedom of movement and *dispositione* for bodies, and was therefore more a stereometric than a painterly problem. The artistic incarnation of the homogeneous and infinite space could thus only be achieved by the collaboration of North and South, for the one was capable of grasping the problem *sub specie qualis*, and the other *sub specie quantis.*

Of course, even in the question of the oblique view the particular approaches of individual artists and schools played an important role. Whereas Altdorfer in some cases carries out the diagonal placement of an entire interior with a resolve almost worthy of de Witte, Dürer, as far as we can tell, avoided it altogether. And whereas Rogier van der Weyden understands, even if not rotated space, at least pictorial architecture rotated in space (middle panel of the Bladelin altar), strict frontality prevails in the Master of Flémalle and in Jan van Eyck. Conversely, Italian art, which was by and large averse to the oblique view and which generally avoided it even in the Baroque, nevertheless occasionally adopted the motif of rotated space already in the sixteenth century, even if usually with mitigating modifications, and (significantly) almost exclusively where a Northern element or at least a Northern influence is present: see, for example, Defendente Ferrari's *Adoration of the Child* in Berlin, or later, Santi di Tito's *Marriage at Cana* (Villa Bombicci at Collazzi, reproduced in Hermann Voss, *Die Malerei der Spätrenaissance in Rom und Florenz* [Berlin: Grote, 1920], vol. 2, ill. 148), or the great *Handing over of the Keys of the City of Verona* of Jacopo Ligozzi (in other ways, too, strongly "suggestive of Northern art") in the Museo Civico in Verona (Voss, *Malerei der Spätrenaissance*, p. 414, ill. 160). The two latter cases are especially instructive in that Santi di Tito leaves open a reassuring vista through large arcades onto a landscape seen normally, whereas Ligozzi, despite the oblique placement of the stair of the senate, which occupies nearly the entire breadth of the picture, frontalizes in a quite inconsistent fashion the rear closing wall of the space (the situation is somewhat similar in Titian's *Last Supper* in Urbino).

72. For a good anthology of the relevant remarks, see Pfuhl, "Apollodoros Ο ΣΚΙΑΓΡΑΦΟΣ," p. 12ff.

73. Most instructive, although – or perhaps precisely because – disputa-

ble, is an essay by El Lissitzky in Kiepenhauer's Verlag-Almanach for 1925, p. 103ff. Older perspective is supposed to have "limited space, made it finite, closed it off," conceived of space "according to Euclidean geometry as rigid three-dimensionality," and it is these very bonds which the most recent art has attempted to break. Either it has in a sense exploded the entire space by "dispersing the center of vision" ("Futurism"), or it has sought no longer to represent depth intervals "extensively" by means of foreshortenings, but rather, in accord with the most modern insights of psychology, only to create an illusion "intensively" by playing color surfaces off against each other, each differently placed, differently shaded, and only in this way furnished with different spatial values (Mondrian and in particular Malevich's "Suprematism"). The author believes he can suggest a third solution: the conquest of an "imaginary space" by means of mechanically motivated bodies, which by this very movement, by their rotation or oscillation, produce precise figures (for example, a rotating stick produces an apparent circle, or in another position, an apparent cylinder, and so forth). In this way, in the opinion of El Lissitzky, art is elevated to the standpoint of a non-Euclidean pan-geometry (whereas in fact the space of those "imaginary" rotating bodies is no less "Euclidean" than any other empirical space).

74. That Botticelli, despite his ever-more clearly emerging disinclination for the perspectival view of space, nevertheless had thoroughly mastered perspectival construction, is demonstrated by Kern, "Eine perspektivische Kreiskonstruktion bei Sandro Botticelli," *Jahrbuch der Königlich Preussischen Kunstsammlungen* 26 (1905), p. 137ff.

75. The extent to which this is true is shown by the often markedly antiperspectival Mannerism, in which the reawakening of a religious and dogmatic worldview, one which in many respects reestablishes contact with the ideas and creations of the Middle Ages, acts together with the awakening of a desire for "artistic freedom," a desire protesting against all rational, specifically mathematical, restrictions (see note 68, above). Bruno, whose personal temperament lent especially vehement expression to a widespread contemporary view, raised himself to a veritable wrath against mathematics (see Olschki, "Giordano Bruno," pp. 41 and 51).

Plates

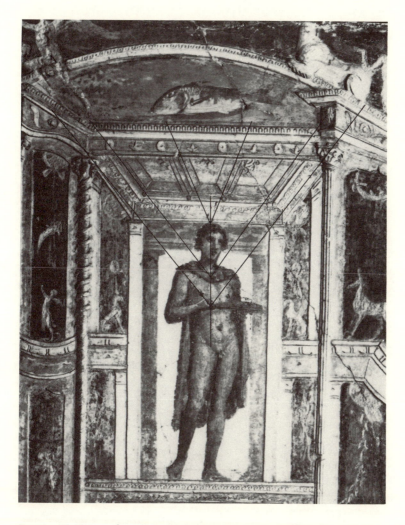

PLATE 1. Fragment of a wall decoration in stucco and paint from Boscoreale, in the "fourth style," first century A.D. Naples, Museo Nazionali.

PLATE 2. Perspectival dentil, ornament from the neck of a southern Italian vase, end of the fourth century B.C. Hamburg, Museum für Kunst und Gewerbe. (See Plate 3 and note 30.)

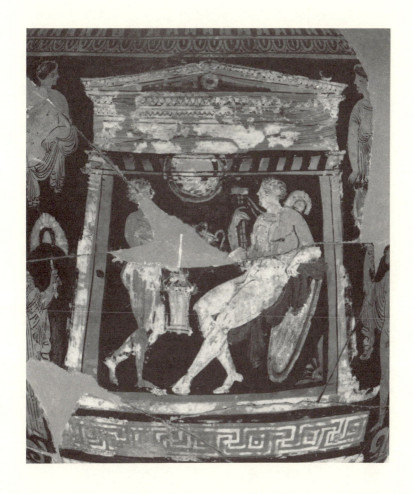

PLATE 3. Architectural representation on a southern Italian vase, end of the fourth century B.C. Hamburg, Museum für Kunst und Gewerbe. (See Plate 2.)

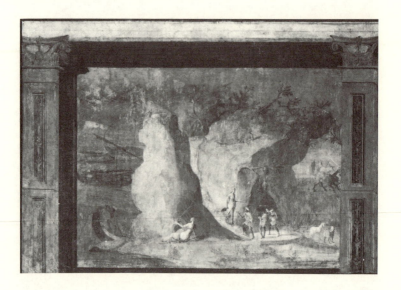

PLATE 4. *Odysseus in the Underworld*, painted frieze in the "second style" from the Via Graziosa on the Esquiline, first century A.D. Rome, Biblioteca Apostolica Vaticana.

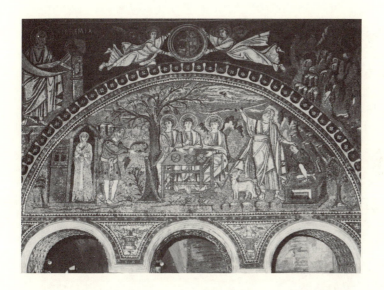

PLATE 5. *Abraham Receiving the Angel* and *The Sacrifice of Isaac*, mosaic, middle of the sixth century A.D. Ravenna, S. Vitale.

PLATE 6. *Last Supper*, relief on west choir screen, c.1260. Naumburg, Cathedral.

PLATE 7. *Pharoah's Dream*, mosaic, end of the thirteenth century. Florence, Baptistry.

Plate 8. *Last Supper*, mosaic, second half of the twelfth century. Monreale Cathedral.

Plate 9. *The Healing of the Cripples*, mosaic, second half of the twelfth century. Monreale Cathedral.

PLATE 10. Duccio di Buoninsegna, *Last Supper* from the *Maestà*, 1301–1308.
Siena, Museo dell'Opera del Duomo.

PLATE 11. Ambrogio Lorenzetti, *Annunciation*, 1344. Siena, Pinacoteca.

PLATE 12. Ambrogio Lorenzetti, *Presentation in the Temple*, 1342. Florence, Uffizi.

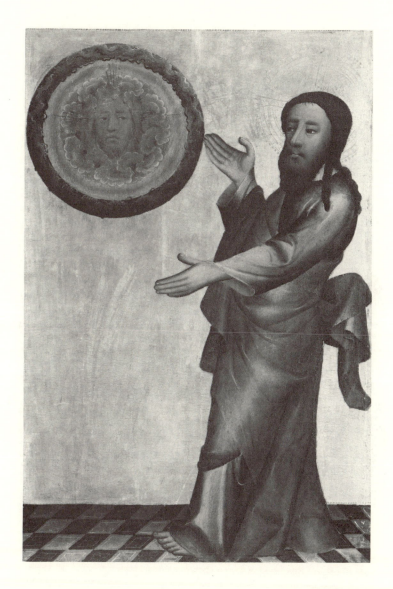

PLATE 13. Master Bertram of Minden, *Creation of the Heavens* from the Petri altar, 1379. Hamburg, Kunsthalle.

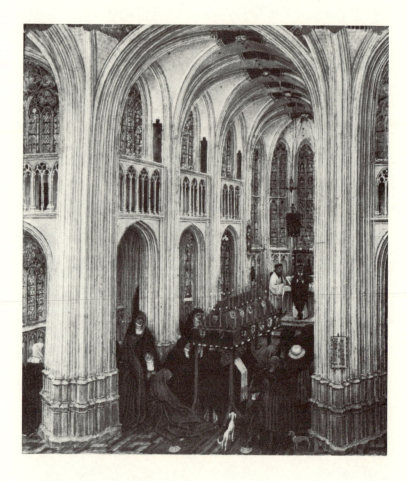

PLATE 14. Jan van Eyck, *Office of the Dead*. Miniature from the Turin-Milan Hours, between 1415 and 1417. Turin, Museo Civico. (See note 52.)

PLATE 15. Jan van Eyck, *Virgin in the Church*, in this author's opinion
c. 1432–1434. Berlin, Staatliche Museen Preussischer Kulturbesitz,
Gemäldegalerie.

PLATE 16. Jan van Eyck, *Birth of John the Baptist*. Miniature from the Turin-Milan Hours, between 1415 and 1417. Turin, Museo Civico. (See note 52.)

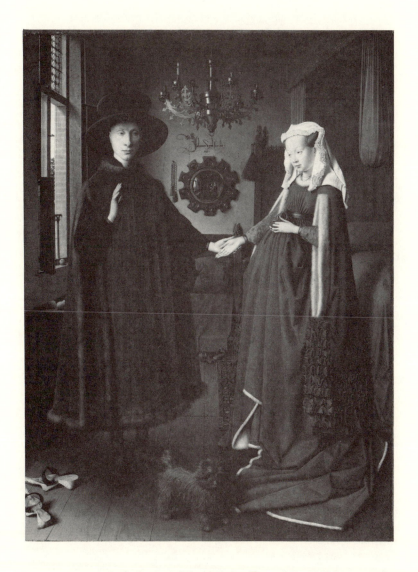

PLATE 17. Jan van Eyck, *Portrait of Giovanni Arnolfini and His Wife Giovanna Cenami*, 1434. London, National Gallery. (See note 52.)

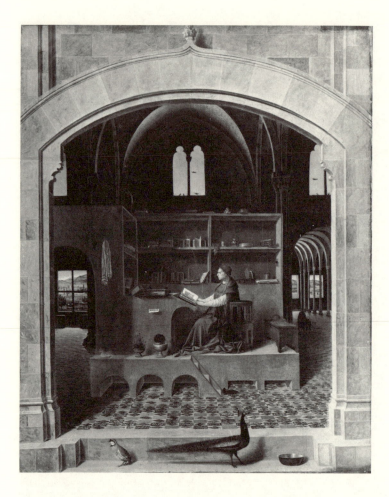

PLATE 18. Antonello da Messina, *St. Jerome in His Chamber*. London,
National Gallery.

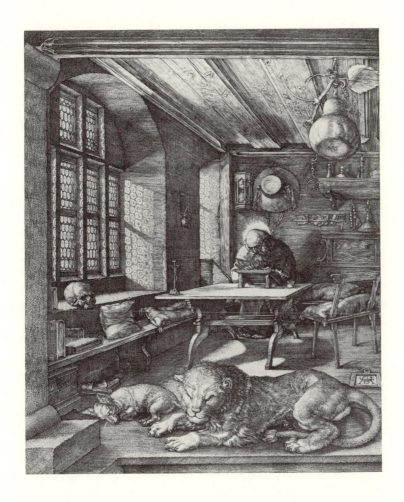

PLATE 19. Dürer, *St. Jerome in his Cabinet*, engraving, 1514.

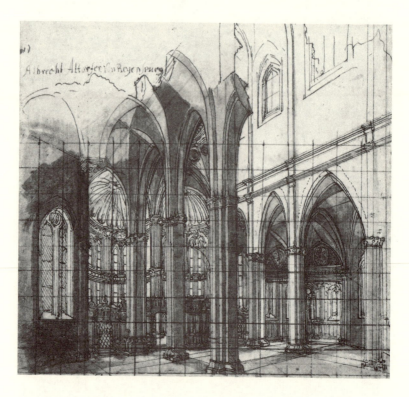

PLATE 20. Albrecht Altdorfer, study for the *Birth of the Virgin* in Munich, shortly after 1520. Berlin, Staatliche Museen Preussischer Kulturbesitz.

PLATE 21. Black-figure vase, second half of the sixth century B.C. Hamburg, Museum für Kunst und Gewerbe. (See note 24.)

177

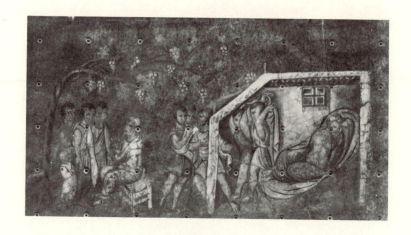

PLATE 22. *The Shame of Noah*, miniature from the Vienna Genesis;
c. 500 A.D. (?). Vienna, Österreichische Nationalbibliothek. (See note 30.)

PLATE 23. *Denial of Peter*, mosaic, first quarter of the sixth century A.D.
Ravenna, S. Apollinare Nuovo. (See note 30.)

PLATE 24. *Joseph's Brothers before His Steward*, miniature from the Vienna Genesis; c. 500 A.D. (?). Vienna, Österreichische Nationalbibliothek. (See note 30.)

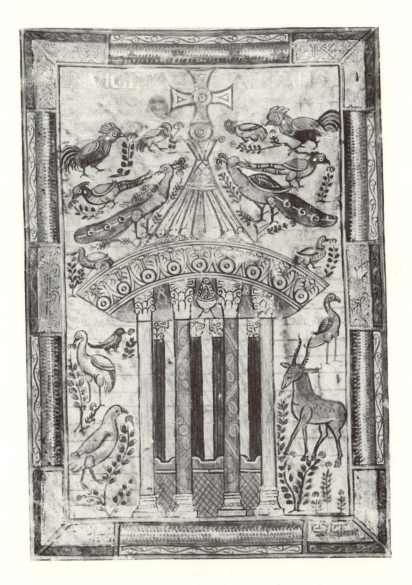

PLATE 25. *Fountain of Life*, miniature from the Godescalc Gospel, 781–783. Paris, Bibliothèque Nationale, ms. lat. 1993. (See note 30.)

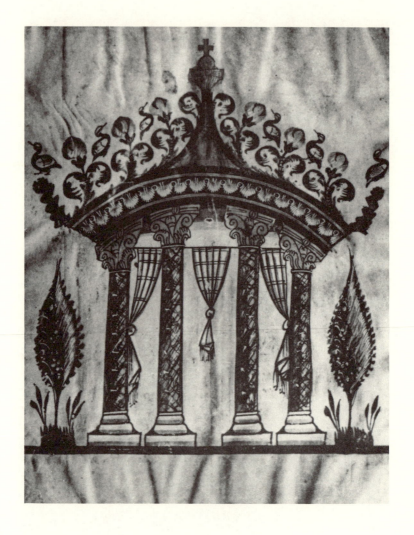

PLATE 26. *Fountain of Life* (?), Syrian miniature of the sixth century A.D. (?).
Echmiadzin, Monastery Library. (See note 30.)

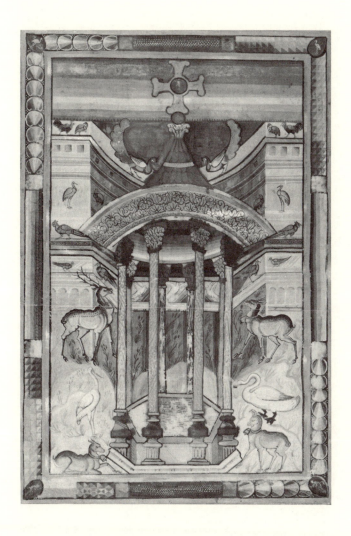

PLATE 27. *Fountain of Life*, miniature from the Gospel of St. Médard in Soissons, supposedly completed around 827 (according to W. Köhler, already before 814). Paris, Bibliothèque Nationale, ms. lat. 8850. (See note 33.)

PLATE 28. Macellum, fresco in the "second style" from a villa at Boscoreale, first century A.D. New York, Metropolitan Museum. (See note 33.)

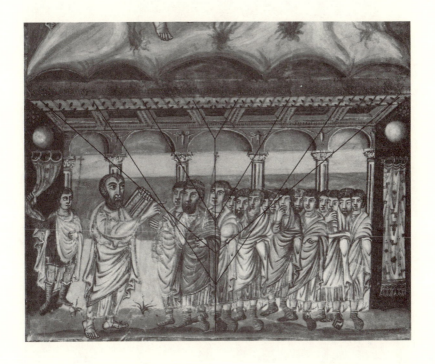

PLATE 29. *Presentation of the Tables of the Law* from the so-called London Alcuin Bible, second quarter of the ninth century. London, British Library, ms. Add. 10546. (See note 33.)

PLATE 30. Canon page from the Codex Aureus from St. Emmeran, completed 870. Munich, Bayerische Staatsbibliothek, cod. lat. 14000. (See note 33.)

186

PLATE 31. Frescoes from St. Johann in Pürgg (Steiermark), second half of the twelfth century. (After Borrmann; see note 34.)

PLATE 32. Ambrogio Lorenzetti, *Madonna with Angels and Saints*. Siena, Pinacoteca. (See note 47.)

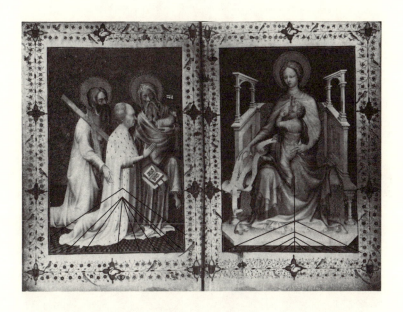

PLATE 33. André Beauneveu (?), *Duke Jean de Berry with Saints Andrew and John Worshipping the Madonna*, first dedication picture from the Brussels Hours of the Duc de Berry, c. 1395, no later than 1402. Brussels, Bibliothèque Royale Albert 1er, ms. 11060. The sheet was bound into a later codex executed in the workshop of Jacquemart de Hesdin. (See note 50.)

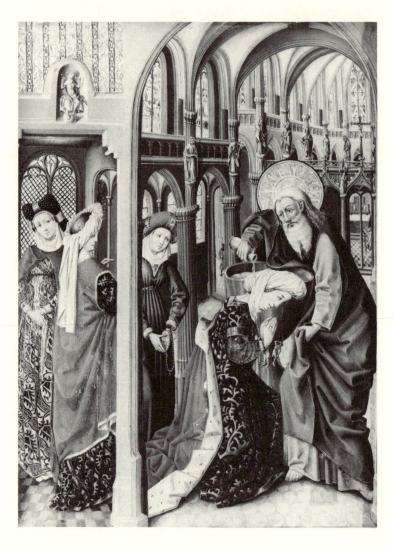

PLATE 34. Master of Heiligenthal (Konrad von Vechta?), *St. Andrew Baptising*, c. 1445. Lüneburg, St. Nicholas. (See note 52.)

PLATE 35. Annunciation relief before the alterations by Pelligrino Tibaldi.
Milan, Cathedral. Etching from Martino Bassi, *Dispareri in Materia d'Architettura
et Prospettiva* (Brescia, 1572). (For Plates 35–38, see note 68).

Plate 36. Annunciation relief after the alterations by Pelligrino Tibaldi.
Milan, Cathedral.

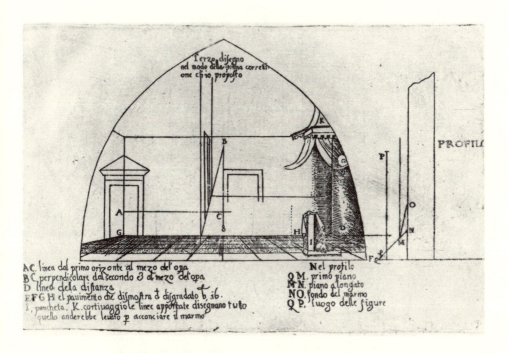

Terzo disegno
nel modo della prima correti-
one ch'io proposto

PROFIL

AC. linea dal primo orizonte al mezo del'opa.
BC perpendicolare dal secondo ɔ al mezo del'opa
D linea dela distanza
EFGH el pauimento che dismostra ɟ disgradato b, 16.
I. poncheta. K. cortiuaggio le linee apportate disegnano tutto
quello anderebbe leuato p̄ acconciare il marmo

Nel profilo
QM. primo piano
MN. piano alongato
NO. fondo del marmo
QP. luogo delle figure

PLATE 37. Martino Bassi, first recommended improvement for the Milan Annunciation relief.

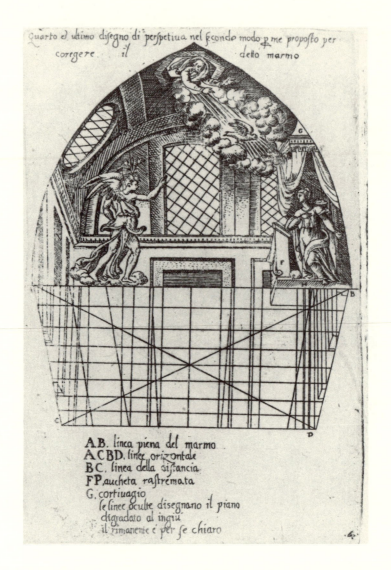

PLATE 38. Martino Bassi, second recommended improvement for the Milan Annunciation relief.

PLATE 39. *Robbery of the Virgins of Lokri by the Tyrant Dionys of Syracuse*, miniature from the Boccaccio of Jean sans Peur, between 1409 and 1419. Paris, Bibliothèque de l'Arsenal, ms. 5193. (See note 71.)

Photo Credits:

1. Alinari/Art Resource.
2. Beatrice Frehn.
3. Beatrice Frehn.
4. Biblioteca Apostolica Vaticana, Rome.
5. Soprintendenza per i Beni Ambientali e Architettonici per le Province di Ravenna.
6. Marburg/Art Resource.
7. Alinari/Art Resource.
8. Alinari/Art Resource.
9. Alinari/Art Resource.
10. Foto Soprintendenza B.A.S., Siena.
11. Foto Soprintendenza B.A.S., Siena.
12. Alinari/Art Resource.
13. Kunsthalle, Hamburg.
14. Museo Civico di Torino.
15. Gemäldegalerie Staatliche Museen Preussischer Kulturbesitz, Berlin.
16. Museo Civico di Torino.
17. Reproduced by courtesy of the Trustees, The National Gallery, London.
18. Reproduced by courtesy of the Trustees, The National Gallery, London.
19. Giraudon/Art Resource.
20. Staatliche Museen Preussischer Kulturbesitz, Kupferstich-kabinett, Berlin.
21. Beatrice Frehn.
22. Bild-Archiv der Österreichischen Nationalbibliothek, Vienna.
23. Soprintendenza per i Beni Ambientali and Architettonici per le Province di Ravenna.
24. Bild-Archiv der Österreichischen Nationalbibliothek, Vienna.
25. Bibliothèque Nationale, Paris.
26. Jean Vigne.
27. Bibliothèque Nationale, Paris.
28. Metropolitan Museum of Art, Rogers Fund, 1903, New York.
29. By Permission of the British Library, London.
30. Bayer. Staatsbibliothek, Munich.
31. Bibliothèque Nationale, Paris.
32. Foto Soprintendenza B.A.S., Siena.
33. Bibliothèque Royale Albert 1er, Brussels.
34. Niedersächsisches Landes-museum, Hanover.
35. Biblioteca Trivulziana, Milan.
36. Biblioteca Trivulziana, Milan.
37. Biblioteca Trivulziana, Milan.
38. Biblioteca Trivulziana, Milan.
39. Bibliothèque Nationale, Paris.

This edition designed by Georgie Stout
Zone Books series designed by Bruce Mau
Type composed by Archie at Archetype
Printed and bound Smythe-sewn by Quebecor Printing/Kingsport